ON THE ROAD WITH
TEXAS HIGHWAYS

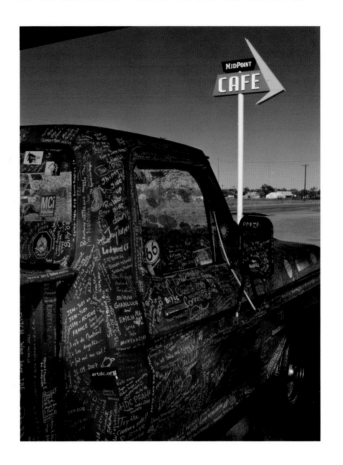

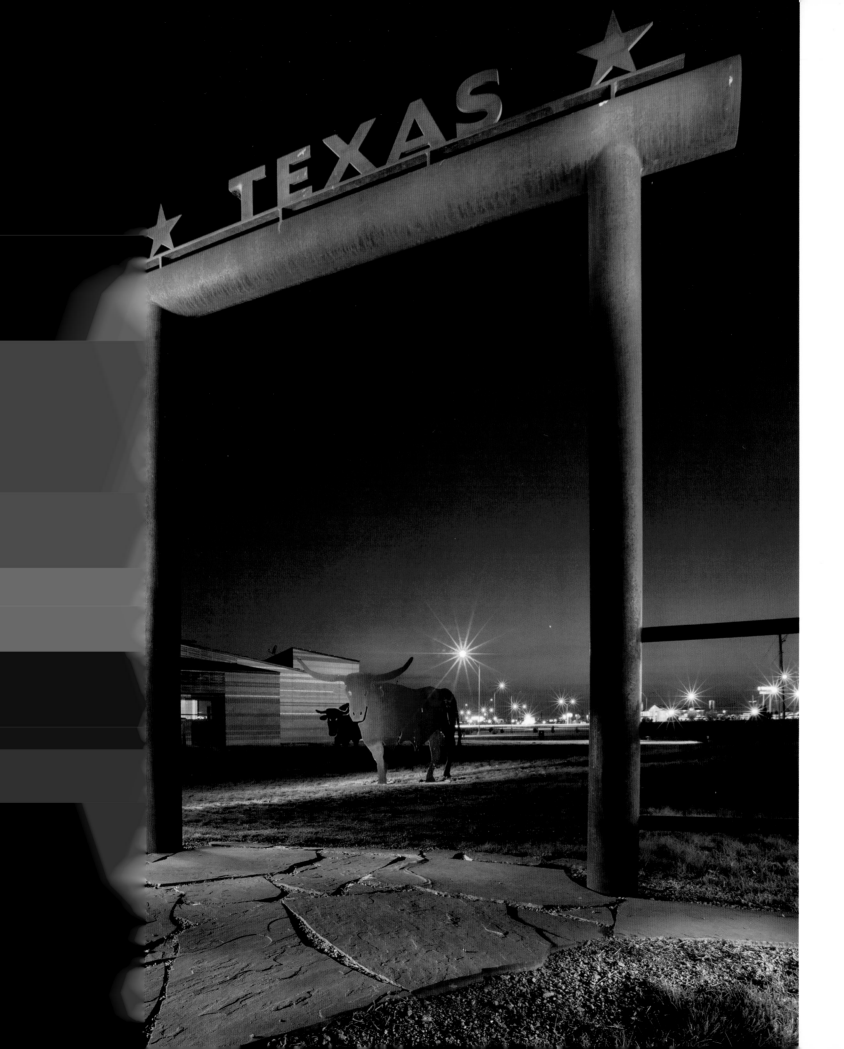

On the Road with Texas Highways

A TRIBUTE TO TRUE TEXAS

J. Griffis Smith

Essay by E. Dan Klepper

Foreword by Charles J. Lohrmann

Texas A&M University Press • College Station

◀ TxDOT travel information center, Amarillo, 2013.

This paper meets the requirements
of ANSI/NISO Z39.48–1992
(Permanence of Paper).
Binding materials
have been chosen for durability.
Manufactured in China
by Everbest Printing Co.
through FCI Print Group

Library of Congress Cataloging-in-Publication Data

Smith, J. Griffis, author.
 On the road with Texas highways : a tribute to true Texas / J. Griffis Smith ;
foreword by Charles J. Lohrmann.—First edition.
 p. cm.
 Includes index.
 ISBN 978-1-62349-183–3 (book/flexbound (with flaps) : alk. paper)—
 ISBN 978-1-62349-199-4 (e-book)
1. Texas—Pictorial works. 2.Texas—Description and travel. 3. Landscape
photography—Texas. 4. Portrait photography—Texas. 5. Texas highways.
I. Texas highways. II. Title. III. Title: Tribute to true Texas.
 F387.S64 2014
 976.4—dc23
 2014014175

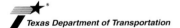

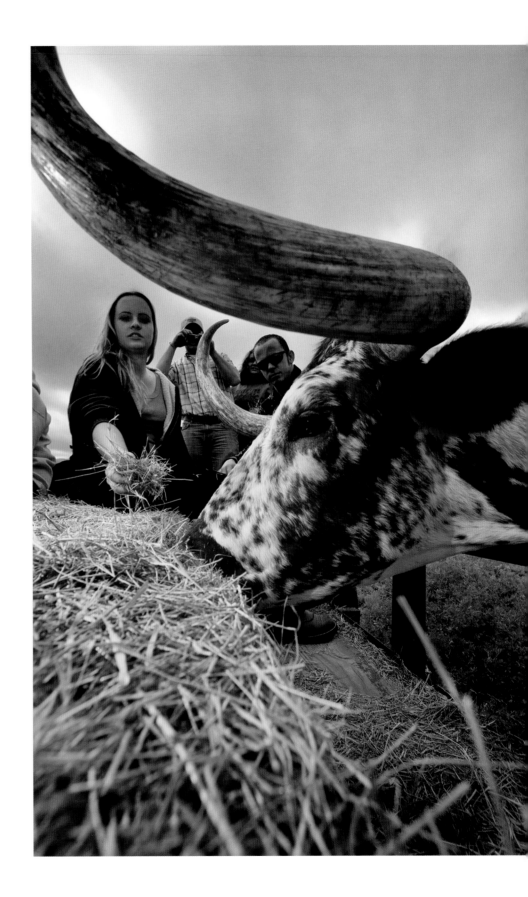

CONTENTS

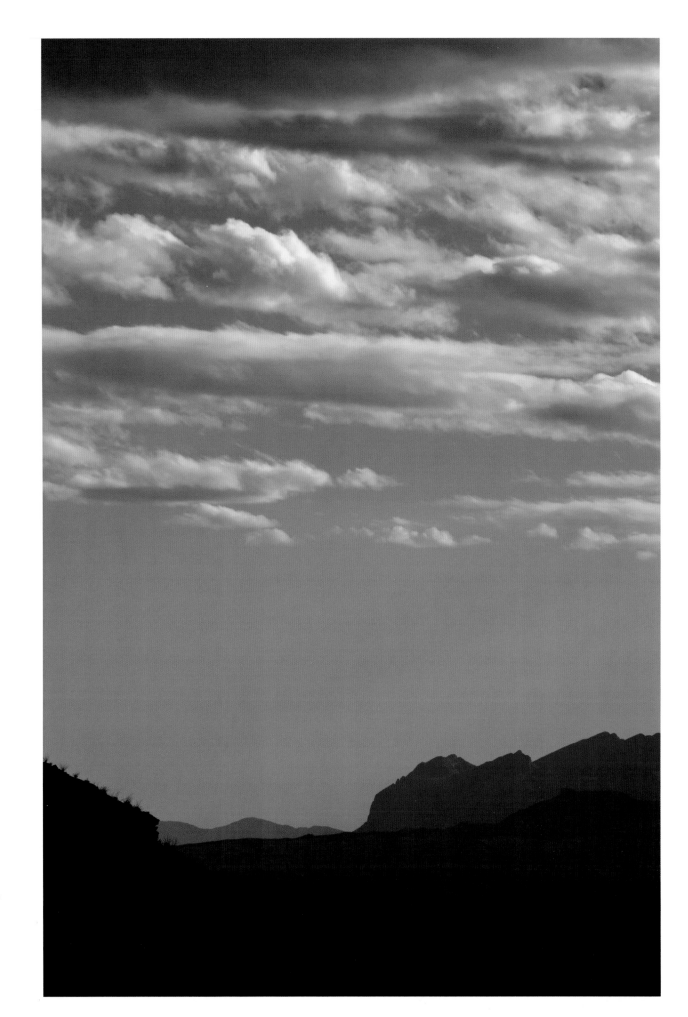

Pinto Canyon Road, Presidio
County, 2010.

FOREWORD: THE LIGHT WAITS FOR NO ONE

In the years I've worked with photographer Griff Smith, I've seen his photography influence my experience of events as well as shape my memories of them.

One example is the day I drove through fire.

My vehicle's tires had not actually touched the flames, but I could see the firefighters working feverishly right up to the very edge of the Interstate 20 access road, and the emergency vehicles patrolled slowly nearby. Smoke billowed across the highway in voluminous white clouds so thick that I couldn't see through the swirling mass at times, and I slowed the vehicle to 20 mph or less to navigate safely.

It was a Saturday morning in mid-April, but months of debilitating drought and a persistently vicious high-pressure weather system had transmogrified much of Texas into a dusty, parched ghost of its former geographic self. The landscape almost seemed to ache, as if suffering through the last painful weeks of a brutal summer rather than luxuriating in the first lush weeks of spring. Needless to say, no bluebonnets or red-and-yellow firewheels decorated the harsh roadside landscape. At the time, I could see scarcely any vegetation and no natural color at all to offset the brick red of the clay earth and the orange of the fire.

It was during that afternoon that Griff Smith made one of my favorite photographs. And it is a favorite image of mine for reasons that do not generally describe an outstanding photograph. Because, in this case, the memories were highly personal rather than objective. And the subject made it more of a snapshot than an artistic image or a documentary wonder. Even though the characteristics of the photographic image itself were, and still remain, significant because of my personal reaction to the context, that doesn't change my appreciation of the image or the memory of the day.

That afternoon, Griff and I were in Buffalo Gap, a few miles south of Abilene, tagging along with Tom and Lisa Perini as they hosted a tour of their Perini Ranch Steakhouse, then serving as the headquarters for the Buffalo Gap Wine and Food Summit. On this particular day, the celebrity tourist was internationally acclaimed chef and author Jacques Pépin, along with his entourage, which included friends and his daughter and collaborator, Claudine.

The region's fires, including the ones I had seen on the interstate highway, had generated a distinct haze that drifted overhead. And the weather hadn't improved since I had begun driving west on Interstate 20 earlier in the day. Dust eddied and jumped on the hard-packed red clay, and the temperature edged well into the 90s, more than hot for what should have been a spring day. These smoky and dangerous conditions dictated that Pépin and company had not been able to make the flight from Dallas to Abilene. Perini had ferried them to Buffalo Gap in his Suburban, and they were getting, literally in this case, the

cook's tour before the evening's festivities.

One would expect nerves to be worn at least a little thin, or even honed to a fine edge, or even frayed to a frazzle, because drought and hot, windy days will do that to even the most obliging and optimistic of souls.

But that wasn't the case. Their nerves were fine. Even on that searing, gritty day, a sense of humor and an appreciation of the place trumped frustration. Pépin and his long-time friend Jean-Claude clowned around with each other, staging mock battles with mesquite logs stolen from the woodpile out behind the steakhouse. Just 30 yards or so away, chandeliers swayed gently from the lofty vaulted ceiling of a huge tent where chef, restaurateur, and author Stephan Pyles and his crew would serve dinner.

Even on that day, plagued by drought and fire and dust and heat, a sense of humor took its place, and the photo opportunity appeared. The group crowded up the slanted walkway into a side-load horse trailer Perini had rigged up for his mobile catering kitchen. Here, Pyles, Perini, Pépin, and Jean-Claude mugged for the camera. Opposite this quartet of culinary desperadoes, from the other end of the trailer, I knew I was witnessing a scene absolutely unique to this specific day on this specific site in Texas.

And it became a moment that would be etched in my memory.

The point in relating the personal memory captured in a snapshot-like photograph is that Griff Smith often cajoles photographers, particularly amateurs aspiring to have their work published in *Texas Highways*, to remember that the readers weren't along—with the photographer—to enjoy that day and that moment, whether the experience was a fabulous High Plains sunset, the roiling dark clouds of a Trans-Pecos thunderstorm, or the light glittering off the surface of the Laguna Madre.

As Griff points out, as a photographer, you can't expect those memories or special conditions to come through in the final image automatically. You need to plan your shot carefully and expose it accordingly.

And that image of the four food-world luminaries in the repurposed slant-load horse trailer is not the only image that I have to remind me of experiences with Griff. That was only one of the times when the backstory captured the photograph for me.

Another experience with Griff, one which found us in a remote setting west of Big Bend and beyond even Candelaria, past the absolute terminus of FM 170, a.k.a. The River Road. That route, at its most scenic between Lajitas and Presidio, but persistent enough to continue on west along the Rio Grande, urged us to bounce and jolt our four-wheel-drive pickup down the two-track dirt road that 170 became.

We rolled between pasture fences and through a spring-fed creek, then down close to the river. As our tires jumped one particularly deep set of ruts, the wheels came to rest just about a foot from the Rio itself. It was clear from the tracks that the road, such as it was, crossed a shallow stretch of the river at a narrow spot and continued to follow the watercourse on the Mexican side. With one jump of a rutted tire track, we could be splashing across the international boundary into Mexico. At the time, it seemed like a fascinating and adventurous option but not a wise one.

So we backtracked up to another dirt road, this one leading to a gate locked by a massive wheel lock. Naturally, Griff felt compelled to make a photograph of the lock. That image is another of my favorites because it symbolizes

a scenic and remote afternoon drive and because it embodies the complexity of life in that rough land.

After Griff gathered in that image of the lock sculpture, we navigated to another fork in the road, and our path urged us up a gravelly hill with loose rock so deep our four-wheel-drive truck couldn't make the grade.

On the next stage of that trip, we undertook the drive up the Pinto Canyon Road between Ruidosa and Marfa, a rough-and-tumble passage that takes a few extra hours and offers up some beautiful mountainscapes. Most folks cover that road once every few years—if they're fanatical. Griff and I made the drive three times in two days.

Very slowly.

Why so slow? Because Griff jumped out of the truck every quarter mile or so to try for a particular image. If you travel with a photographer, you become accustomed to a couple of rules: You're always out very early and very late in the day. And schedules are always flexible, because the light waits for no one. And those are just the obvious ways photography itself shapes the experience.

The Pinto Canyon Road does not generally seem too dangerous—apart from lacking any kind of guardrails along the sides to keep you from plummeting hundreds of feet through prickly pear and other spiky flora and into the dry ravines. But there was the one time we bounced around a curve to come face-to-face with a chunk of concrete—one component of a crumbled cattle guard—that had somehow worked itself loose and created a

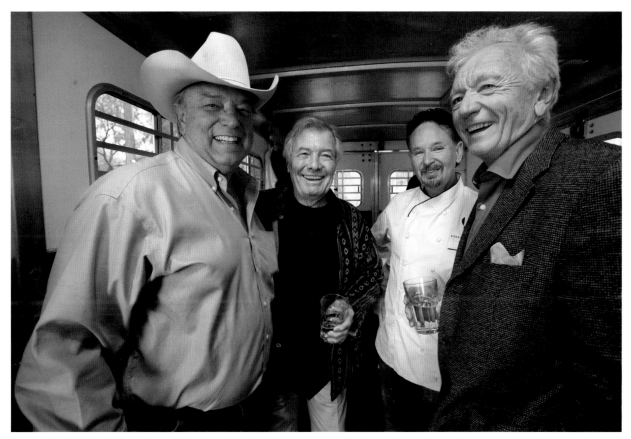

Buffalo Gap Wine & Food Festival.

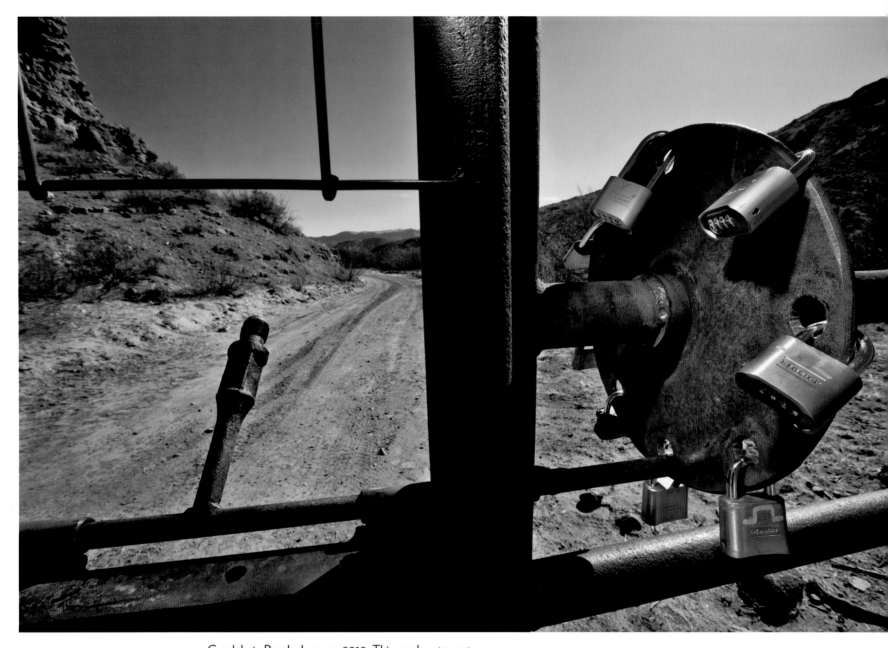

Candelaria Road, close-up, 2010. This ranch gate past
Candelaria is used by several ranchers who have their locks
on this wheel with holes. The rancher removes his lock, the
rod goes through the hole, and then he can open the gate.
I had never seen this kind of gate lock before. I took this
photo more as a record shot, but I liked the way my flash lit
the gate.

pit of tangled pipe in a gaping hole in the road. If navigated incorrectly, that obstacle would have made short work of a tire, if not a complete suspension.

But we successfully passed that obstacle and continued on our trail, Griff always on the lookout not just for scenic spots but also for unusual interplay of light and shadow in that big-sky realm. That's because Griff seeks to enhance his images with the quirky shadows, those not seen by the inattentive or casual observer. He thoughtfully seeks out the combination of narrative and artistic expression that relates the experience on multiple levels.

In addition to landmarks and landscapes, Griff seems to thrive on surprise weather events. Still in Big Bend Country, early one morning at Chinati Hot Springs, he pounded on my door, calling out "It's snowing!" with the urgency only a photographer with changing light conditions can communicate.

Maybe all that work with shifting natural light creates a desire to control light itself.

And maybe that's why one of Griff's obsessions is light painting, a process by which the camera is trained on the subject during the evening, the shutter is opened, and strobes or flashlights are used to bathe said subject with light for an extended exposure. The result is an unexpected interplay of light and shadow, resulting in equally surprising colors.

Through snow and sleet, heat and cold, night and day, the entire state of Texas has served as Griff's studio for more than thirty years. And many—though not nearly all—of his images have appeared in *Texas Highways* magazine. The collection in this book includes some of his best. But you can rest assured that this will not be the end. At this writing, Griff's father is into his nineties, and I'll wager Griff inherited that longevity, so you'll see his shaved-headed, nine-fingered self out trying to beat one more sunrise—or outrun one more sunset.

Because the light waits for no one.

—Charles J. Lohrmann

PREFACE

During my senior year at Caldwell High School in 1976, my dad, who is still my mentor and teacher in life and in art, encouraged me to shoot a roll of Kodachrome slides every day. My friends and I explored as many backcountry dirt roads as we could find, listening to Jeff Beck while I photographed sunsets, landscapes, and my friends. It was an incredible, fantastic opportunity to get out and photograph every day, though some days were better than others. There were times I wouldn't want to go, but my dad always told me that when that happened to him, he would work through the down times and the creativity would soon come back in full force, often taking him to the next level. To this day, I feel that if I just show up and be consciously aware of the beauty of my surroundings, the universe will provide an entertaining, creative journey while I'm experiencing life and connecting with all the people I meet.

I remember once when I was about five years old, I was playing with my Tonka trucks on the floor of our den at home when my dad, who was the only doctor in town at the time, got one of the many emergency phone calls he routinely took. He slammed the handset onto the base of the phone, cracking the heavy plastic that phones were made of back then. I could feel his frustration and desire to have just one night at home without interruptions. I looked up and said, "Daddy, if you didn't want to be a doctor, why didn't you become a truck driver?"

Noticing that most folks seemed to be unhappy in their work, I realized at a very young age that I did not want to end up being unhappy playing life. I began to ask myself on a daily basis, "What job could I do and still have fun?" In high school, I saw that the yearbook photographer did not have to sit down at the assemblies and sports events but could wander around the gym and photograph the event from any angle he was bold enough to take. That's when I knew that I had to get on the yearbook staff as a photographer. Not having to sit still and be bored at high school events was very appealing to me. I guess one could say that I have been doing assignment photography since I was fifteen, starting with the yearbook. And by the next year I knew this might be the answer to my question, "What job can I do and still have fun?"

After high school, I decided to get out of my small Texas town and go to school at The Art Institute of Atlanta in Georgia. Thanks to all the crazy and unique people I met and observed there, I came up with my operating metaphor for life, which still holds true for me to this day: "Life is a stage; we are either on it or we are watching it." I search for the fun and humor in all areas of my life, which has created some entertaining experiences, a few of which I will share with you in the photo captions in this book.

◄ Austin, 2012.

Georgia was nice, but I longed to get back to Texas and the wide-open spaces. After being home for a few weeks, a photographer friend of my dad's called me and said with a big country drawl, "Griff, I was in the bathtub this morning and thought about you." He then began to tell me about an opening for a photographer at the Texas A&M vet school and wanted me to come work as his photo assistant. But I knew I needed to find a job somewhere else as soon as he said, "Griffffff, now when you aren't in the darkroom, you will be a half-ass photographer under me."

Soon after, I learned about a job working as a public relations photographer for Texas A&M and was invited to interview for the position with Art Walton at the Educational Media Production Center on campus. I look back now and, boy, I don't think I would have hired me. I came in with a huge Afro, green tennis shoes, and a cocky art school attitude. After being interrupted by numerous phone calls during the interview, I looked at Art and said, "Are you gonna hire me or not? Because I got other places to go." Art motioned for me to wait as he was talking on the phone. He sent me to the darkroom to make a few prints and then hired me on the spot. The whole job-hunting thing lasted about three hours, and I have worked for the state ever since.

At A&M I photographed everything from DNA gels and nuclear reactors to million-dollar football coaches, presidents, and other VIPs who visited the campus. And, oh yeah, "student life as an Aggie." Art taught me a strong work ethic and quickly put me in my place, earning my respect and stoking my desire to experiment and push the edge a little bit further as a creative, illustrative, storytelling photographer. A&M afforded me the opportunity for all types of on-the-job-

training. I shot numerous formats, from 35 mm to 8×10 view cameras, and processed E6, C41, and black-and-white film. The variety of work experiences from 1978 to June 1984 would prepare me for my career as a photographer for the State Department of Highways and Public Transportation (now the Texas Department of Transportation), which has published *Texas Highways* magazine for forty years.

I wouldn't even have been considered for that position had it not been for then–Travel and Information Division Media Director Herman Kelly, an acquaintance who made sure I got an interview. And I wouldn't have thrived over the following decades without the gentle leadership of Geoff Appold, who gave me (almost) free creative reign to complete photo assignments.

The first week on the job, I was sent to shoot in West Texas, the first of some two hundred fifty thousand-plus miles I would eventually travel for the magazine. Upon giving me this assignment, Bob Gates, who scheduled shoots for me and fellow photographer Jack Lewis (also known as "Mr. Texas Highways" for his defining landscape photography), told me, "You'll either sink or swim." And when I got back, he took a look at my work and said, "You can stay."

In the 1990s, Mike Murphy, then *Texas Highways*' photo editor, called me his "fireman," meaning he could rely on me to go into an assignment under pressure and come back with something he could use. He knew I was always careful about time and money—I made sure I got the shot on the first trip.

In December 2008, I was promoted to photo editor. I quickly learned that actually being in this position, having to make decisions—from who gets the assignments to the

tonal quality of the color reproduced in the magazine—is very scary because my name is on the magazine, every decision I make has costs, and I'm responsible for them.

I believe and say to all photographers I meet, "There are no excuses at the newsstand." People buy what they like, and no one really cares about what we go through to get the photograph. We have to remember that we will not be there to explain our photos to the reader. As photo editor for *Texas Highways*, I think a photograph should be so strong at storytelling that it doesn't need a caption, or so compelling, interesting, and beautiful that the reader wants to know more and will read the caption.

Over the years, I have found that our biggest challenge as photographers is to separate ourselves from our feelings and all that is happening just outside the camera frame during the photo assignment. These feelings and memories can sometimes color our opinions about the quality of our photographs. I always look at my photos on the camera screen about ten minutes after I take them and ask myself, will the reader, who is not here, understand what this photo is about, and will it inspire travel? If I have to say, "Well, I guess you just had to be there to understand the photo," then what I saw on the camera screen did not translate visually. There is no room for reading into my feelings at the time or for embellishing my memories when deciding whether or not the photograph communicates effectively. I believe we photographers often overthink the technical stuff, worrying about perfection and even allowing it sometimes to stop us from taking a chance on creating something different and exciting. The fear of being imperfect can stop an artist from creating at all.

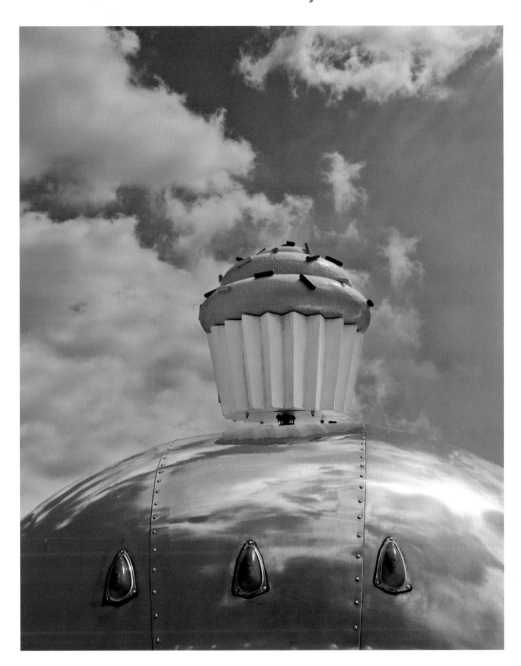

Hey Cupcake. Hey Cupcake! Austin, 2013.

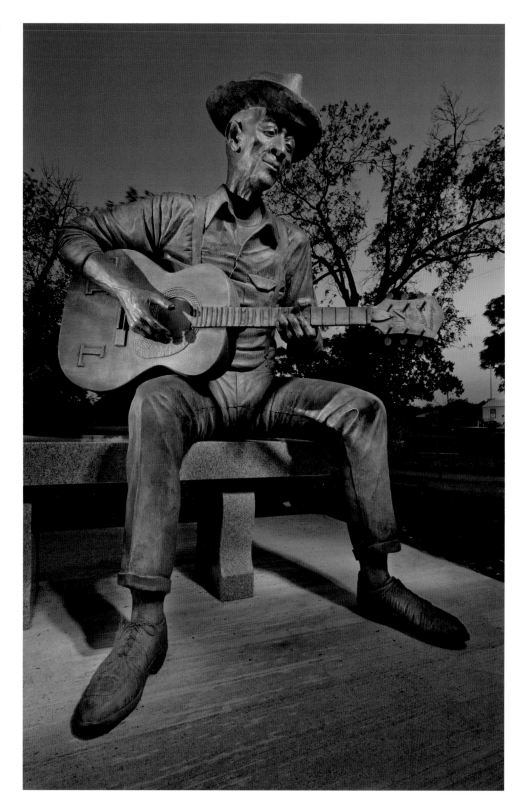

Not worrying so much about perfection and looking for the humor and fun in my work have allowed me to avoid burnout and have a super time traveling and learning about people and places all across Texas. I hope this book touches the creative spirit in all of us and inspires folks to travel and experience the great Lone Star State.

Navasota, 2012. Mance Lipscomb statue by sculptor Sid Henderson.

ON PHOTOGRAPHY

ESSAY BY E. DAN KLEPPER

Photography has always been the odd duck among the traditional studio arts. An offspring of chemists and inventors, photography arrived on the scene a little more than a brief century and a half ago and, in its infancy, shared little as an art form with painting and sculpture, the standard tools of expression that had already been around for at least forty thousand years. Once put into practice, photography was relegated to second-class status for almost half its lifespan to date before it was granted consideration as a "fine" art. The talent of early photographers, artists who practiced the art of not only looking but seeing, and the time they spent in darkrooms guiding chemical transformations into an apparition on paper (alchemy!) somehow paled in comparison to the artists of brushstrokes and bronze patinas.

The moment of creation in photography, a mere "snap of the shutter," further handcuffed the art to its reduced state, as if the push of a button—like the fertilization of an egg—was all that was needed to transform a gesture into a fully formed concern. Photography just seemed too simple when put up against the labors of "real" fine art like oil painting (a process I equate to ditch digging, thanks to years of doing both). "Picture taking" continued to suffer its stigma well into the twentieth century, holding on as a secondary art form until opinion finally swayed in its favor. Yet just when photography appeared to be achieving an art-world status alongside the classical traditions, along came the digital age to spoil it all.

Today, *everyone's* a photographer—a published photographer, in fact, thanks to technology and the advent of social media. And what of that "decisive moment" mastered by the likes of Henri Cartier-Bresson, the late French father of candid photography and Zeus in the photographer's canon? His is everyone's mantra now, every day, moment after moment, captured and posted in an endless stream of visual updates, as if all citizens of the modern age were busy making lifelong documentaries about themselves.

That's not to say, however, that everyone who can take a picture (and everyone can) is actually good at it. A bar of sorts persists for the photographic arts—depending on its context, just as it does for all the other creative arts—a bar that rises and lowers and sidesteps with the rest of a changing culture, and ultimately, despite all that moving about, the enduring still manages to rise to the top.

So what makes a "good" photograph? In the context of *Texas Highways* magazine, founding editor Frank Lively believed photographs in the magazine should have the qualities of *National Geographic* and showcase the best

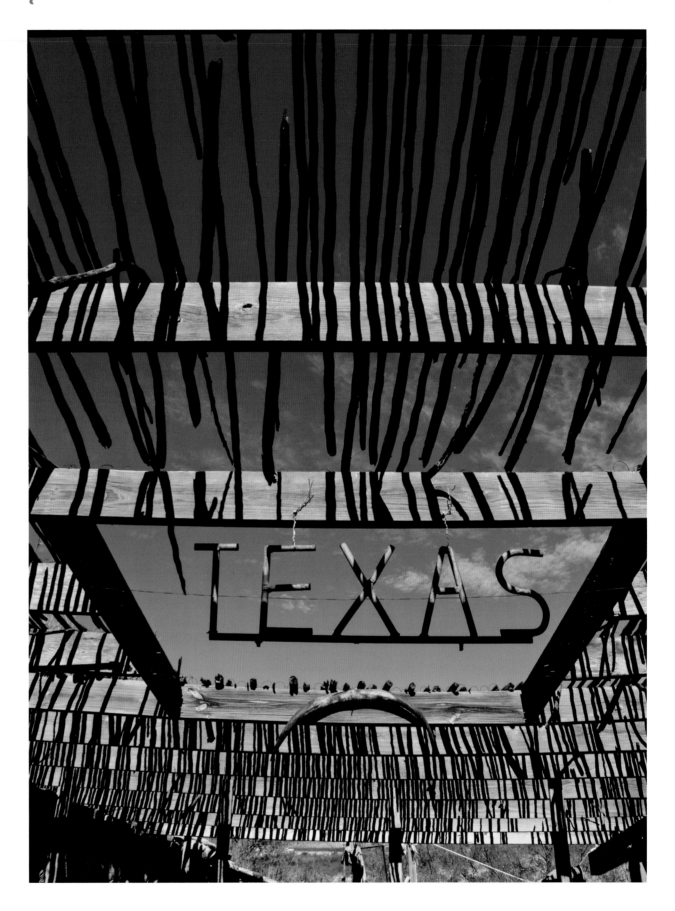

Terlingua, 2011.

that Texas has to offer. A tall order for a small publication in 1974, but one the magazine has strived to fulfill since. Lively, an alchemist of sorts in his own right, took an in-house Texas Highway Department publication (circulation one thousand five hundred) that informed employees about highway engineering and maintenance and repurposed it for the traveling Texan, substituting stories like "Bridge Shifting" and "That Mud Flap Problem" with features about great travel destinations, state history, and culture.

Lively understood the value of photography and began to load the pages with full-color images of the lives and landscapes of fellow Texans, bringing the beauty of the Big Bend eastward into the homes of the Texas bayous and transporting the magic of Gulf Coast sunrises northward to Red River Valley farms. The print media *was* the media at the time, and a slow walk through the pages of *Texas Highways* inspired a generation of Texans, some of whom had never traveled beyond their own backyards, to explore a vision of Texas they had never seen before.

Unlike words, photographs wield the power of spontaneity, closing the gap between seeing and feeling, eliminating the delay that deciphering a sequence of words requires. Photographs don't give you a chance to prepare. Instead, they inspire the mind to complete the story, prompting the imagination to fill in the pieces beyond the picture frame. It's a goal that *Texas Highways* photographers have always worked to achieve—placing Texans in the moment, inspiring the senses to react as if the three dimensions of the grand vistas, the colorful festivals, and the historic restorations offered throughout the state thrive with as much life on the page as they do in real time.

Lively recruited the late Texas photographer Jack Lewis to shoot many of the photographs in the magazine's initial years, helping to define the sweeping, saturated, editorial style that subscribers would soon come to expect for decades. Any foray into a different take on the magazine's photography usually ended relatively quickly.

In an overview celebrating the magazine's thirty-year aniversary, the late editor Jack Lowry wrote, "In 1983, some of the wise owls outside of editorial decided that, to boost newsstand sales, *Texas Highways* should put people on every magazine cover." Lowry revealed in an understatement, "Results were mixed." One particular issue, featuring barbecue and a blonde woman on the cover, elicited this reader's remark: "You can find slabs of meat and pretty blondes anyplace. For your covers in the future, I hope you'll stick with beautiful, beautiful Texas, the landscapes and wildflowers, and even cityscapes that make you want to go to Texas." In other words, stick with what you do best, a mission that has succeeded in transforming *Texas Highways* into *the* travel magazine of Texas.

Today, the subscription number hovers around two hundred thousand, an eight-fold increase from its initial circulation in May 1974. But the actual magazine readership is much larger. Each issue has an estimated "pass around" rate of four (the number of times a single magazine is passed along to friends or relatives), suggesting the magazine reaches more than three quarters of a million readers.

By 1989, the magazine was firmly established, thanks to Lively's efforts and his early contributors. *Texas Highways* had become one of the few major monthly, subscription-based publications offering Texans a par-

ticular vision of the state. Color photography, just the way readers liked it, dominated the pages, and in September of that year an image epitomizing the *Texas Highways* editorial photography style appeared on the cover. It was a shot of the Alamo taken at dusk by Texas Department of Transportation photographer J. Griffis Smith. The sky above gave off an ambient glow, the stone columns were lit just so, and one of the massive wooden doors stood ajar, casting a warm light across the plaza. The cover, according to Lowry, became one of the most popular images in the history of the magazine. It also established Smith's talent for capturing the icons of the state in an editorial style rich in light, shadow, and saturated color. A look through the pages of this book, filled with Smith's classic images for the magazine, provides a concise overview of the *Texas Highways* aesthetic, one that Smith has not only contributed to but has also helped guide into the new century.

Lively's tenure as editor ended in 1990, a relatively early retirement at sixty-two years old. Now eighty-five, Lively says he made the decision so he and his wife could do the one thing they loved to do best while they were still young enough to do it—travel Texas and the rest of the world. Lively, a characteristic Texan of letters (sharp, witty, and just a bit on the wild side), left the magazine with plenty of color photography in place and a subscription circulation strong enough to pay the salaries of all nine employees on the editorial staff at the time.

Lively still reads the magazine every month (and drinks a glass or two of champagne every week). "My column," Lively says of the obligatory message from the editor that appears in each issue, "was always a little crazier than the later editors." When asked whether he felt he achieved success for the magazine in the ways he had hoped, Lively tells this anecdote:

"One time my wife and I were attending a Cowboy Breakfast at Palo Duro Canyon. I was editor at the time and when one of the women in the crowd found out I was editor of *Texas Highways* she ran to her car and pulled out a copy of the magazine and actually asked me to sign it. Not only did it make me feel like we had finally arrived but, more important, it impressed my wife."

Lively jokes, but his sense of pride and satisfaction in the work he and his staff performed in order to transform *Texas Highways* into a first-class travel magazine always shines through. It wasn't just an enthusiasm for the project but a sincere appreciation for what the state's people and places had to offer. "A fellow editor who produced a magazine for the Ford Motor Company that covered travel across the entire U.S. asked me one time how I could put out a magazine every month on just one state," Lively recalls. "Are you kidding, I told him, Texas has so much going on that I could put out an entire year's worth of issues on just one city."

Photography in *Texas Highways* has always aspired to represent iconic Texas—"big, bold, independent images that speak to the Texan in everyone," contributing photographer Kevin Stillman explains—still a driving endeavor for *Highways* even after forty years in the magazine business.

Think about our Texas icons: the Alamo, the Longhorn, the Bluebonnet. Although icons make great subject matter, they can also find the quickest route to their own stereotypes (cowboys, for instance). The trick, and it

is a magic trick of sorts given photography's tendency to portray reality without actually fully committing to the real, is to find a way to represent the icon in a context or perspective that most readers haven't thought about before. But *Texas Highways* photographers like Stillman, Smith, and others aren't looking only for the big guns. They must also ferret out the subtle and lesser-known symbols, deciphering how the quieter parts of the Texas mythology fit into the state's travel narrative, and then bring them to light.

If you love traveling, seeing new places, and seeking out different experiences, then you're no doubt a member of the magazine's readership. The duty as well as the pleasure of the magazine's photography is to guide you to the small and silent as well as the big and bold and then suggest what your own experience might be like with just enough enthusiasm to make you want to encounter the world of Texas yourself.

A good look at the photographs by Smith in this book provides convincing evidence that the magazine seems to know exactly how to do just that.

Smith explains: "My goal as a photographer for *Texas Highways* is to make the scene come alive and appear three-dimensional to the readers, as if the readers were there with me experiencing the feeling of the textures and the depth of the space. When I'm shooting, I use creative composition and lighting to build a romance about the subject and try to capture the emotions and personalities I see in the people and places I'm shooting."

Smith joined the Department of Transportation almost thirty years ago, often serving as contributing photographer for the magazine before succeeding Kevin Vandivier as the magazine's photography editor in 2008. When it comes to the mission of the magazine—to inspire Texans to travel the state—Smith's singularity remains steadfast after three decades at work, not all that surprising for someone who's been photographing for most of his life and much of it for *Texas Highways*.

"The reader is not there with us when we take that photograph," Smith explains. "So the photograph has to tell the story and compel the reader to want to know more no matter what the subject is, whether it's food or a portrait or a place. As a photographer shooting for *Texas Highways*, you want to capture that feeling."

Fellow freelance and contributing *Texas Highways* photographers concur. "The best of the magazine's photographs," says freelancer Erich Schlegel, "evokes emotion, place, and time. When readers look at an image it should make them pause and think 'I want to experience that!'"

Smith has logged thousands of miles for the magazine, not to mention the thousands of images he has taken for it along the way.

"One of the things I love most about my job is the access to the most unusual places in Texas," Smith confesses. Courthouse cupolas, backstage dressing rooms, historic attics, museum collections, lighthouse stairwells, railroad cabooses, drive-in projection booths, ghost towns, diners, and dance halls: Smith, it would seem, has photographed them all. So how does he keep it fresh?

"I always look for abstract, textural scenes or some unusual point of view," Smith reveals. "In fact, I often find myself on my back to come up with different angles."

Smith also uses a technique known as

"light painting," an old photographer's craft that uses a variety of alternative light sources beyond the standard strobes and flashes to create a havoc of bright spots, shadows, colors, and shapes that wouldn't otherwise appear under natural conditions. The technique has continued to gain popularity in photography circles as more and more alternative light sources have become available and inexpensive. In fact, the word *photography* itself is derived from the Greek *phos,* or "light," and *graphis,* meaning "of or pertaining to drawing," thus photography means "to draw with light."

To understand just how far the technique of light painting has come, imagine the works of the modernist Man Ray, the first artist recognized for putting it into play. In 1935, Man Ray created a series of photographs he called *Space Writing* in which he sat before the camera during an extended exposure time and, using a penlight, drew his signature in the air. Today, light painting entails more than just lines and shapes of light. The availability of handheld devices like powerful spotlights, found at most sporting goods stores, gives photographers like Smith the opportunity to pull out all the creative stops.

Smith is also an accomplished steel-guitar player, and his avocation as musician made one particular day on the job his most memorable. "I had a photo session scheduled with Willie Nelson," Smith recalls, "and I brought along my Dobro." (Dobro is a trademark owned by Gibson to describe a distinct design of resonator guitars. It is both a contraction of "Dopyera" and "Brothers"—the original manufacturers of this type of instrument—and the Slovak word for "goodness.") While Smith waited for Nelson to show up for the shoot, he pulled out his Dobro and played, hoping to kill some time. Surprisingly, when Nelson arrived he stopped Smith from putting his instrument away for the shoot and asked him to jam instead.

In addition to documenting the occasional brush with celebrity, the photography in *Texas Highways* takes on a lot of heavy lifting with each issue—journalism, narration, art—and thus it must work twice as hard to evoke its message with a single glance in the same way that words do with an entire paragraph. As much as writers would like to believe otherwise, words work in service to the image in most editorial venues, including *Texas Highways.* Unless the photograph tells the complete story without caption or compels the reader to seek out more information by reading the text, the photograph fails to do its job. But the accompanying text fails as well, simply by not being read.

Full disclosure: As a freelancer, I not only write for the magazine but also shoot for it on occasion, and thus I operate in a rarified world where both my words and images arrive at Texans' doorsteps with some regularity. To write and shoot is doubly challenging, particularly for a magazine as distinguished as *Texas Highways.* The challenge comes with all the attendant joy and calamity of juggling a left-brain process (linear, logical, sequential—as in composing with words) with a right-brain process (visual, emotional, inventive—as in creating images). The writer/photographer is both narrator and documenter, journalist and artist, chronicler and inventor, and unlike the fine art free-for-all that dictates much of the rest of my work, an editorial piece for *Texas Highways* must adhere to the parameters of the magazine's mission, which is, bottom line, to inspire Texans to hit the road and enjoy the sights.

It also means I am fortunate enough to work with the complete suite of editors driving the magazine, including Smith. Much like photography itself, Smith ("Griff" to everyone who knows him) is a bit of an outlier. He doesn't like shoes. He has no hair on his head, but not because he's naturally bald. He shaves his entire skull down to the skin perhaps because he's simply committed to having no head hair. He claims he doesn't read, including the magazine, but I can pretty much guarantee he'll be reading this. Working with Griff is a bit like performing in an episode of *The Griff Show* in which the main character (a cross between a photography editor with sincere convictions and a life force from another galaxy) cajoles you into producing the best you're capable of producing for the greater good of the universe (in this case, the magazine).

After turning in an assignment, you'll get one of several responses from Griff, the first being a check, promptly. Then you may get a phone call asking if you have any more versions of a certain shot you've taken, at which time, despite the fact that you think the remaining shots are all lousy, you might oblige. On occasion, in response to your query about how he liked the latest assignment you sent him, you'll get a long, drawn-out "weeeeelll" followed by silence. Not good. It means your vision of things didn't quite sync with his. Once in a great while you'll hear him say, "I loved the one of the [fill in the blank]." Enjoy it. You probably won't hear it again for a while. The response you should actually be looking for, however, is a moderately enthusiastic "yeah, I think I can work with that," which in Griff-speak means you've succeeded in tackling the job at hand.

"Griff is a very humane photo editor," says

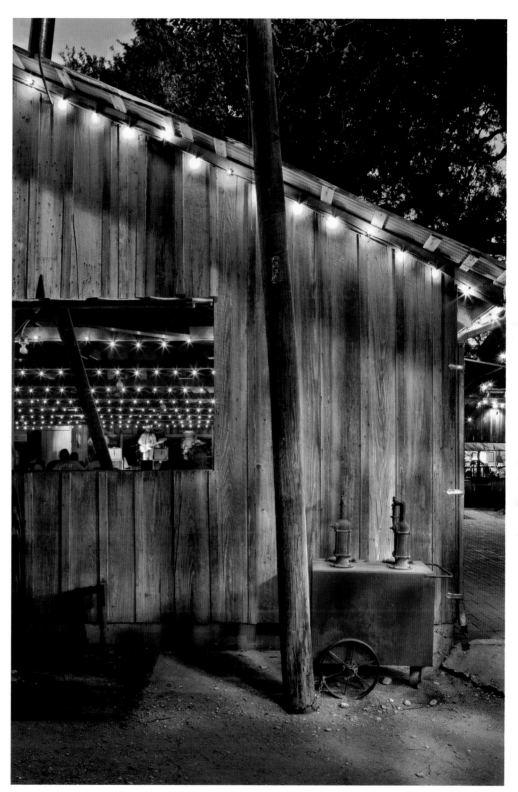

Luckenbach.

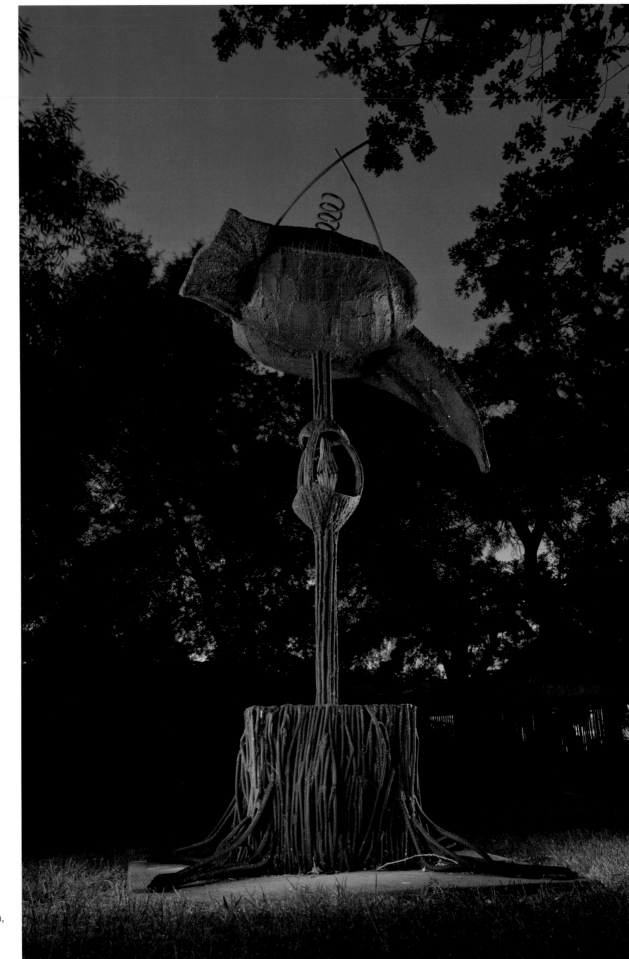

Caldwell, 2013. Shirted Energy, a
sculpture by my dad, Joe C. Smith,
also known as J Lyle.

contributing photographer Will van Over-beek, "with a love of laughter." Griff's easygoing personality, his support of personal styles, and his enthusiasm for the state's subject matter are all attributes that come to mind for many of the photographers he recruits. "He encourages me to combine the artist and the journalist in me to get the best of both worlds," says contributor Michael Amador. "It's not easy but with Griff in my head it helps to make my photographs stand out."

Freelancer Schlegel believes Griff puts a lot of thought into which photographer he assigns to a particular story. "He's able to pinpoint a photographer's strengths," Schlegel says. As one of the state's most active professional photographers, Schlegel puts a lot of time and energy into his editorial assignments for *Texas Highways*. It's an emotional investment that he and other photographers are compelled to make. "My own desire to have the story come together is always greater than just wanting to see the story published and getting a paycheck," Schlegel reveals. "Sometimes I'll travel to the story location two or three times on my own beyond the story assignment. I always see something new every time. It gives me the opportunity to review what I've done, get feedback, and then return better prepared to shoot again. Although I'm pretty much a literal guy when it comes to editorial photography, I have passion for shooting and I want that to show in the work."

In keeping with Griff's galactic personality, his image selections can appear mercurial at times, a trait that no doubt derives from Griff's "I like what I like" approach to image choice—although who isn't guilty of the same thing in any given aspect of life? His thoughts about the work, however, are far more accessi-ble, thanks to the fact that Griff is also a musician. As the art historian and critic Gabriel Bauret suggests in his essay about photography, the language of color photography draws heavily from the metaphors of music. Words like *tone, saturation, harmony, rhythm, composition, dissonance, resonance,* and *timbre* are all descriptors that the two art forms share. Griff, in his effort to talk about editorial photography, swings comfortably between them.

The magazine and its photography have transitioned through several periods of dramatic technological change since the first issue, much of it in fact before the arrival of the Internet. Retired editor Lively recalls the "old" days in one succinct (and Livelyesque) statement—"It was like daguerreotype." Lively appreciates the ease with which the digital age enables color photography reproduction today, although, he reminds us, color is what the magazine's photography has always been about, regardless of the state of the technology. "Fortunately, all we had was color for the magazine," he recalls, "since there's nothing worse than running pictures of wildflowers in black and white." Lively's biggest challenges with the state of color reproduction in the early days of the magazine involved register (the way an image's different layers of color lined up together on the page) and color shift. "I used to have to travel to where we printed the magazine in order to monitor the progress," Lively says. "The register was almost always off and the color was almost always too red. Outdoor travel photography should portray a perfect day for traveling, you know, sunny, happy, bright blue sky. But too much red will ruin the look of a bright sunny day. I'd show up at the printer for a press check and before I even saw the proofs I would shout 'Get the red out!'"

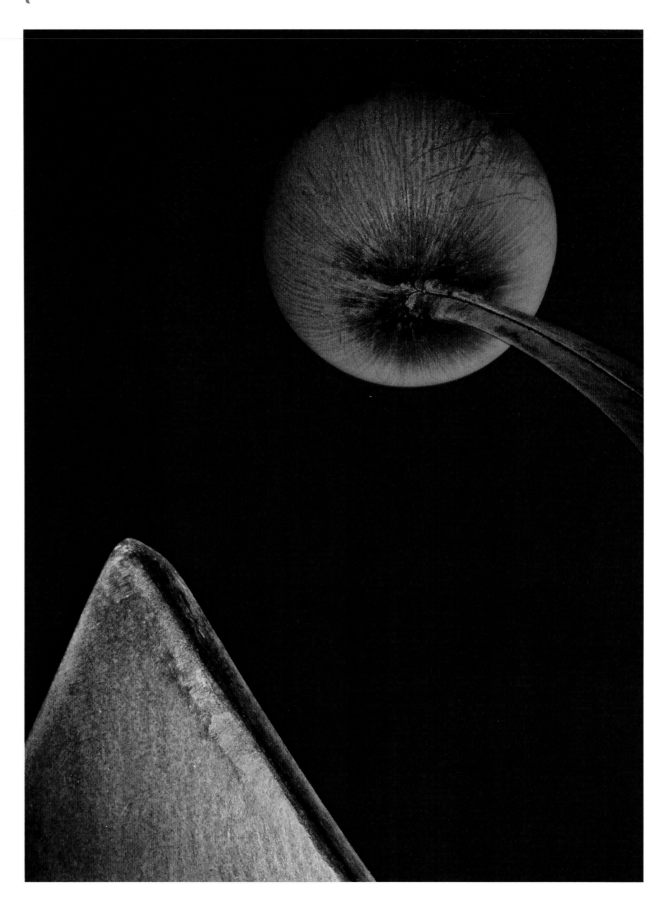

Amarillo Museum of Art, 2007.
Detailed shot of Talon Sweep, a
sculpture by John Brough Miller.

Everyone of a certain age remembers color photographs from the 1960s and '70s. There are, no doubt, boxes of color prints in closets and storage units all across the state, enough to recreate the height and mass of the tallest peak in Texas (Guadalupe Peak at 8,751 feet, located in the Guadalupe Mountains of West Texas, for readers who missed a number of stories on the peak that have appeared in the magazine over the years). Everyone's got them—pictures of family birthdays and picnics, fishing trips and grandparents, beach retreats and holiday celebrations, all fading away thanks to unstable chemicals and the lousy printing job courtesy of your local photo developing retailer circa 1975.

Fortunately, while the digital age seems to have turned us all into photographers, it has also managed to make us *better* photographers, thanks to a technology that left behind many of the variables beyond our control. You can see it in the quality of photography in the magazine as well. The saturated colors and lively compositions were always present, but it took digital technology to usher in the nuances, enabling photographers to capture the deeper subtleties inherent in dusk light, a sky full of stars, or the morning's first rays. Even the shadows reveal life now. Digital technology allows photographers to capture the darkness in all its degrees and variations, a period of time in each twenty-four hour cycle when almost half of our activities as travelers take place. Once characterized by bright spots and washed-out flashes against a black backdrop, images featuring the world of Texas after sundown appear prominently in many of the magazine's issues, giving readers a far more detailed insight into the dynamics of the Texas vision.

Whatever photography means to you and however it's meant to serve the magazine, above all else it's a chronicler of our time, at least in the way we see it through the perspective of a frame and a lens. Its technology has played a major role in determining how we appear through the years, from the foggy gum bichromate prints of the late nineteenth and early twentieth centuries to the megapixel clarity of the twenty-first. As you thumb through the editorial photographs on these pages, you'll see not only some of the magazine's best work but likely a documentation of our time as Texans over the past few decades. Like Technicolor in the age of film, in "every period a particular process emerges," Bauret reminds us, "becoming the colors of an age."

Welcome to the color of ours.

ICONS

Texas itself is an icon. Thirty years ago on a train in Yugoslavia, a Japanese traveler asked me if I had an oil well in my backyard and if I knew J. R. Ewing from the TV series *Dallas*. Movies and TV shows have spread Texas stereotypes across the world. Just the word Texas conjures up images of cowboy hats, fancy boots, herds of cattle, oil wells, bleak deserts, spicy barbecue and enchiladas, the Rio Grande, Willie Nelson, and "Remember the Alamo." I admit it. I love to photograph these Texas symbols, but with a twist. I want to make the obvious bigger than life. I want you to feel as if you could put your hand into the scene and touch the subject I've photographed.

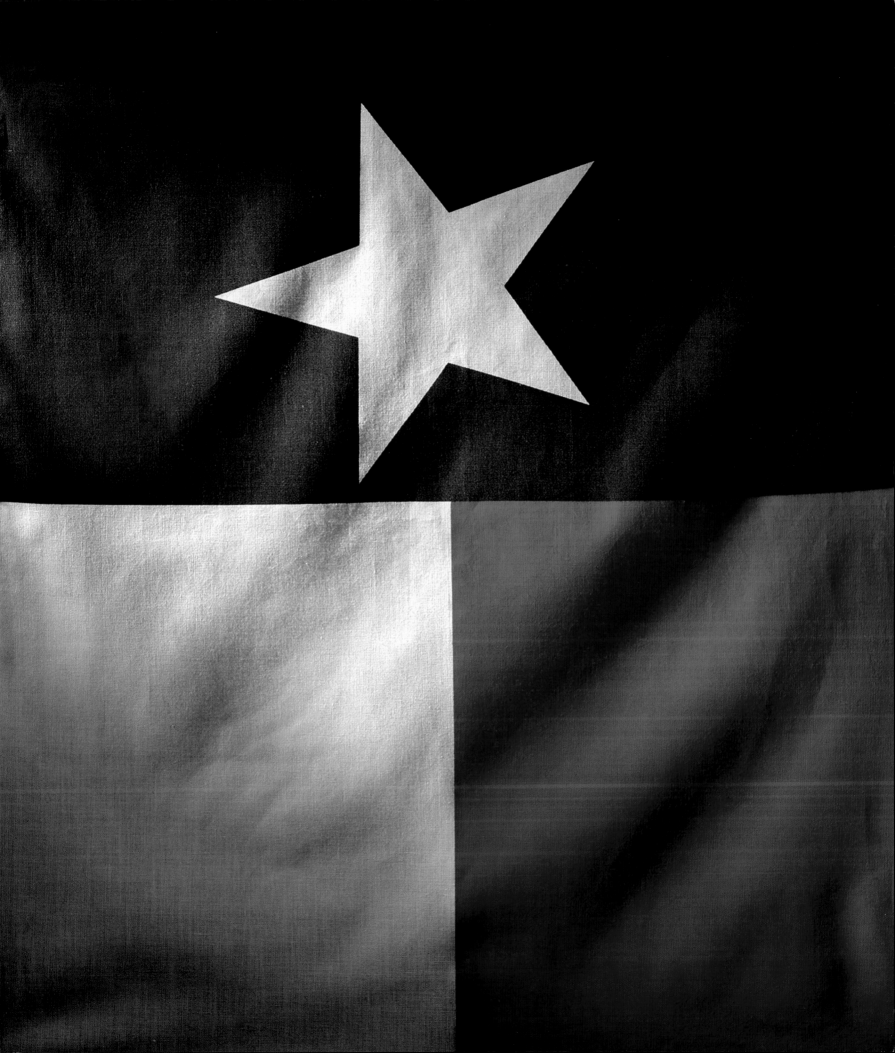

Texas Flag
The strong graphic background of this 11-foot neon Texas flag at the Institute of Texan Cultures in San Antonio was a spectacular backdrop for the cowboy silhouetted in front, 1985.

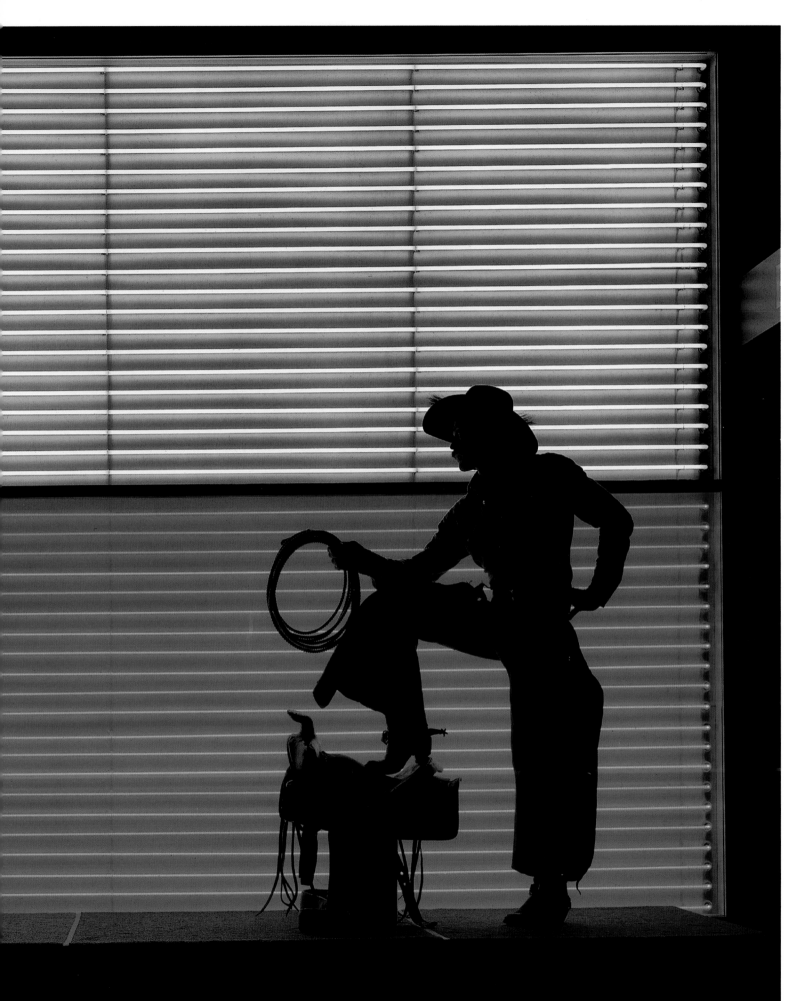

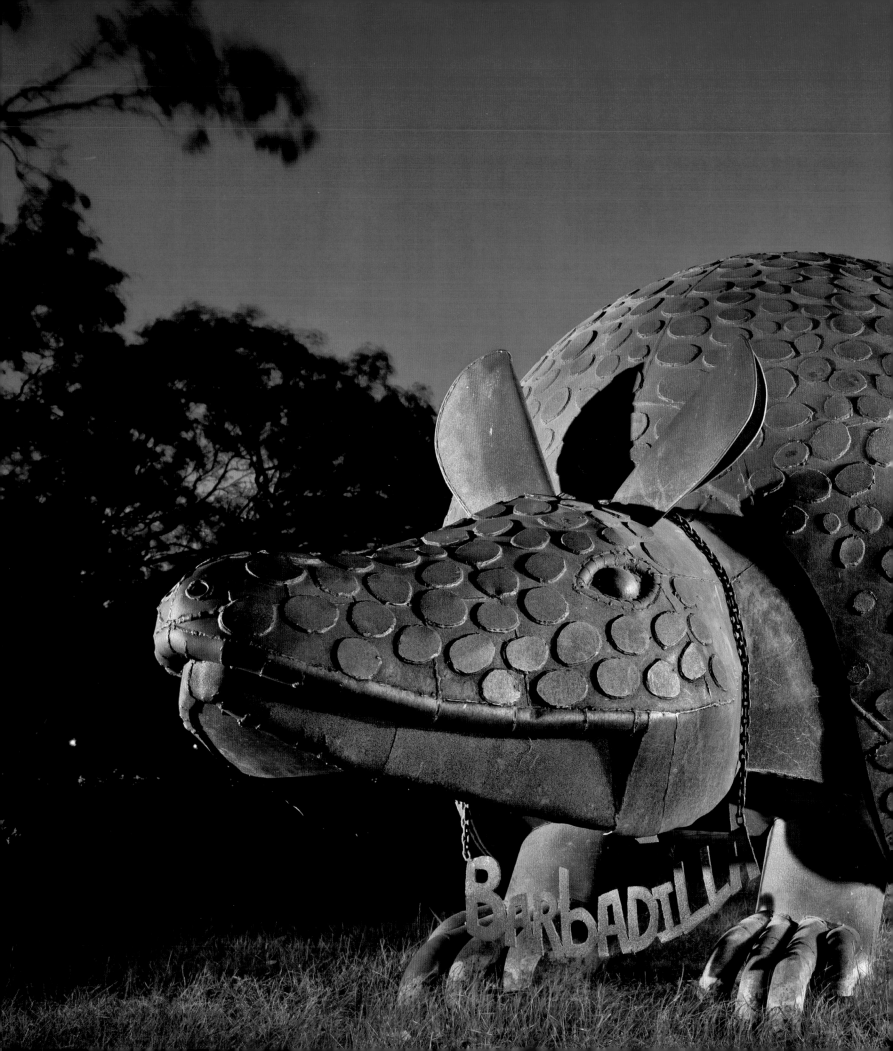

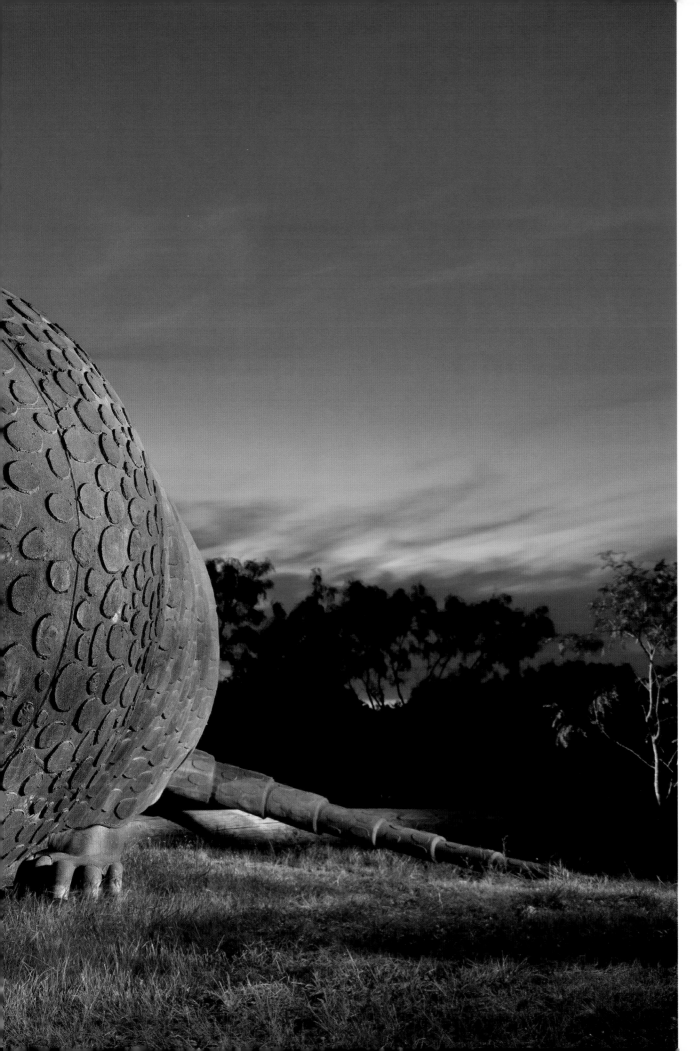

Barbadilla, Buffalo Gap, 2009

Barbadilla, a 10-foot-tall armadillo, greets visitors at Perini Ranch Steakhouse in Buffalo Gap—a bizarre sight in a remote area. Nanci Liles of the Abilene Convention and Visitors Bureau convinced me to take this shot for a story about the Abilene area. It had been a long day, and I was exhausted, but I'm so glad she insisted because it is one of my favorite photos.

A little backstory on Barbadilla: Tom Perini, who owns Perini Ranch Steakhouse, was in Connecticut some years ago, cooking for friends who owned Barbadilla. They told Tom they were moving and could not take the giant sculpture with them and that he could have it if he moved it. Tom put Barbadilla on a flatbed trailer and brought her back to the restaurant. Joe Barrington, the artist who created the giant armadillo, lives in Throckmorton, not too far from where Barbadilla stands today. It is always interesting how things intertwine.

The Cadillac Ranch, I-40, Amarillo, 2007
Light painting with powerful spotlights is a technique I like to use to enhance the mood of a setting—in this case, Cadillac Ranch near Amarillo. I've been told that this is owner Stanley Marsh 3's favorite shot of the famous buried Cadillacs.

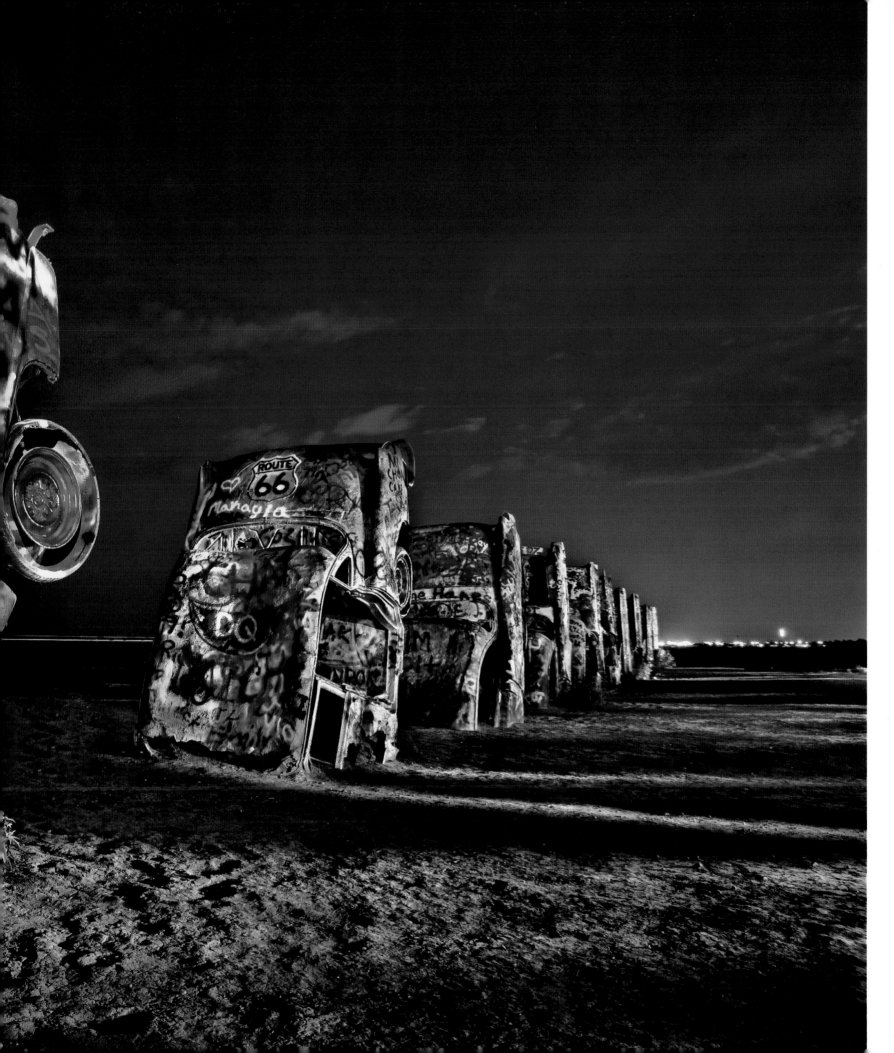

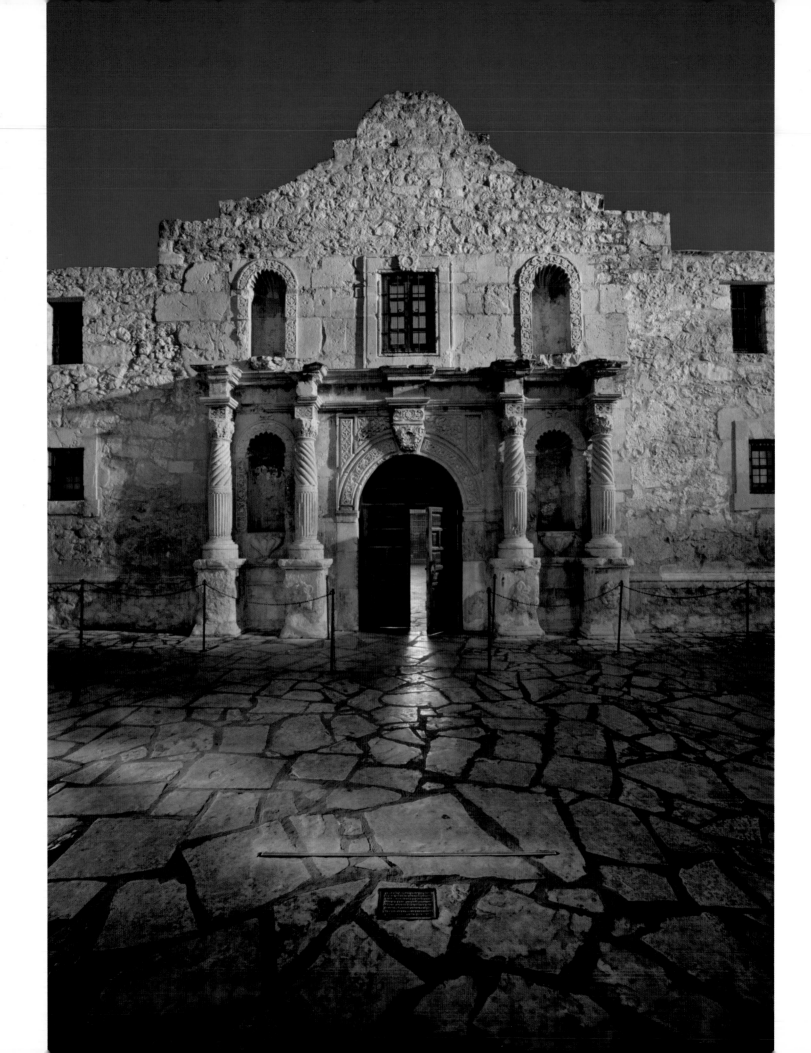

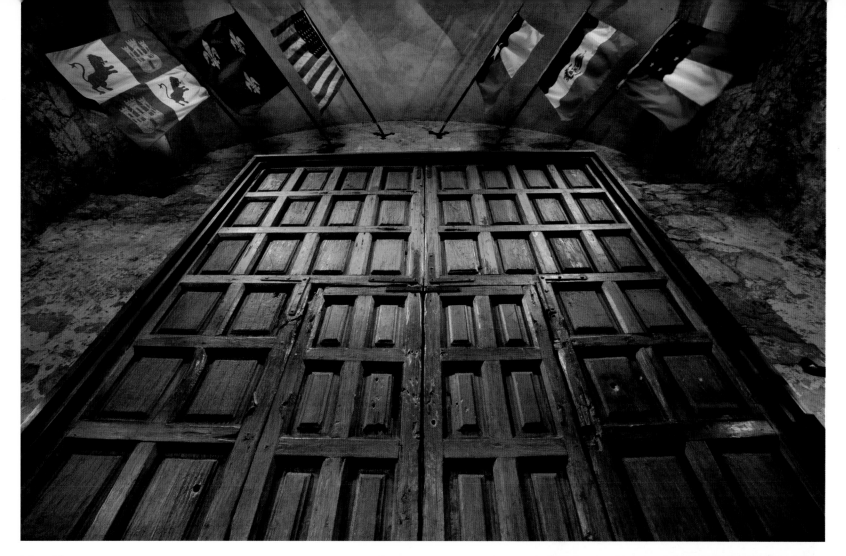

The Alamo, 2009

◀ I was left in the Alamo alone to photograph for about an hour. It was one of those awe-inspiring moments when I could almost feel all the lives that were lost there.

I remember the first time I shot the Alamo for *Texas Highways* in 1989. The director told me to use the employee entrance in the back. As I approached the Alamo with my big 4 × 5 view camera, my seventy sheets of 4 × 5 film, and a heavy tripod on a pull cart, one of the security guards yelled out, "Halt!" I think he was ready to draw his gun until I showed him the letter from the Daughters of the Republic of Texas, then caretakers of the Alamo, giving me permission to be there. At that point, he and the other guards could not have been more helpful. (The Alamo is now managed by the Texas General Land Office.)

▲ This dramatic image was taken inside the Alamo after a ceremony commemorating the anniversary of the March 6 battle. Rock legend Phil Collins, an Alamo history buff, was there. I was allowed to photograph in the Alamo after-hours (a rare event) only because I received special permission from the Daughters of the Republic of Texas.

▶ Tourists with cameras flock to the Alamo every year. It's one of the most photographed sites in the country.

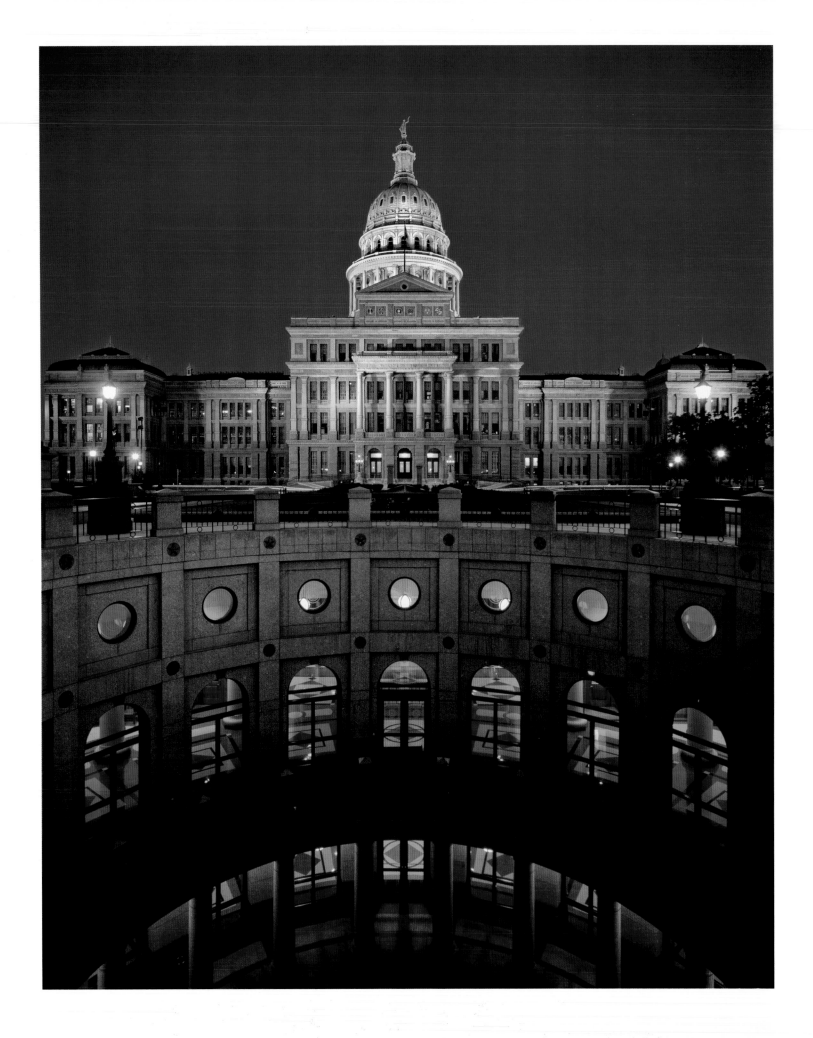

The Capitol, Austin

⬆ In 2000 I convinced the Polaroid Corporation to test their new 20 × 24 field camera in Austin. The Texas Department of Transportation and the State Preservation Board came together with funds to cover travel expenses. Our goal was to stage a 20 × 24 Polaroid show in the Texas Capitol. The day of the shoot, Polaroid called to say that the camera was not working properly and the shoot was off. I was really bummed out. However, when I realized I was able to get two state agencies and one major corporation to cooperate on a project, I felt pretty good.

⬇ Looking up in the rotunda of the Texas Capitol, 2000.

➡ This is a 2011 shot that I used for the first in *Texas Highways'* series of photo tips, which ran from January 2012 to August 2013 and appeared on the Window on Texas page in the magazine. The tip: use sidelight to create texture.

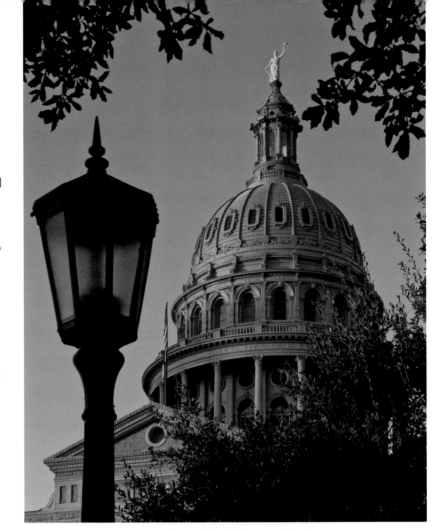

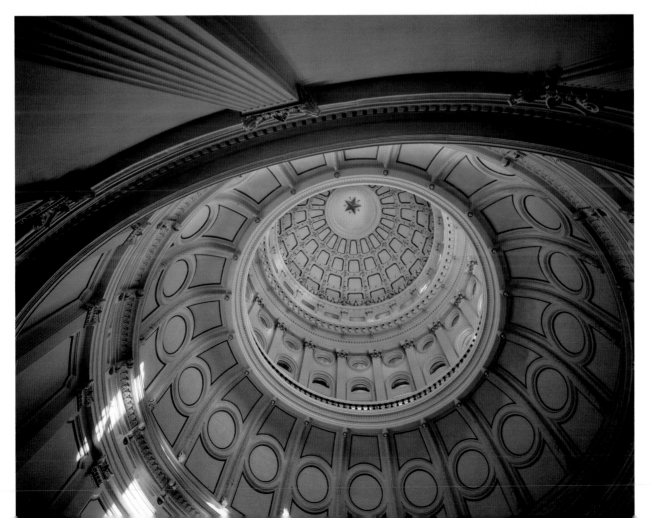

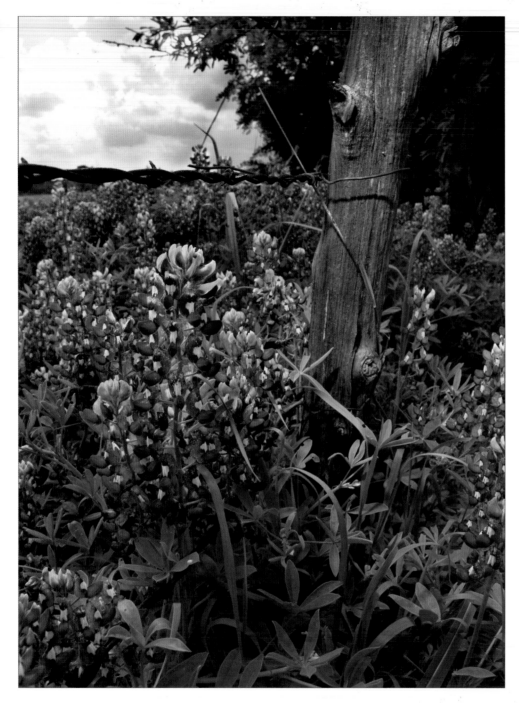

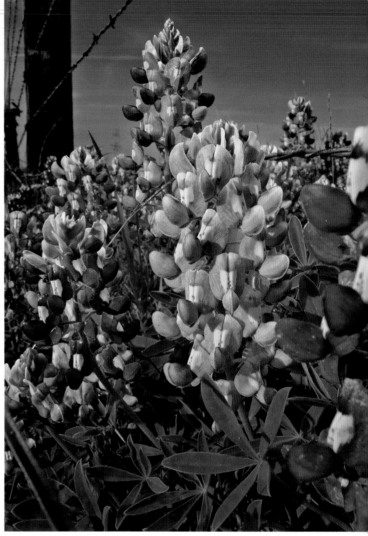

Bluebonnets, Spring 2012

➔ In the Round Top area on Texas 237.

◀ In Iredell on FM 927.

▲ Near Blooming Grove, close to my uncle Tom's farm in Navarro County, just off of Texas 55.

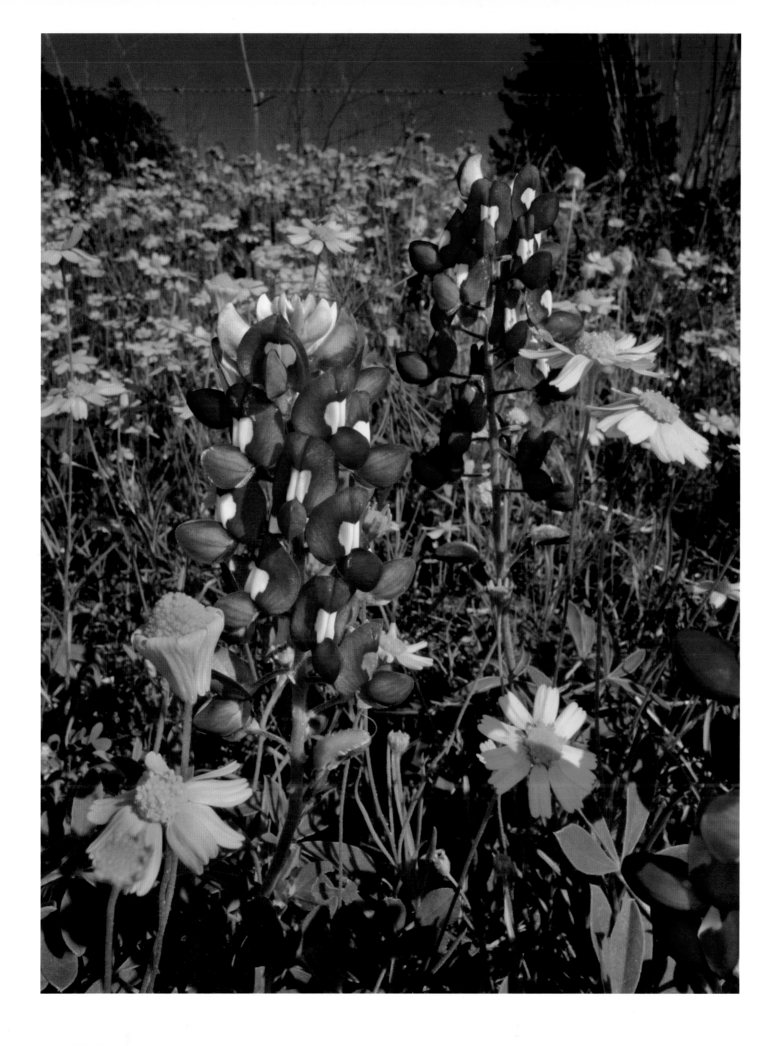

Wildflowers

A collection of photos from *Texas Highways* would not be complete without shots of the state's colorful wildflowers.

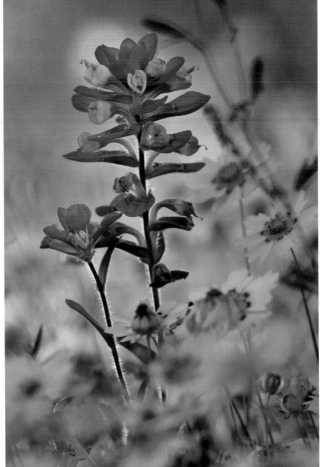

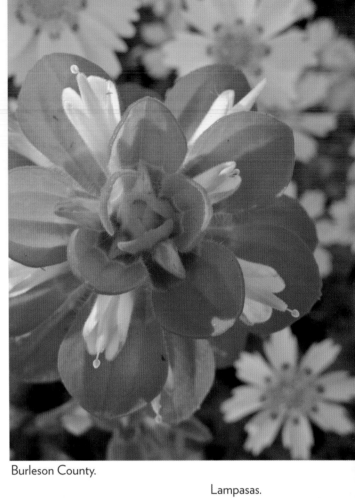

Burleson County.

Burleson County.

Lee County.

East Texas near Lufkin.

Lampasas.

eson County.

Burleson County.

Fayetteville.

Dinosaur Valley State Park, Glen Rose.

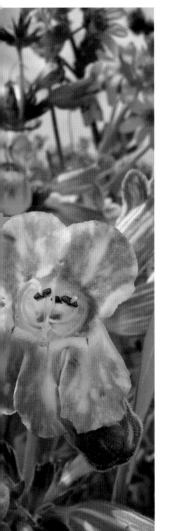

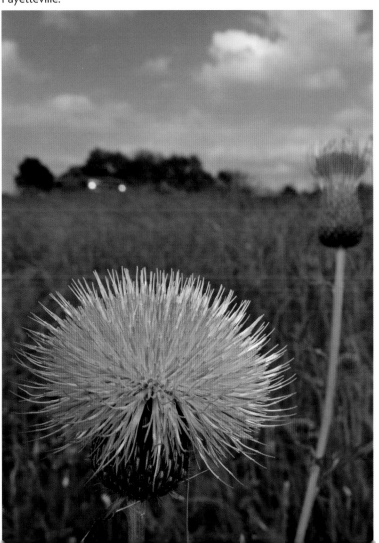

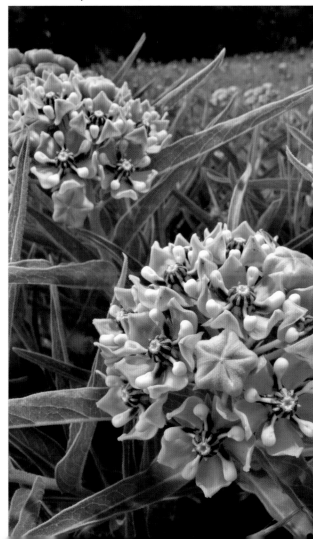

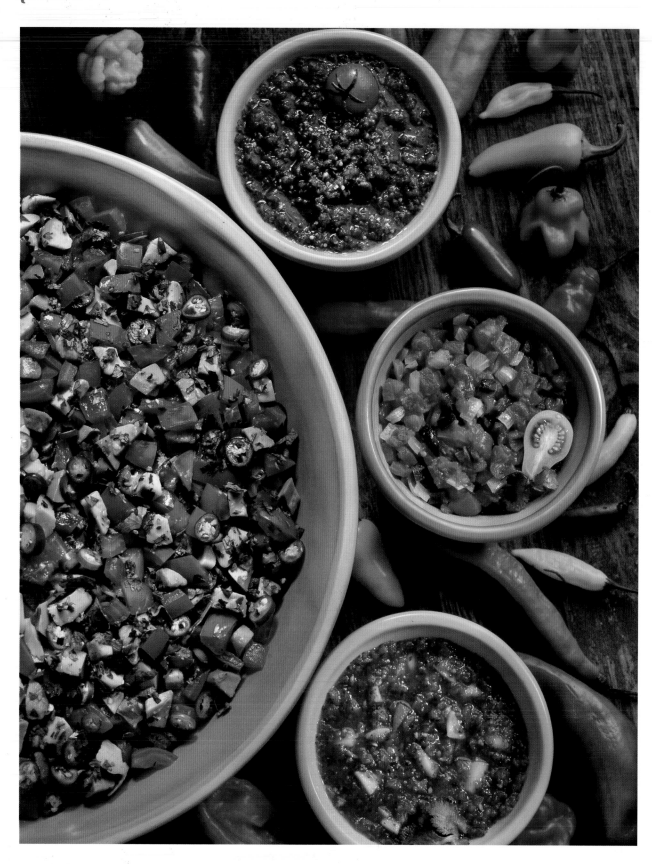

Texas Salsa
My favorite food is chips and salsa. I couldn't resist sampling this spicy assortment after the shoot in Austin, 1998. The salsas are from the recipes of Matt Martinez Jr. of Matt's El Rancho restaurant.

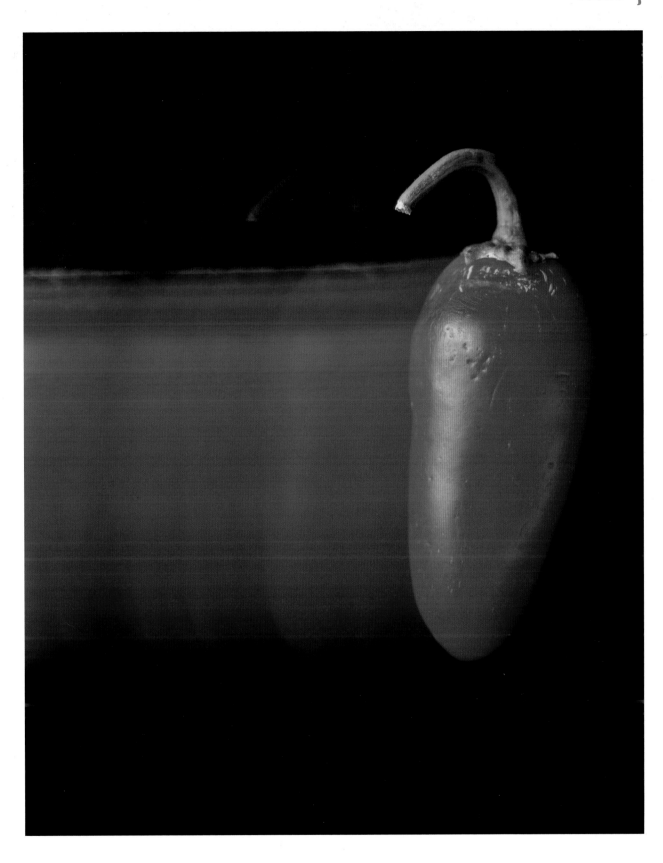

Jalapeño
I put the red jalapeño pepper on black velvet, with a thick card underneath. I shot one eight-second exposure and then slowly pulled the cardboard with the pepper for another eight seconds to get this motion-blur effect, 1992.

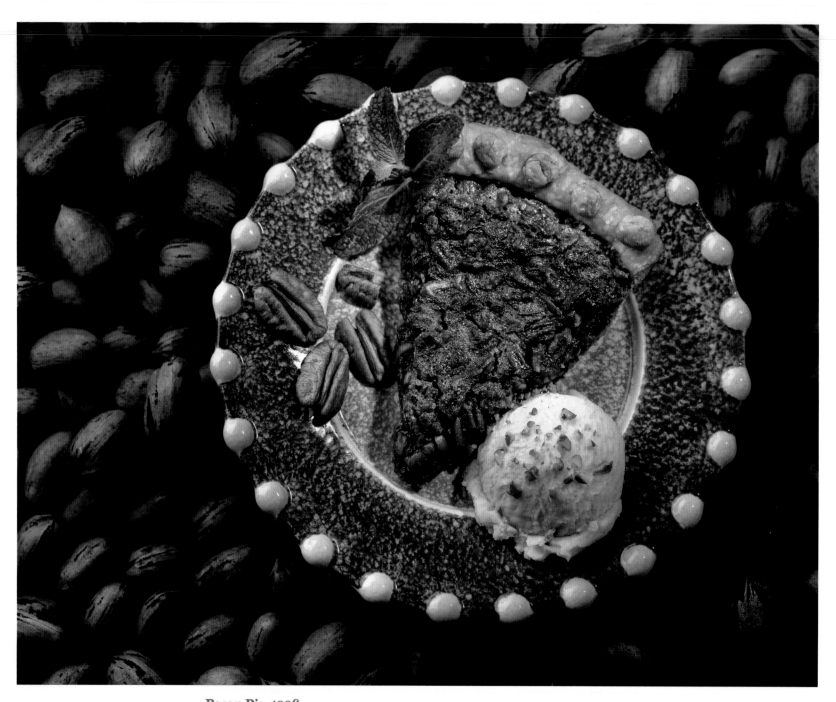

Pecan Pie, 1996

Food stylist Fran Gerling tested and styled recipes for the readers of *Texas Highways* for more than twenty years, including this Threadgill's recipe for pecan pie. We found this bright blue plate at Breed & Co., added a big slice of pie, and set the whole thing on top of a bed of unshelled Texas pecans, 1996.

Chicken Fried Steak, 1999

➤ Studio shot of crispy chicken fried steak on a blue speckled enamel plate styled by Fran Gerling, 1999.

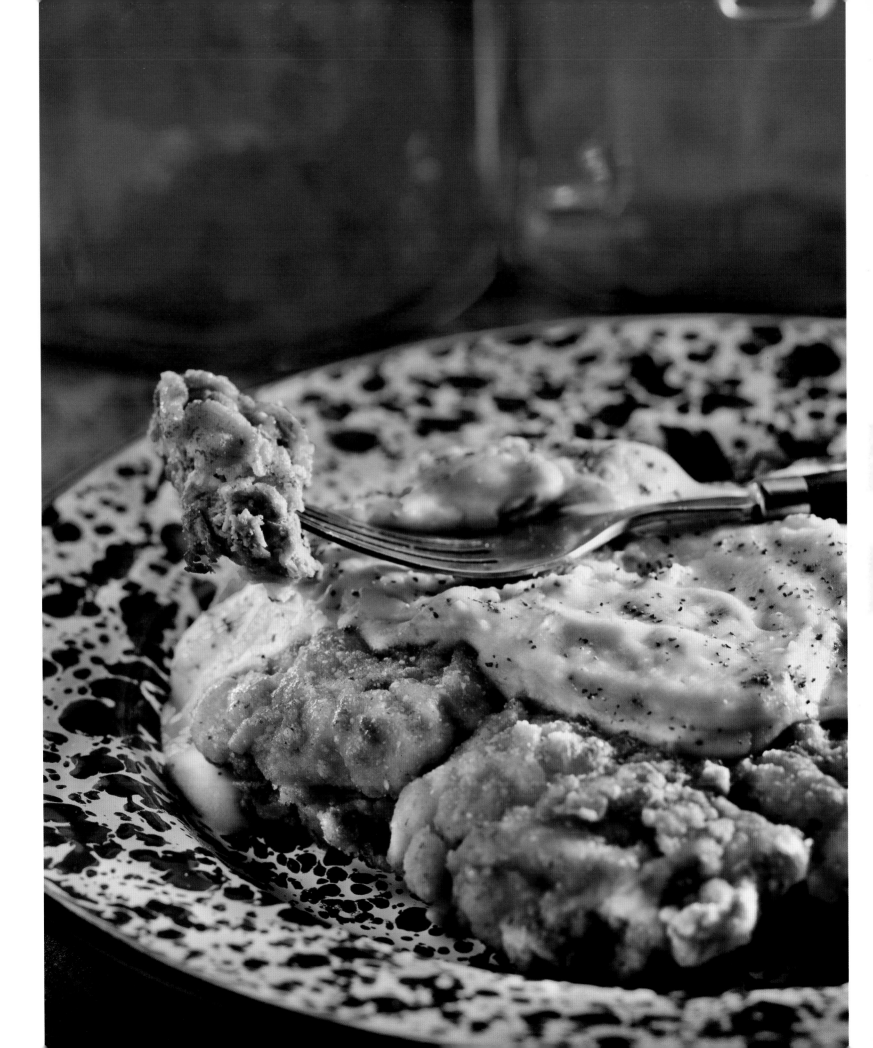

Chili, 1997

Food stylist Fran Gerling and I went on a hunt for unique props and dishes for this shot in 1997. I saw this beautiful frame on South Congress and it came to me—put the chili in the frame and present it as classic art. Fran had to put the $1,700 frame on her credit card in case we damaged it. We didn't.

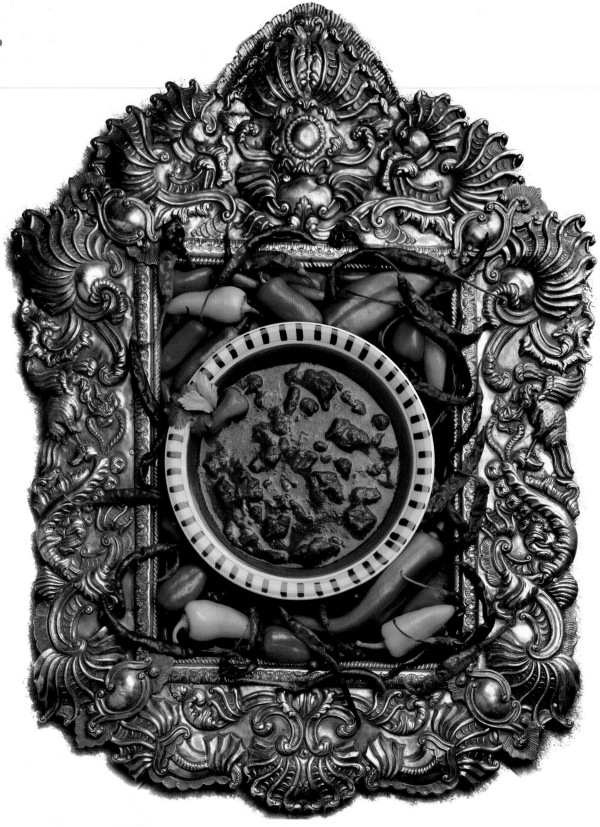

◆ Wolf Brand Chili Can, Terlingua, 1990s. The paint on this water tank has faded since I took this shot, but the Wolf Brand Chili can marked the way to the early Terlingua chili cook-offs about a mile away.

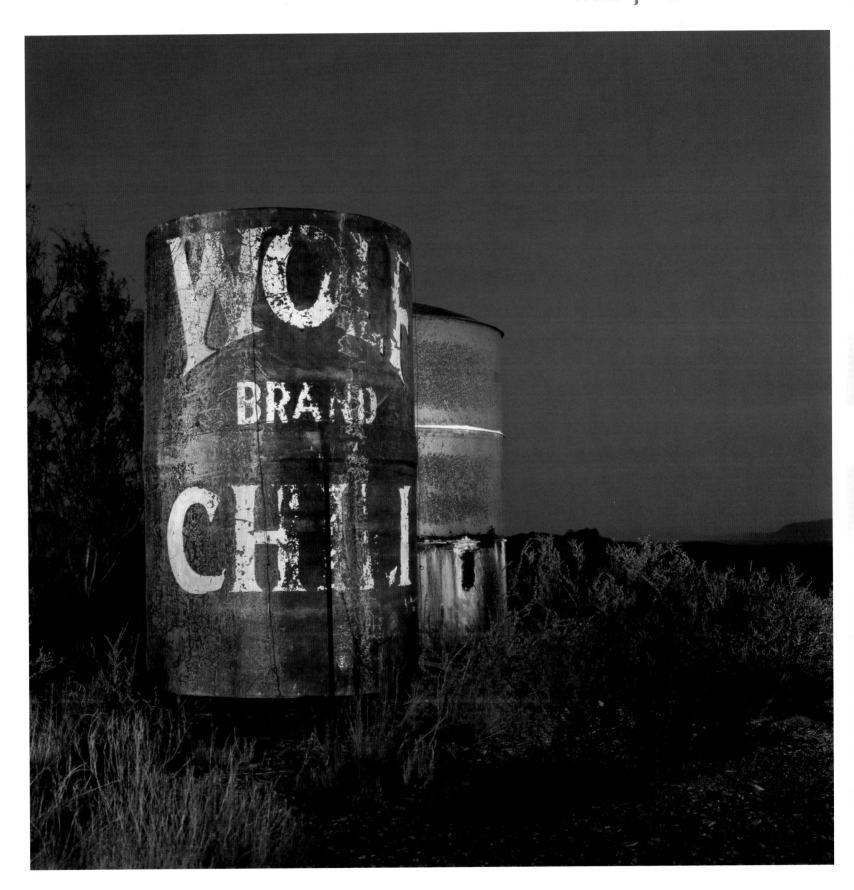

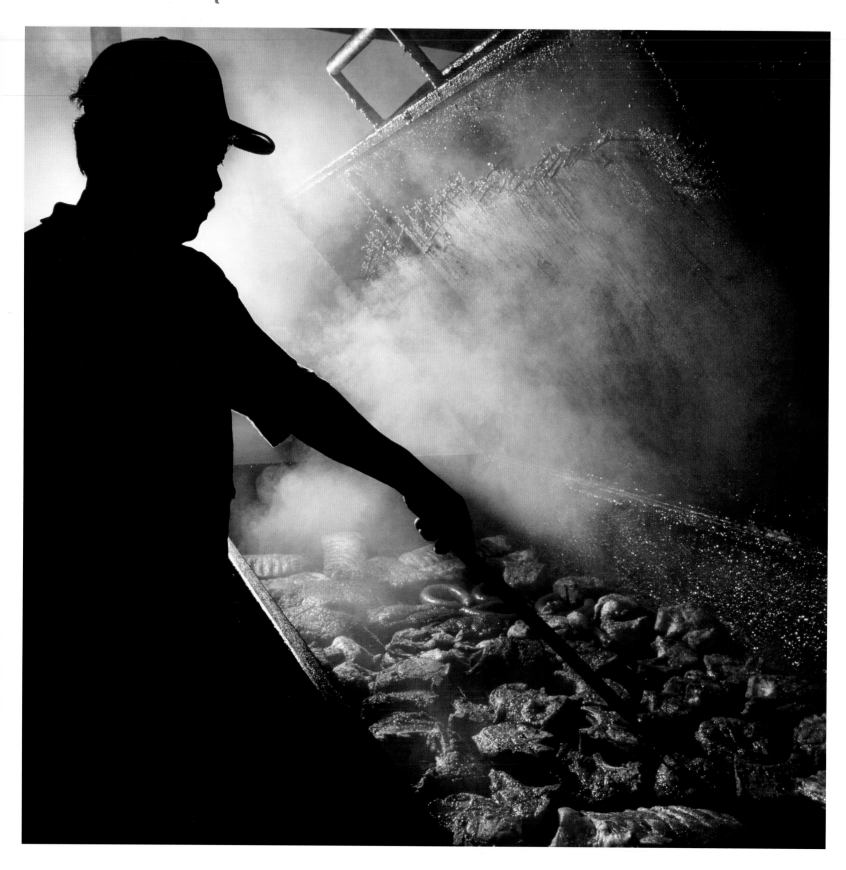

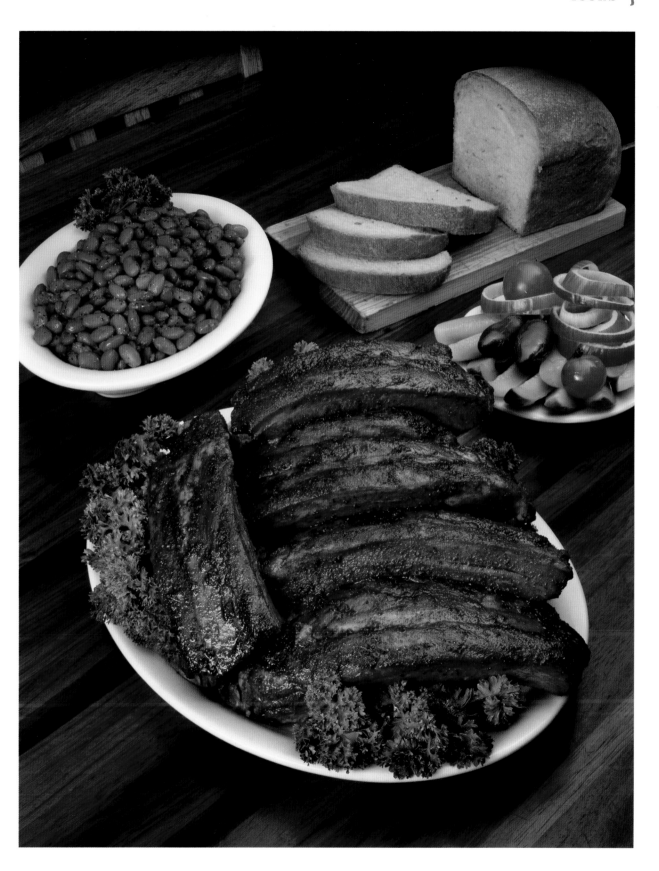

Cooper's Old Time Pit Bar-B-Que, Llano, 2000
◄◄ During my setup for this "smoke, smoke that BBQ" shot, a very *well-endowed* young woman decided to jump into the scene at the end of the pit, giving me a memorable profile pose. It was a little too racy for the magazine, but it was an entertaining story to retell and remember.

The County Line, Austin, 1986
◄ Here I learned how to style barbecue ribs for a food shot. One of the owners smoked the rack for about an hour and then painted the ribs with chili powder and oil. We placed the ribs on top of a stack of bread slices to make the pile of ribs appear higher.

Oil and Gas

Back in 1978, I carried my brand-new Sinar F 4 × 5 view camera everywhere I went just in case I saw a chance to create art. The shot of this gas flare was taken in 1979 in Snook on one of my drives near my hometown of Caldwell. In January 1996, the magazine ran my portfolio, which allowed some images I took before I started shooting for *Texas Highways.* This image, along with the cowboy in front of the neon Texas flag at the Institute of Texan Cultures, was not shot on assignment for the magazine, but they are among my favorite photographs.

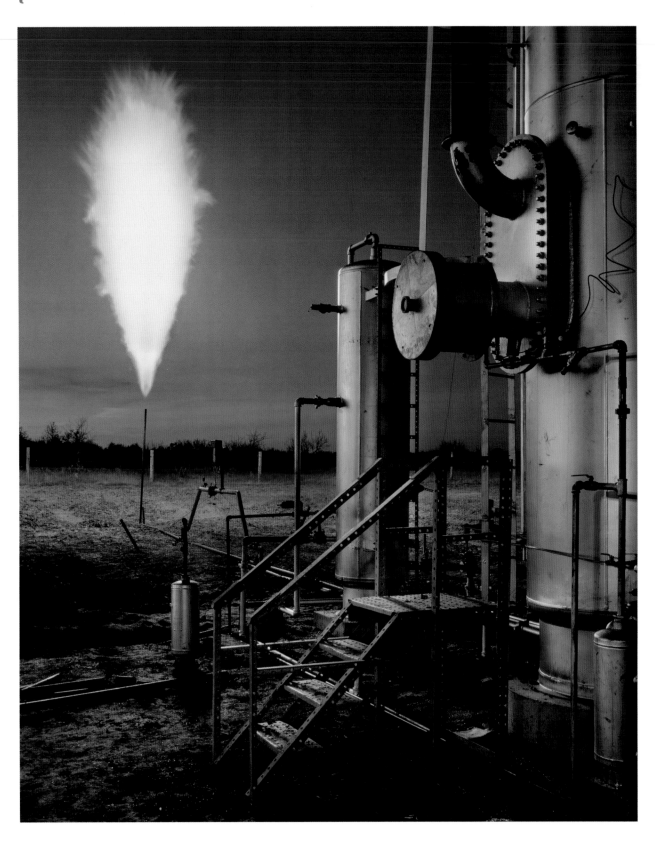

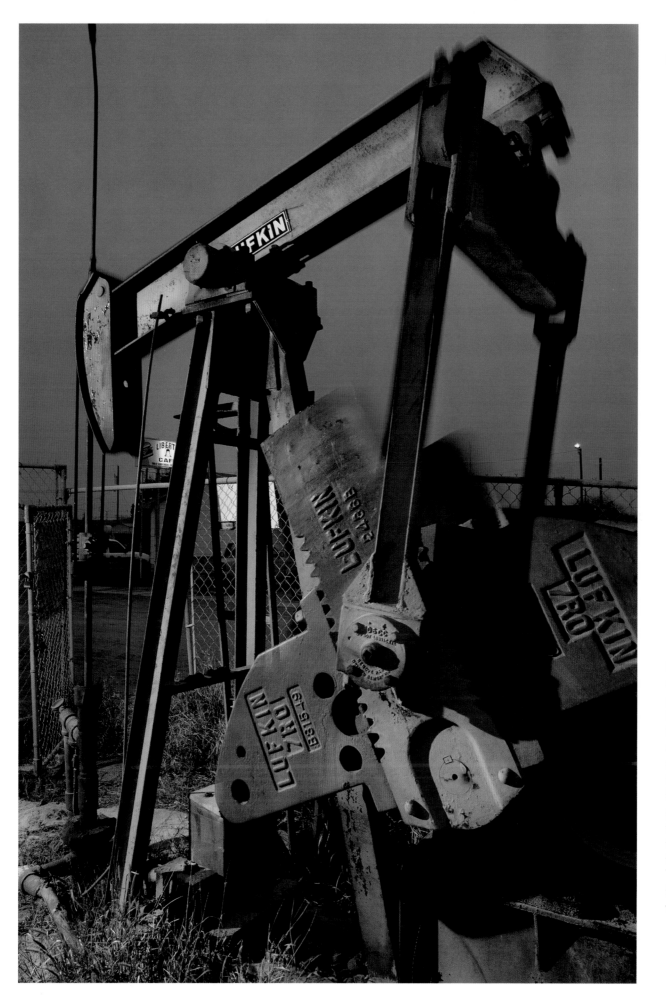

In 2003, I just wanted to see if I could turn a 4:00 p.m. cloudy, gray sky in Freer into a dramatic twilight by using complementary filtration and flash. My digital camera was set to tungsten with a blue, 85B filter on my lens and two CTO (orange) filters on the flash. The blue filter caused the gray sky to go deep blue, and the orange-filtered flash made the pumpjack look naturally lit through the 85B (blue) filter. This technique can change a flat, boring scene into something very cool.

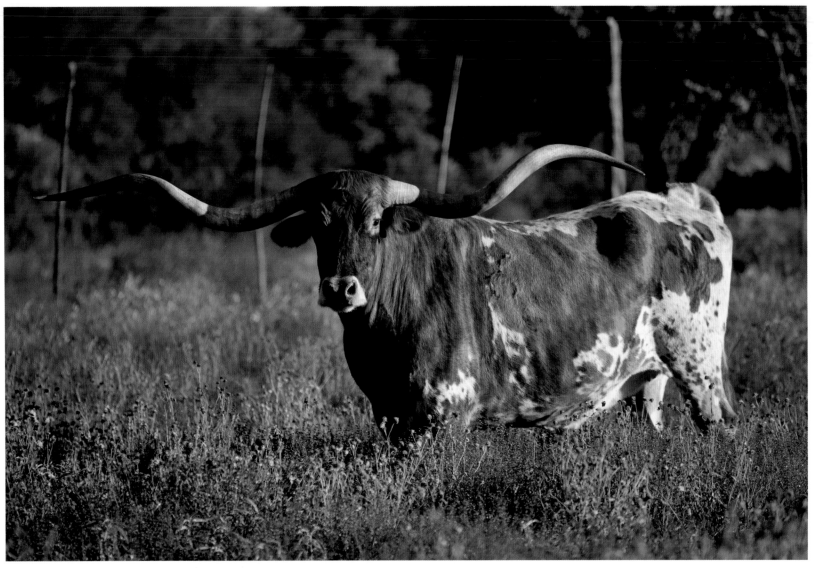

Longhorns

In 2010, the longest horns in the state measured 98 inches across on the YO Ranch in Mountain Home. We had to herd this massive Longhorn bull out of the thicket into open pasture while keeping our eyes on an aggressive camel that shared the pasture. I am not quite sure what the camel could have done, but he was a lot bigger than me. I kept my distance.

➡ People ask me how I got so close to this Longhorn on the Woodward Ranch south of Alpine in 2009. I just moved slowly and kept talking nicely to him.

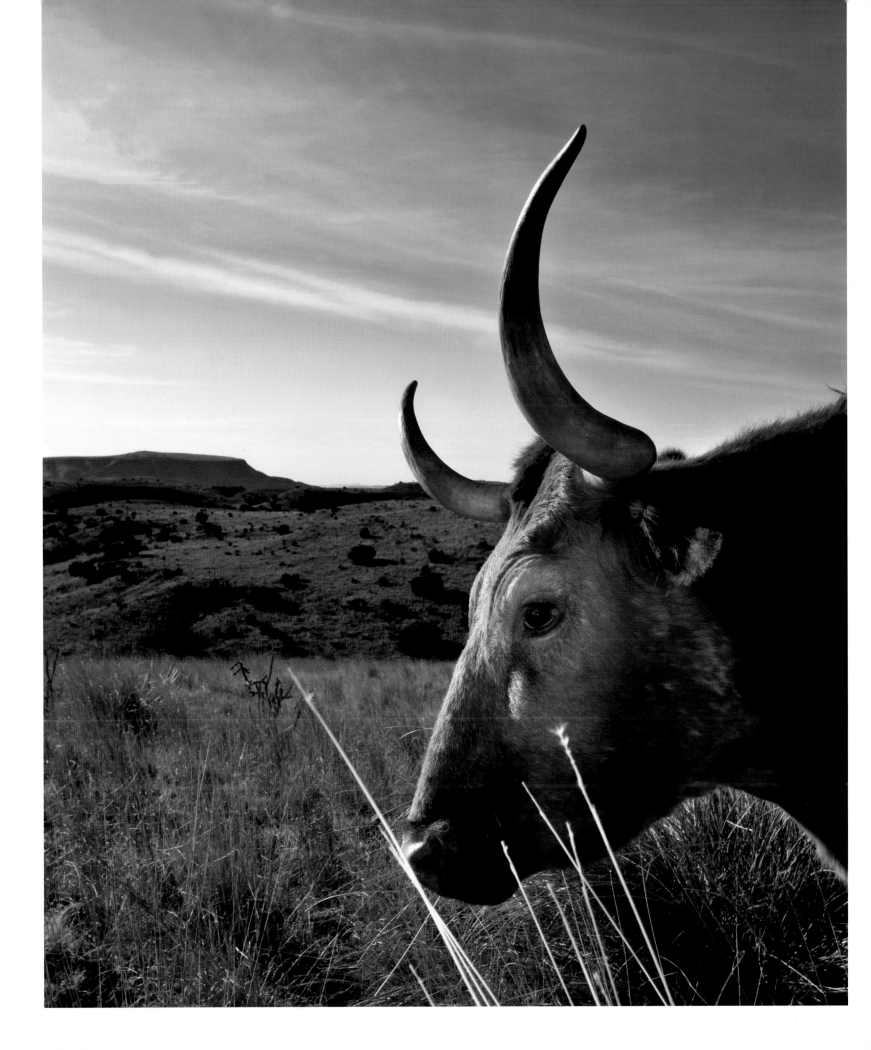

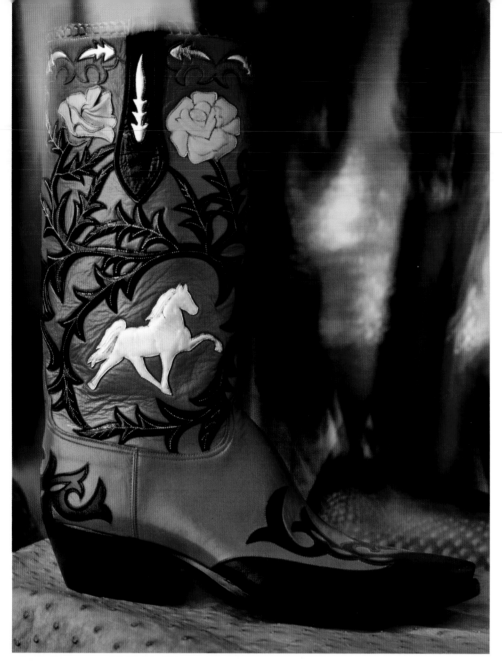
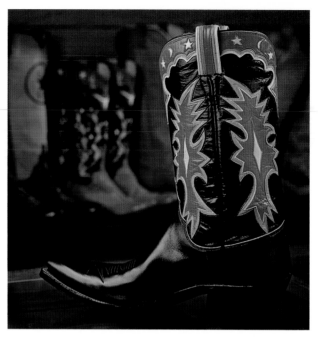
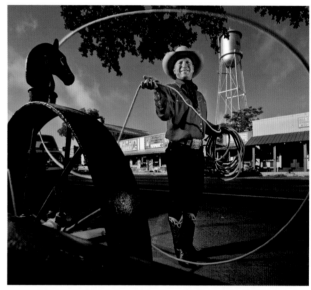
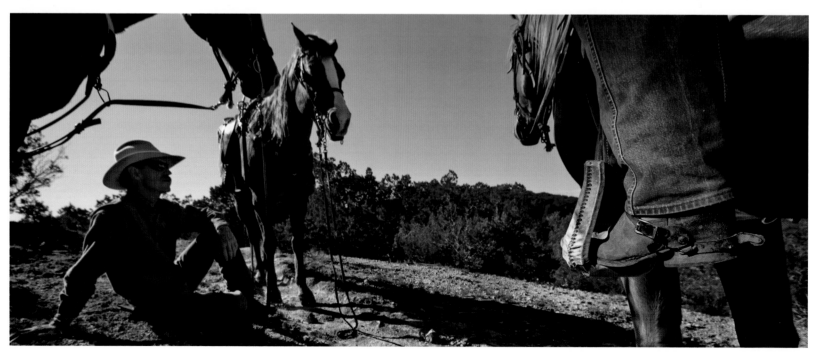

Boots

◄◄ Red boot with yellow roses, white horses, and barbed wire at Little's Boot Company in San Antonio, 2001.

◄▲ Rusty Franklin Boot Company, San Angelo, 2001.

◄ One of my favorite subjects, trick-roper Kevin Fitzpatrick, Bandera, 2010.

◄▼ Cowboys in their work boots, Silver Spur Ranch, Bandera, 2010.

▶ Lyle Lovett's last ink footprint, used to measure his custom boots at Texas Traditions in Austin, 2001.

▼▶ A pair of custom boots made for a New York City client at Cavazos Boots in Mercedes, 2008.

▼ Ceramic boots—San Angelo Museum of Art, Ceramic Symposium, 2005.

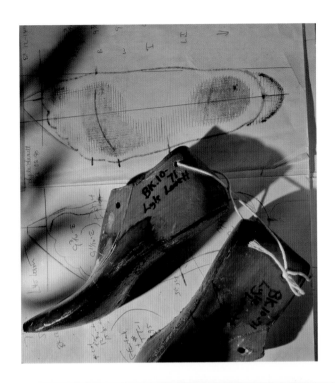

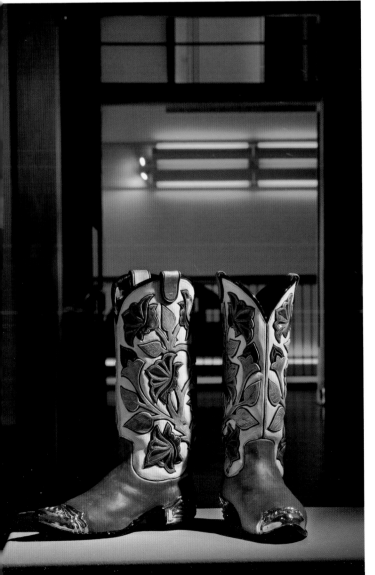

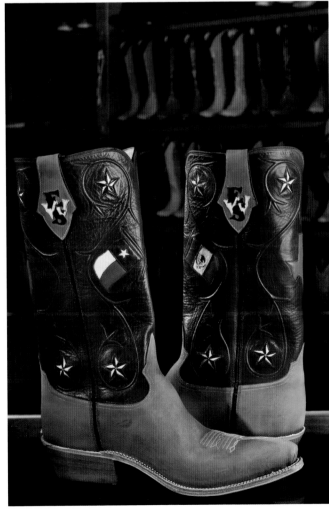

Dancing
Boots and flip-flops on the
dance floor at Arkey Blue's
Silver Dollar, Bandera, 2009.

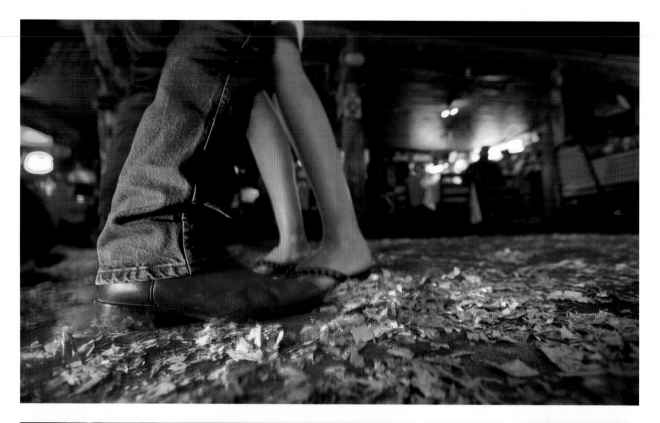

Broken Spoke, Austin, 2011.

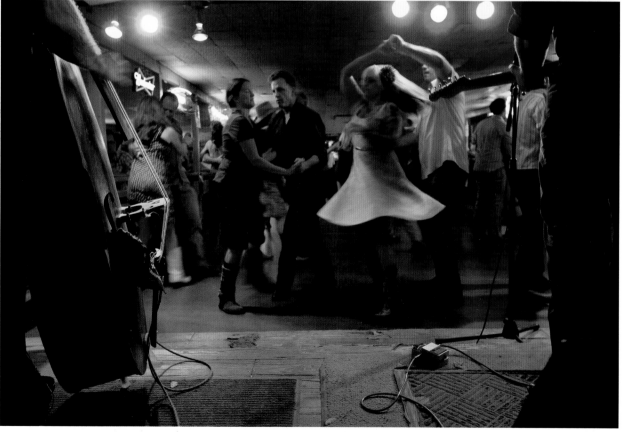

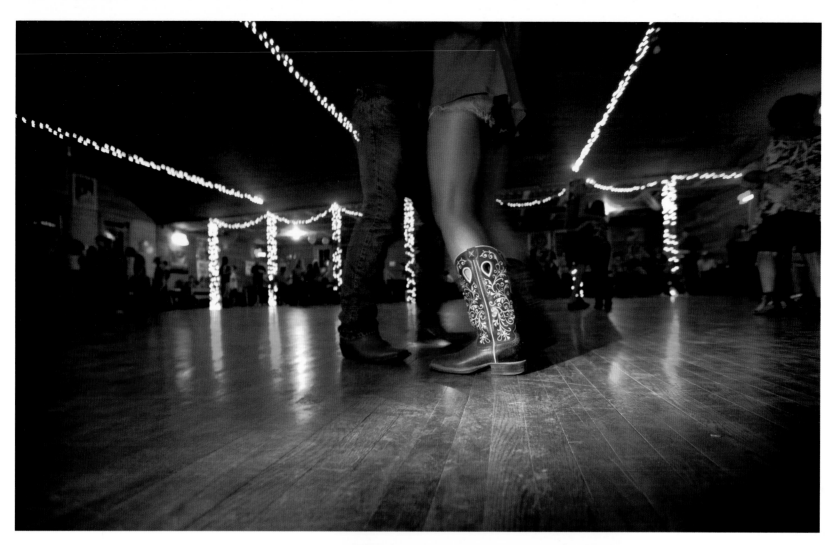

This 2011 shot at Twin Sisters Dance Hall in Blanco of a girl dancing in shorts got me into some trouble. The photo was cropped much tighter than shown here. It looked like I was on the floor looking up. However, I was not even looking through the camera. I was just grabbing shots of feet dancing by. For weeks we got angry comments from some folks who thought this kind of photo did not belong in *Texas Highways*. Some even sent Bible scriptures.

Hats
A Roy Rogers hat design unique to Mike's Custom Hats in Longview, 2008. At Mike's, I learned the difference between a hat you buy in a store and a custom made-to-fit hat. He sized a hat off the rack for me that I love mainly because it fits perfectly. Custom fitting is the reason those cowboys riding across the plains never lost their hats in old Western movies. I had always wondered how those hats stayed on while the cowboys were riding so fast.

Fischer Hall, Fischer, 2010
The man who built Fischer Hall
was a ship builder. That's why
the inside looks like an upside-
down boat. A scene in the film
Honeysuckle Rose with Willie
Nelson was filmed here. I always
liked that movie. Maybe it's
because I like being "on the road
again," too.

**Let's Go To Luckenbach,
Texas, 2012**
➤➤ Songwriter circle held
Friday, Saturday, and Sunday
afternoons. Some of these folks
are very talented. But since
anyone can sit in, I enjoy putting
my camera down and playing a
little slide or Dobro, if I think I
can keep up with the players.

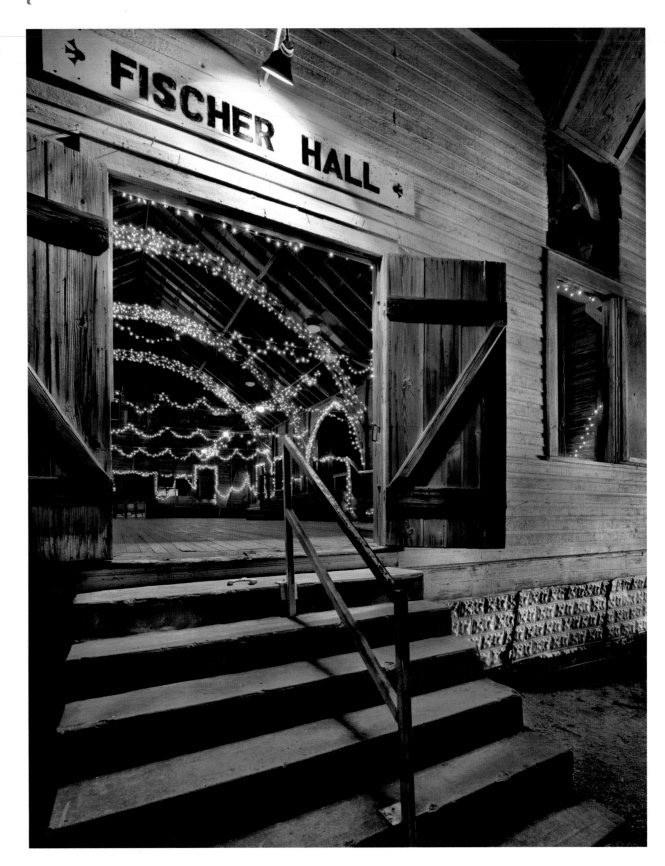

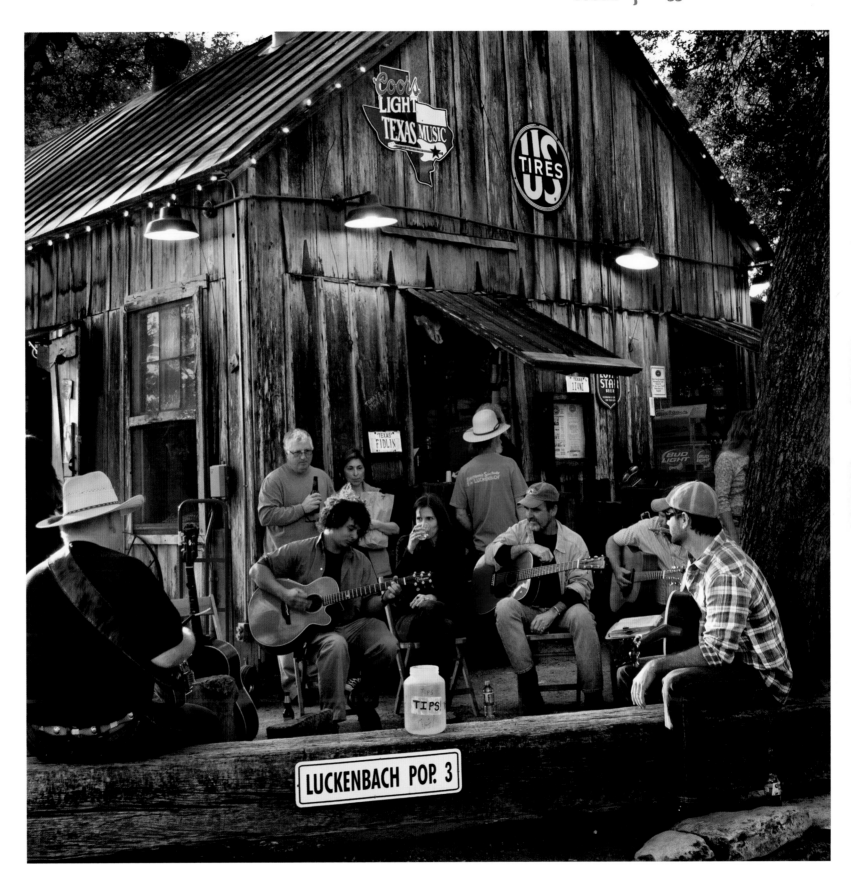

**Lady Bird Lake,
Auditorium Shores,
Austin, 2010**
A twilight photo of the Stevie
Ray Vaughan statue on Lady
Bird Lake in Austin. This is where
I demonstrated my light painting
technique for a video shown at
my photo exhibition at Hunts-
ville's Sam Houston Memorial
Museum in the spring of 2011.
The video was later shown with
my exhibit at the Institute of
Texan Cultures in San Antonio
from November 2011 through
March 2012. The shot was the
March 2011 *Texas Highways*
magazine cover.

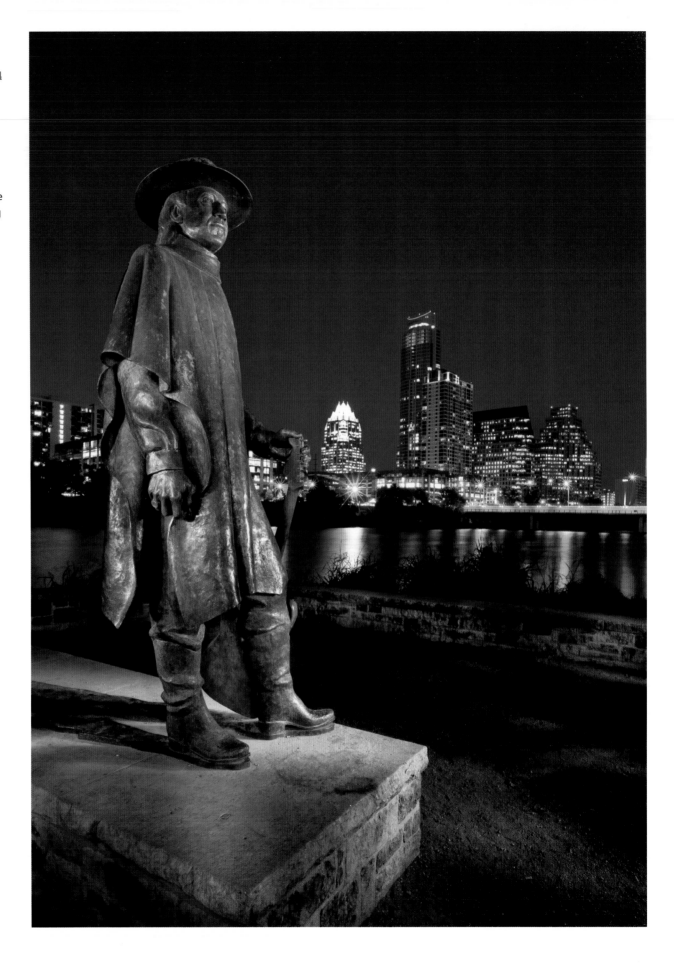

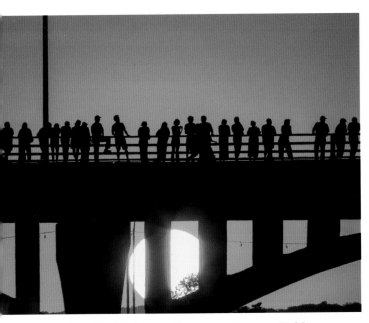

Ann W. Richards Congress Avenue Bridge, Austin, 2006
Waiting for the bats to fly. The bridge is host to thousands of bats that fly out each night, looking for insects to eat.

Studio, 1987
I got a call around 2:00 one afternoon, asking me to come up with a photo illustration about Texas music before the end of the day. I like challenges. Sometimes I just like to see if I can make it happen. That's one of the things that keeps my work interesting and rewarding.

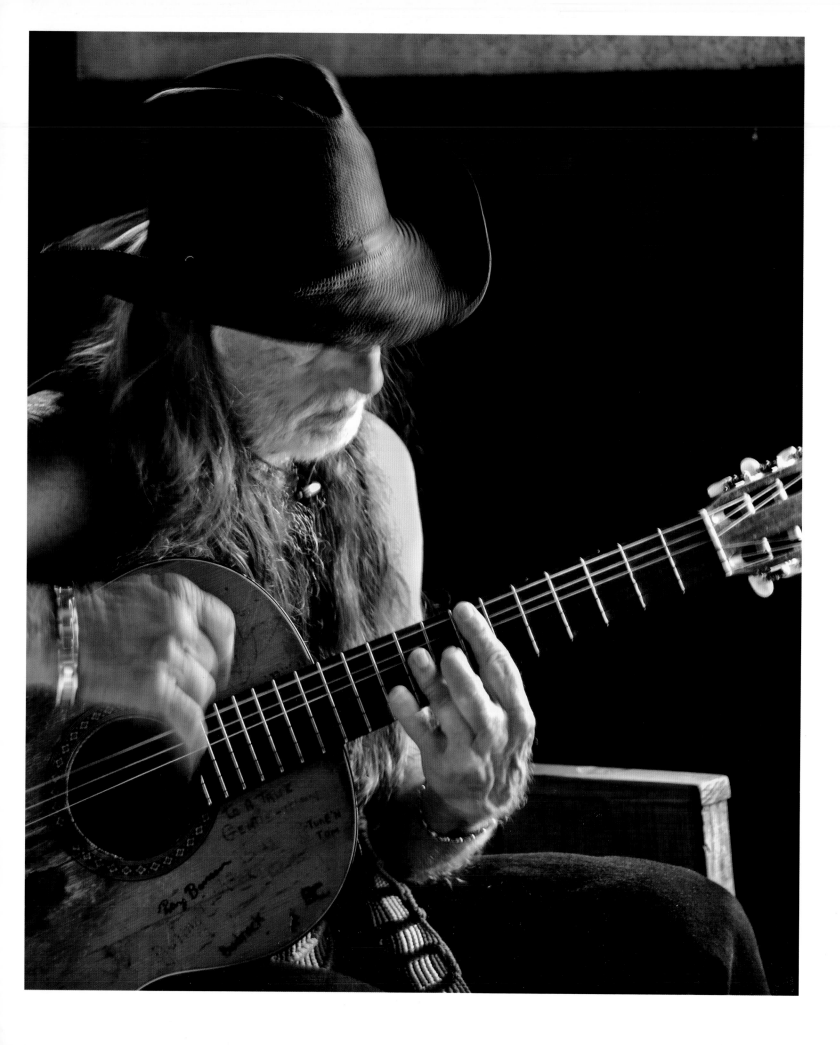

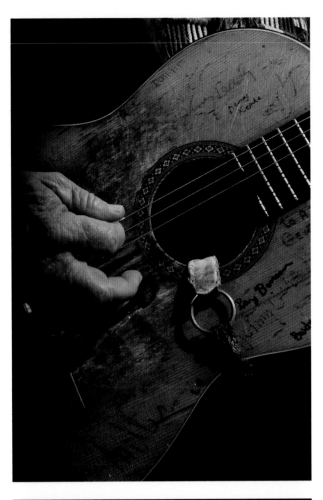

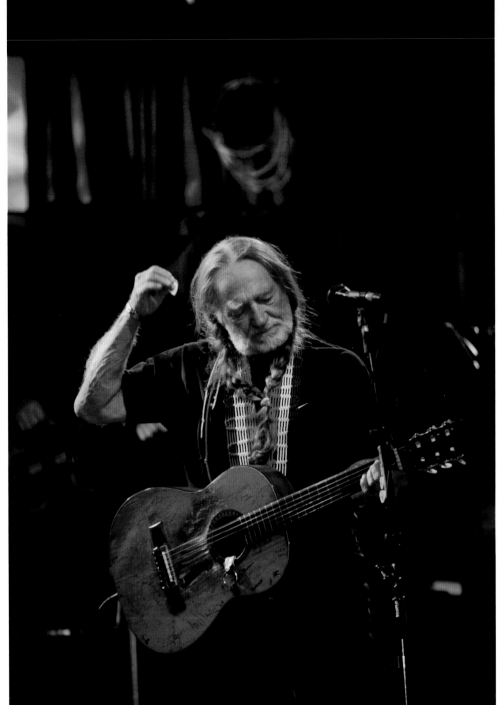

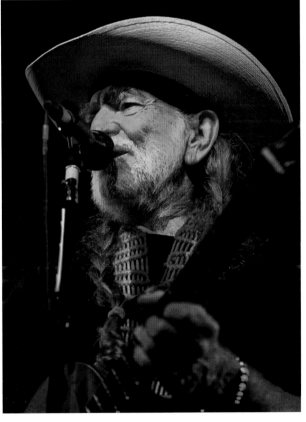

Willie, 2003

⬅⬅ The little chapel at Luck—the movie set built for *Red Headed Stranger*. While I was waiting for Willie, I picked up Trigger, Willie's guitar, and I thought his personal assistants, Jon and Ben, were going to have a cow. A little later I had Willie sit on the church pew and play.

⬆⬅ "Let's Jam." That's what Willie said when he drove up to the location to be photographed, as he saw me starting to put up my Dobro. It was a surreal and memorable moment to be picking and grinning with Willie on the porch. Definitely a high point for me.

⬅ Willie at Billy Bob's, Fort Worth Stockyards.

⬆ Willie at John T. Floore's Country Store in Helotes.

LAND

My love for driving and exploring back roads developed with my interest in photography during my senior year of high school. That year my Dad encouraged me to shoot a roll of Kodachrome 64 every day. My friends and I would explore different parts of Burleson County, listening to Jeff Beck on my eight-track stereo system and stopping to photograph barns, flowers, landscapes, and, of course, sunsets.

I remember showing my sunsets and landscapes to my teachers and classmates at The Art Institute of Atlanta. They were impressed with my ability to make very colorful photographs. From then on, I realized my passion for traveling and making color photographs of everything along the way was my purpose in life. After thirty years, this is still true for me.

Today the control of digital photography allows me to actually create colorful photographs. I try to reproduce the intense colors of my transparencies or slide film days. Digital lets me see images immediately. I can quickly make adjustments to exposure and composition on-site. Sometimes I play a game with myself to see how many good photographs I can make during the magic hour—thirty minutes before and thirty minutes after sunset. During that time, the unique qualities of the light make it easy to create incredible photographs. The key for me is to be in position to get the best-composed and best-exposed image of a potentially good scene I scouted out earlier.

I have traveled thousands of miles of Texas highways and back roads making photographs of spectacular scenes, showing readers a Texas many have never seen. In this section are some of my favorites.

Monahans Sandhills State Park, 2009
I had dreamed about light painting the sand dunes in Monahans Sandhills State Park for twenty years. When I finally did it, the shot came out even better than I had imagined. And the sand felt good between my bare toes.

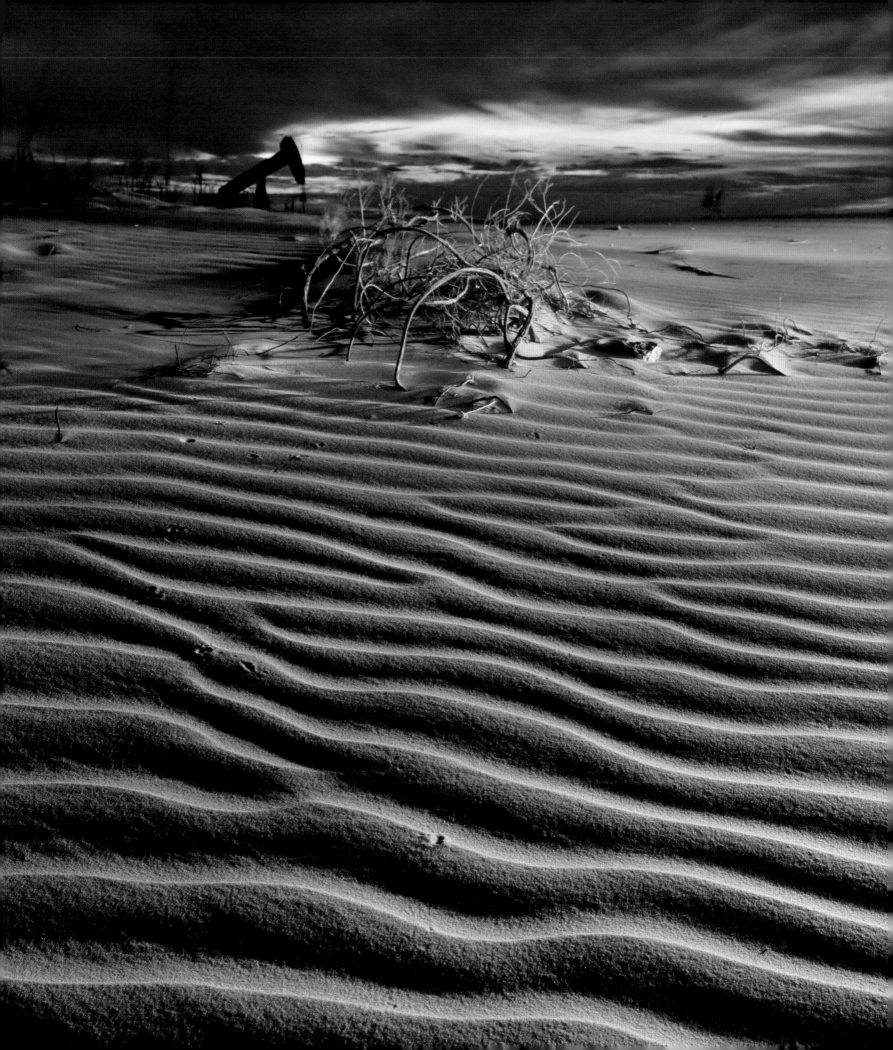

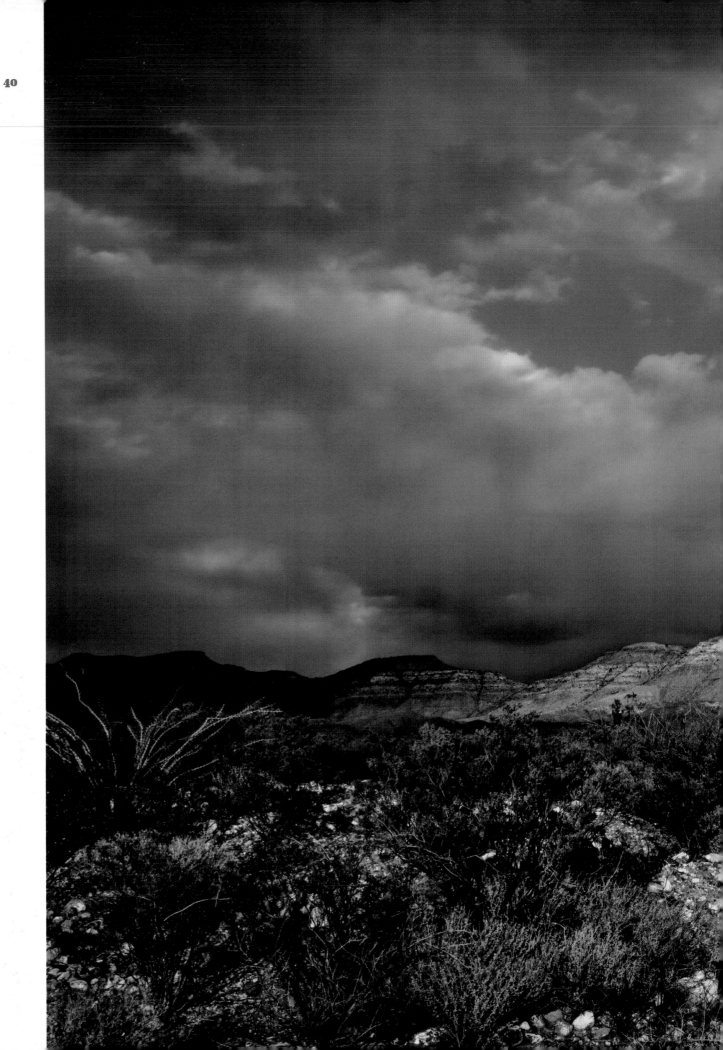

**Pinto Canyon Road,
Presidio County, 2010**
Pinto Canyon Road.

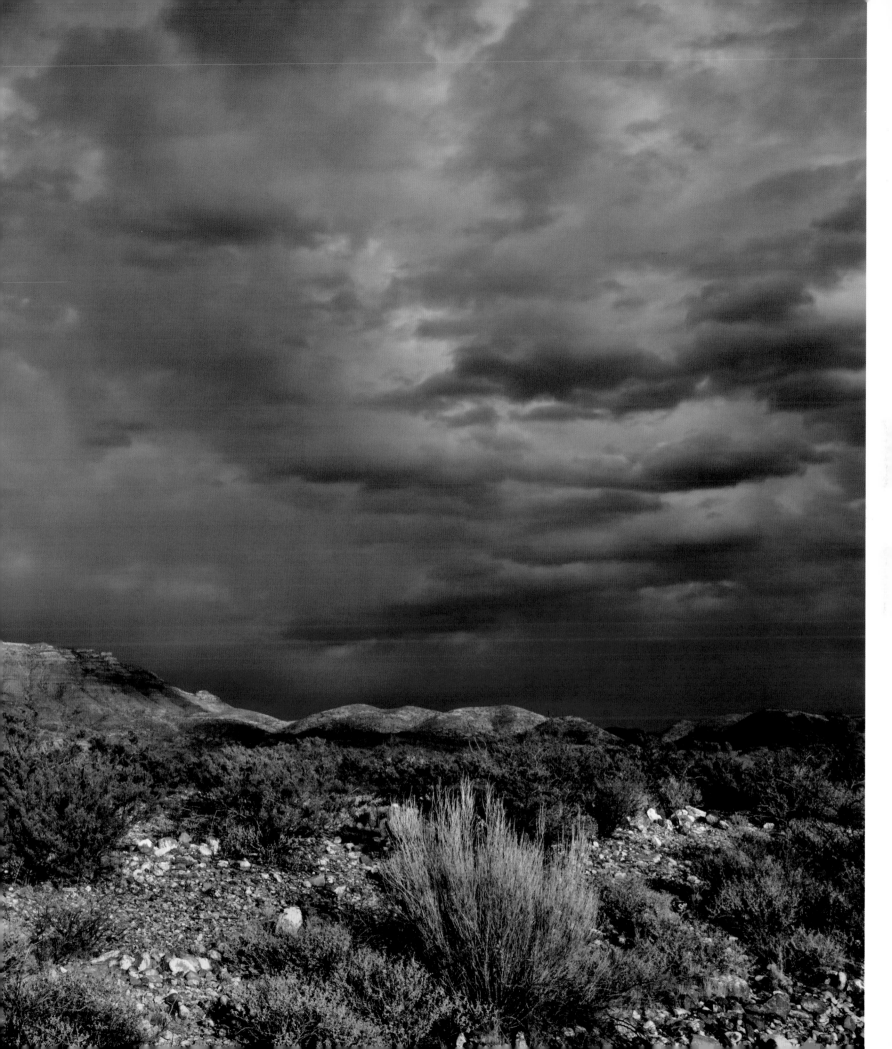

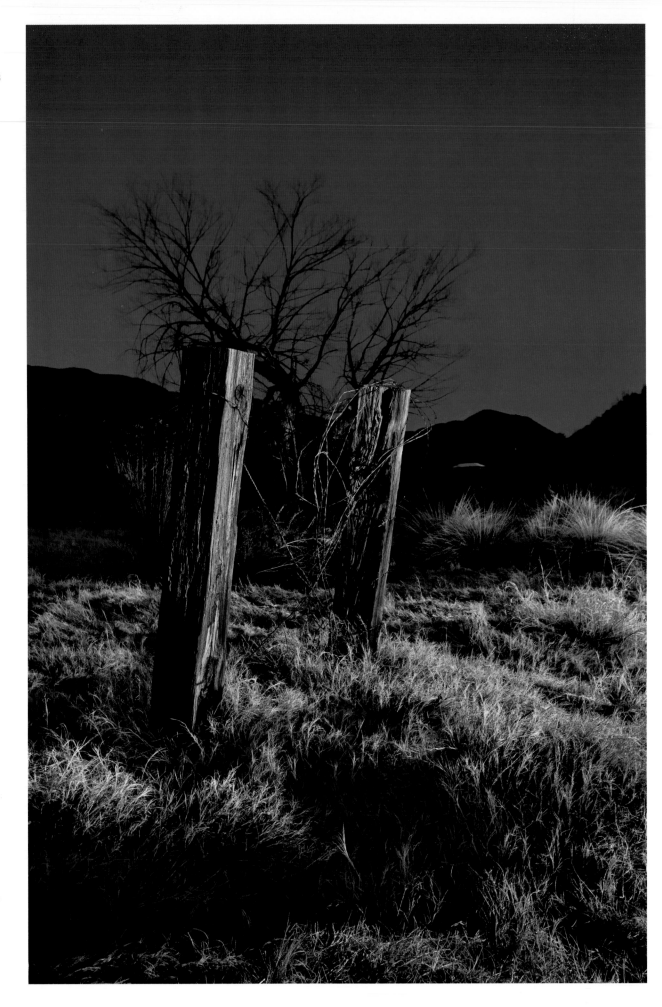

Nighttime falls on Pinto Canyon
Road, 2010.

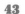

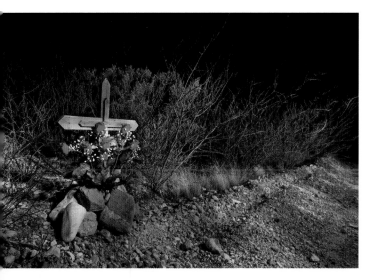

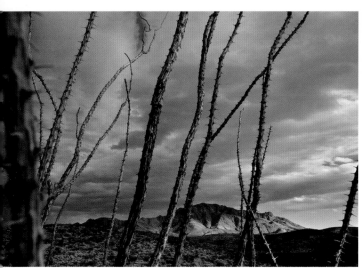

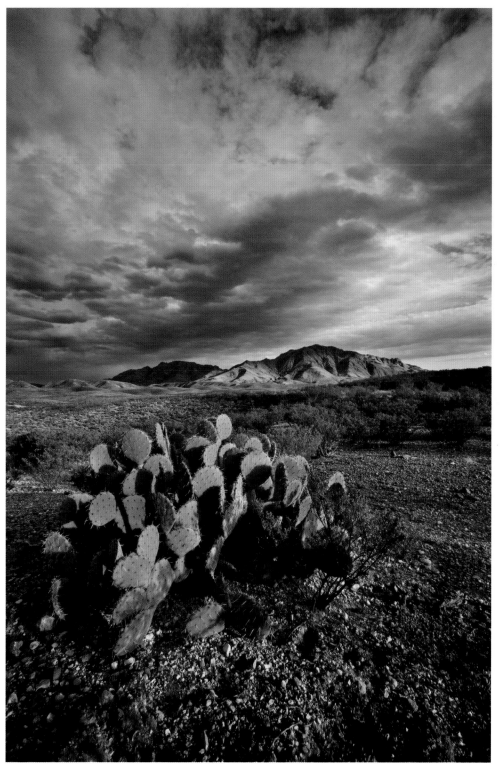

⬆⬆ Cross on Pinto Canyon Road.

Below the cross, down the big gulch, is an old truck that ran off the road.

I highly recommend taking a drive on the spectacular and rough road called Pinto Canyon Road in Presidio County. You have to go slow so your truck will come out intact and so you can take in all of the scenery.

Texas Highways editor Charles Lohrmann and I took a five-day trip to photograph Terlingua, Presidio, the Marfa area, Chinati Springs, and Pinto Canyon Road. I took so many photos that we are still using some of them for stories on the area. It was a very productive trip.

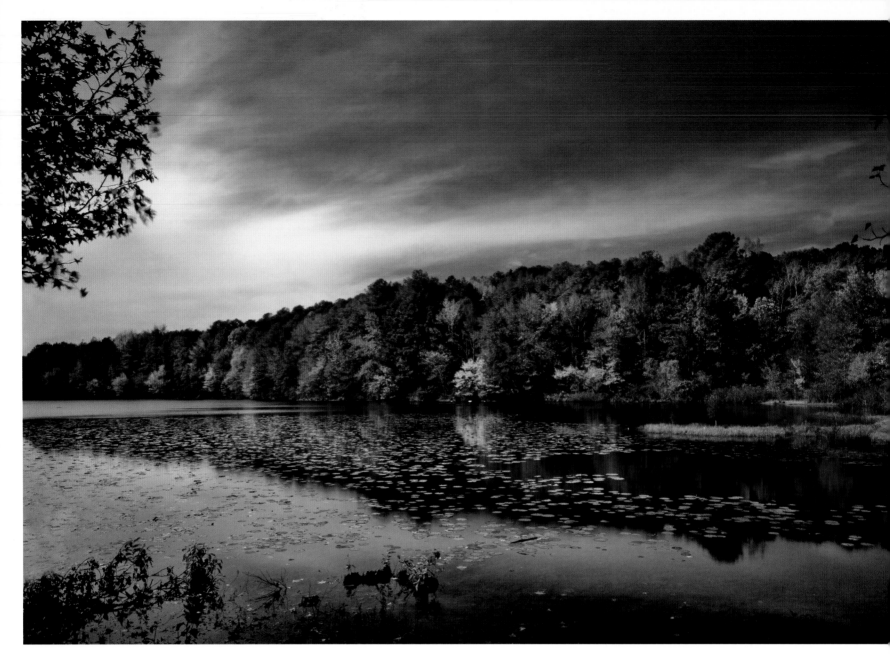

East Texas Fall Color, Hughes Springs, 1984
These two East Texas images were made about four months
after I started at *Texas Highways*. The shot of the lake at
Dangerfield State Park was made into a poster.

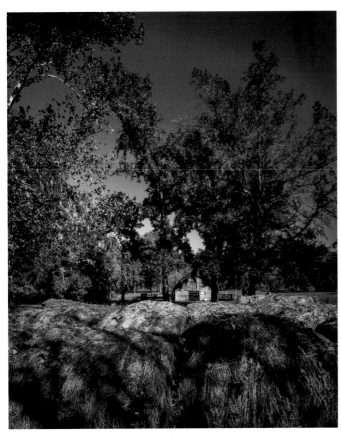

Linden, 1984
Red barn in Linden, shot on 4 × 5 sheet film.

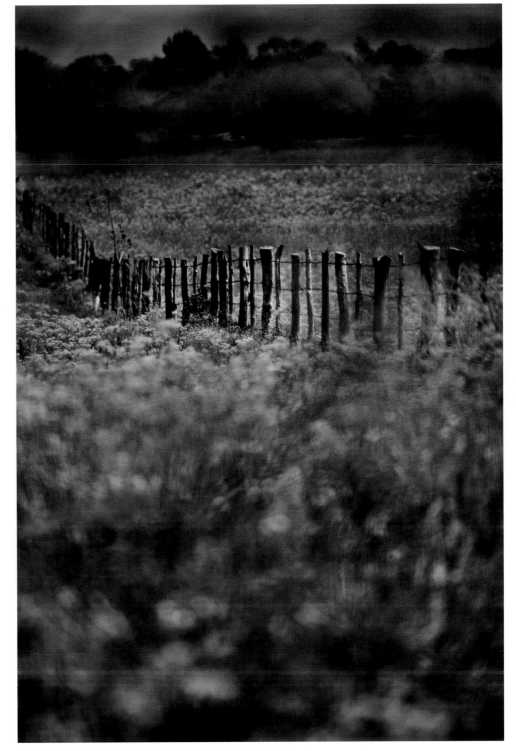

Crockett, summer 2011
This was one of the best fields of flowers I saw that year near Crockett. The light at midday is usually too bright and flat, but when I peered through my 400-mm lens beyond the dead vines and focused on the center fencepost, I got this painterly look. After this photo appeared on the magazine's back cover in July 2011, I got an email from a couple of longtime subscribers saying they hoped the printer had messed up their copy. They considered the shot to be one of the worst photos ever on a *Texas Highways* cover. At least these subscribers cared enough to write to us, but I didn't agree with them.

Guadalupe River State Park, 2005
My friend Techa Majalca was a little reluctant to model for this photo. I told her that I really thought the shot would make the cover. I was right. Later, I gave her parents a poster of the cover. They probably still have it on their wall.

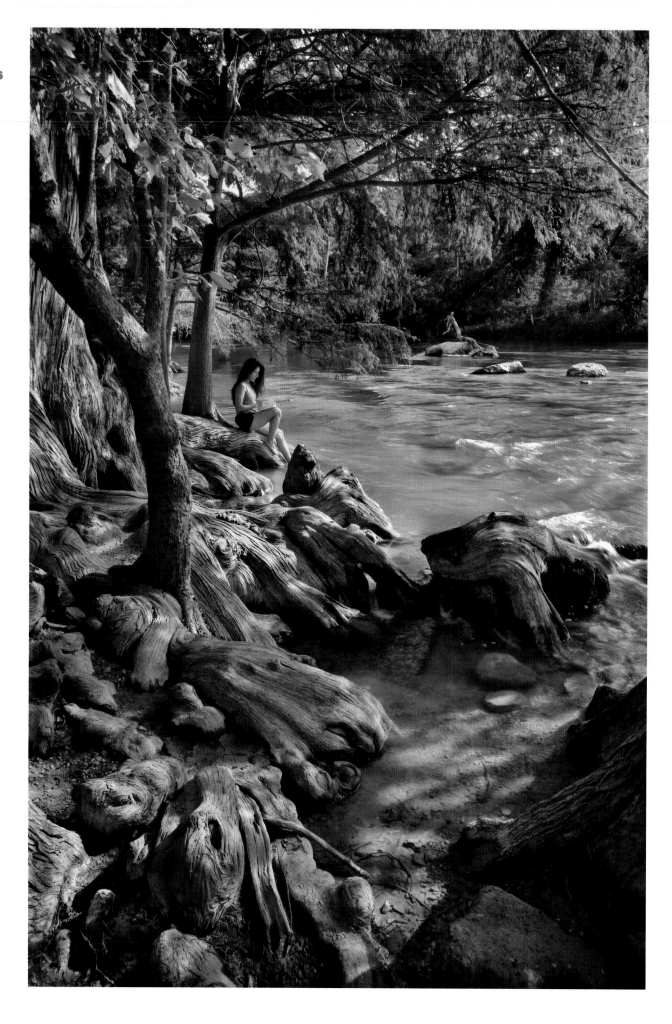

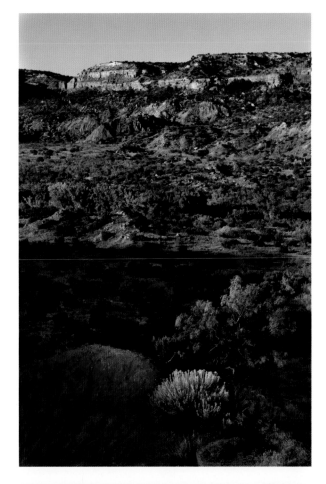

Palo Duro Canyon, 2004

I have not shot many landscapes in my career at *Texas Highways*, mainly because I lacked the time. It's difficult to be on the scene at that magic moment when the light is at its most dramatic. Every now and then, though, I've been lucky. This is one of those lucky shots.

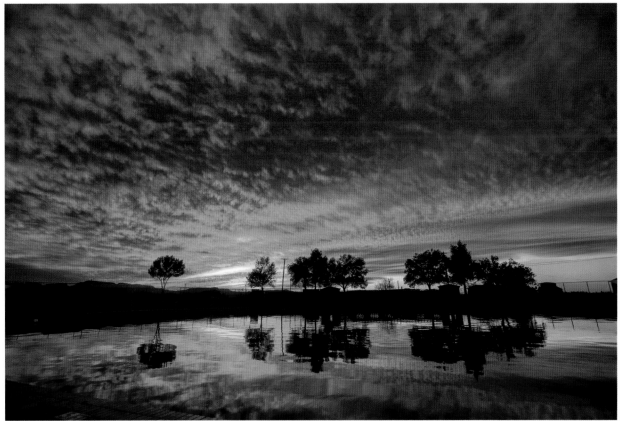

Balmorhea State Park, 2004

Fossil Rim Wildlife Center, Glen Rose, 2011
I woke up in a safari tent at Fossil Rim Wildlife Center with one thought: My new Canon 5D Mark II's sensor would let me capture the stars. With the bathroom door cracked open just enough to light up the path and one light in the parking lot, I shined my LED spotlight straight up. The light falloff from the side of the LED lit up the trees during a thirty-second exposure. I was so excited that I called my girlfriend at 1:30 in the morning to tell her.

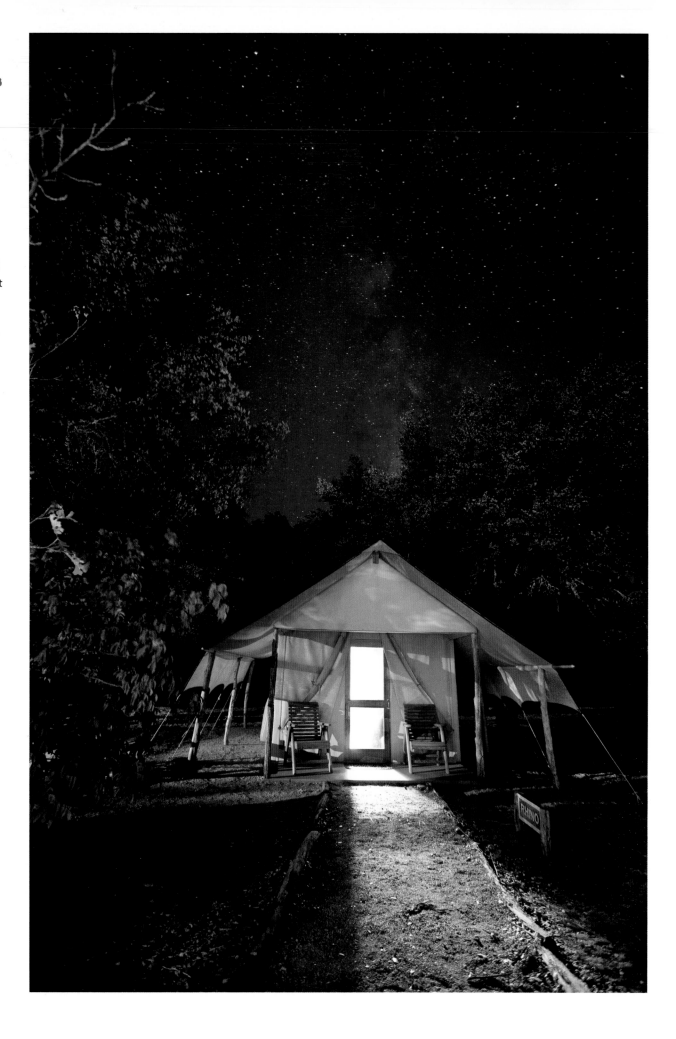

Flowers near Frenstat, 2012
Just off the intersection of FM 60 and FM 976 in Burleson
County. It is always fun for me to photograph places that
I shot during those years back in high school when I first
started in photography.

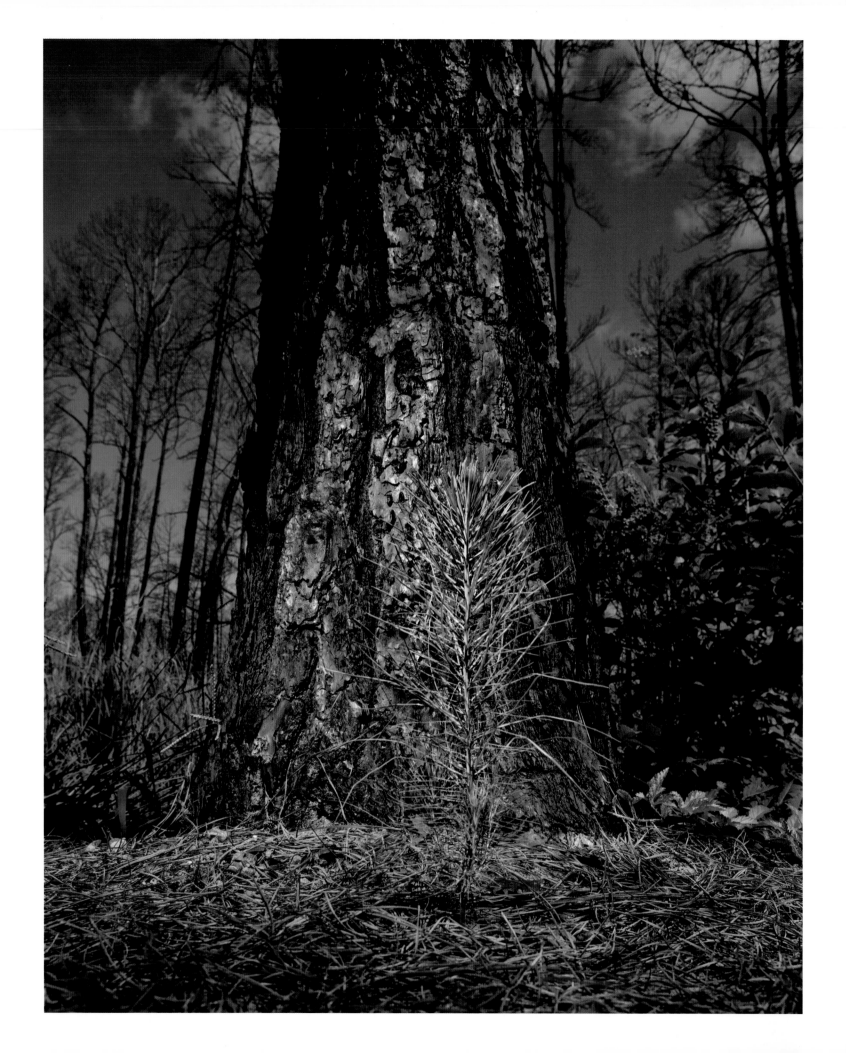

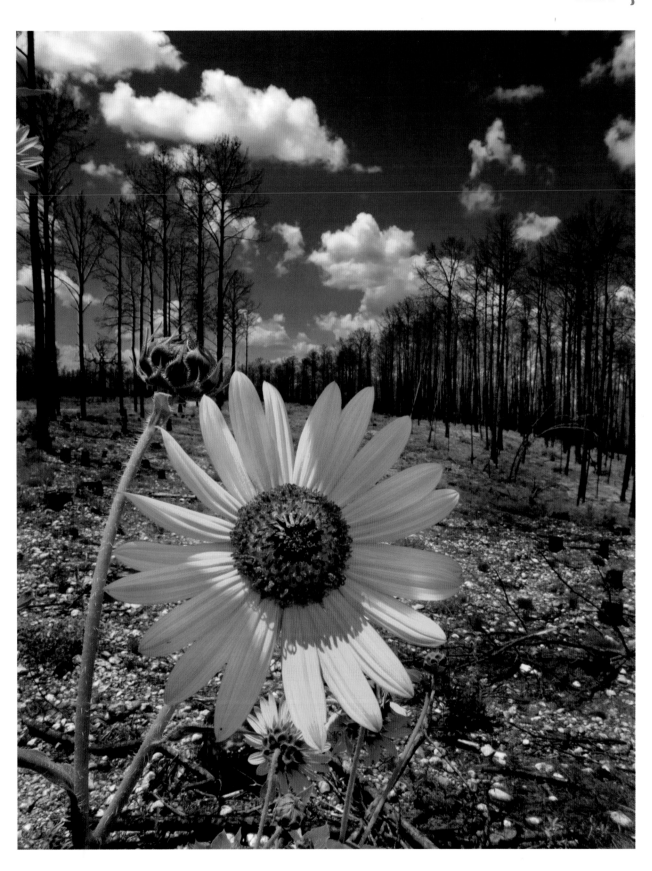

Bastrop State Park, 2012
These photos show new growth one year after the devastating fires of Labor Day Weekend, 2011.

◄◄ I almost got heatstroke crawling around on my stomach in 100-degree, humid heat for more than an hour in the soot, ash, and dirt to get close enough to photograph these tree saplings.

◄ The park rangers were hopeful that some of the destroyed trees behind this blooming sunflower would come back. It looked like another planet to me.

**Natural Bridge Caverns,
New Braunfels, 1988**
It was so humid in the cave and so cool above ground that it took an hour for the condensation on my lens to clear. To solve that problem, I had to leave my gear in the cave overnight to acclimate. Some of my sheet film buckled during the long exposure, causing parts of the cave scene to be out of focus. It took us awhile to figure that one out.

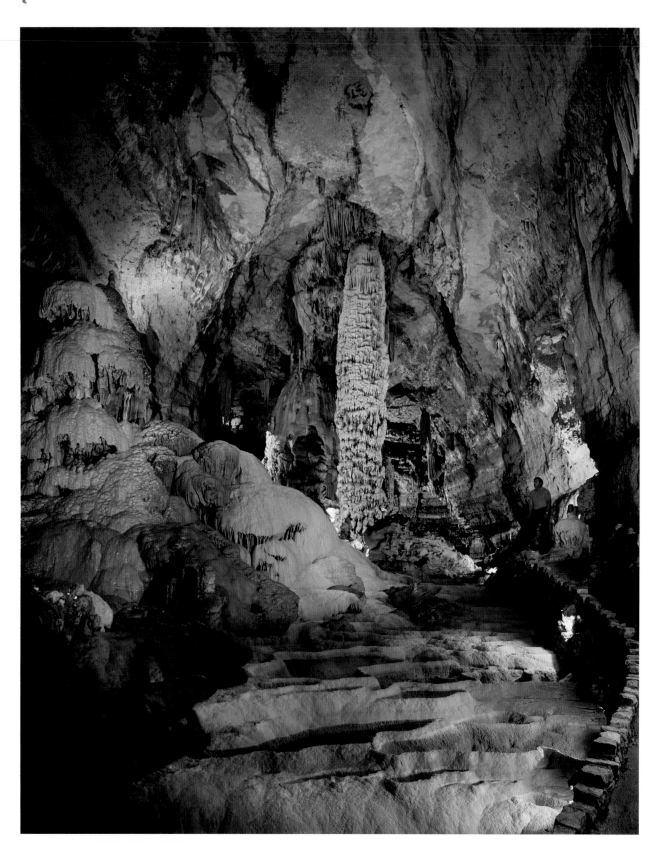

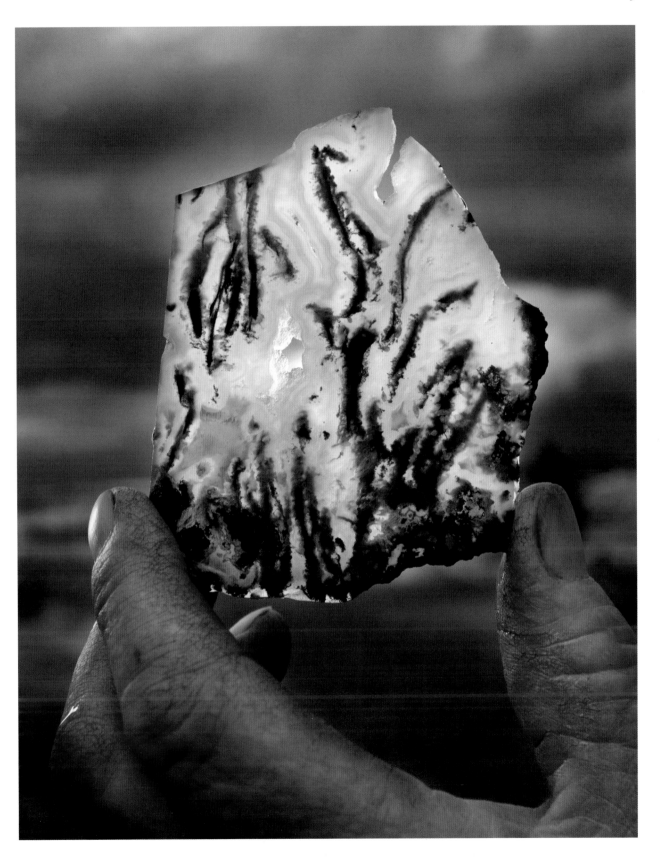

Woodward Ranch, Pom Pom Agate, Alpine, 2010 Trey Woodward, the owner of the ranch, held the agate while I experimented with numerous flash positions before I found the right one to light up the specimen. The green water plants had frozen in place when volcanic lava flowed into the water thousands of years ago. The Woodward Ranch is well known for its wealth of agates.

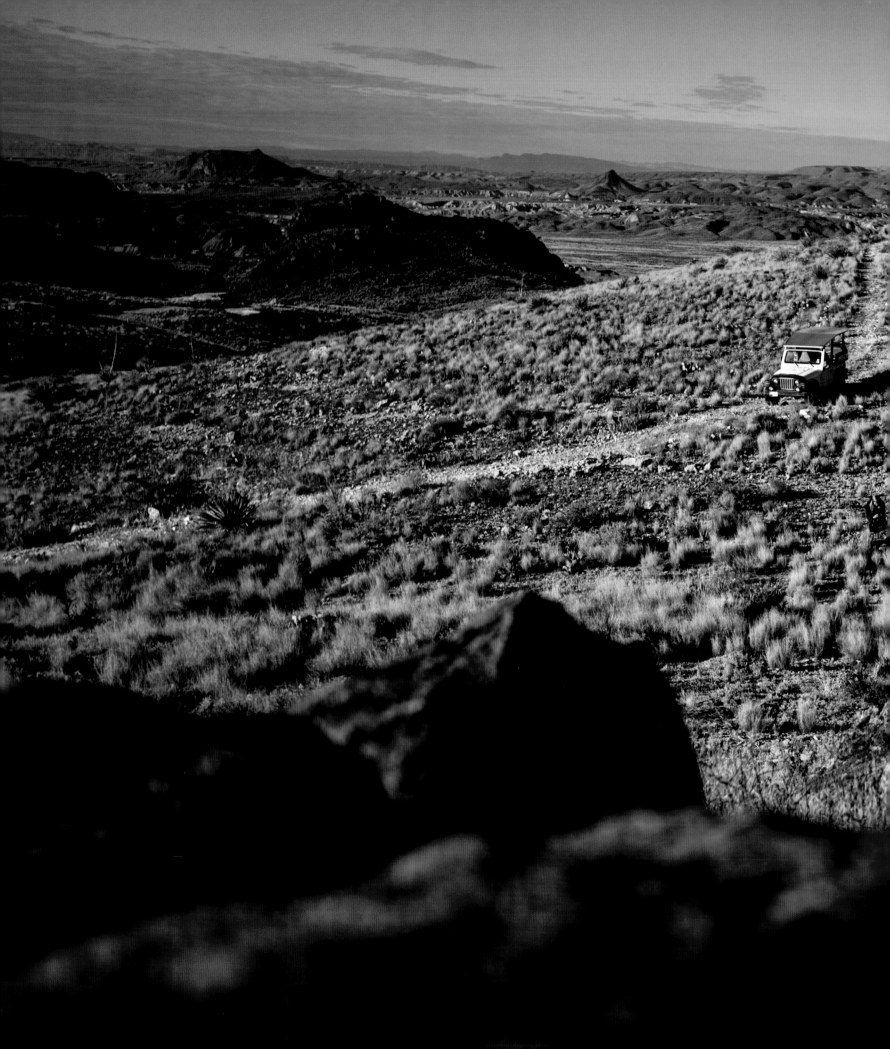

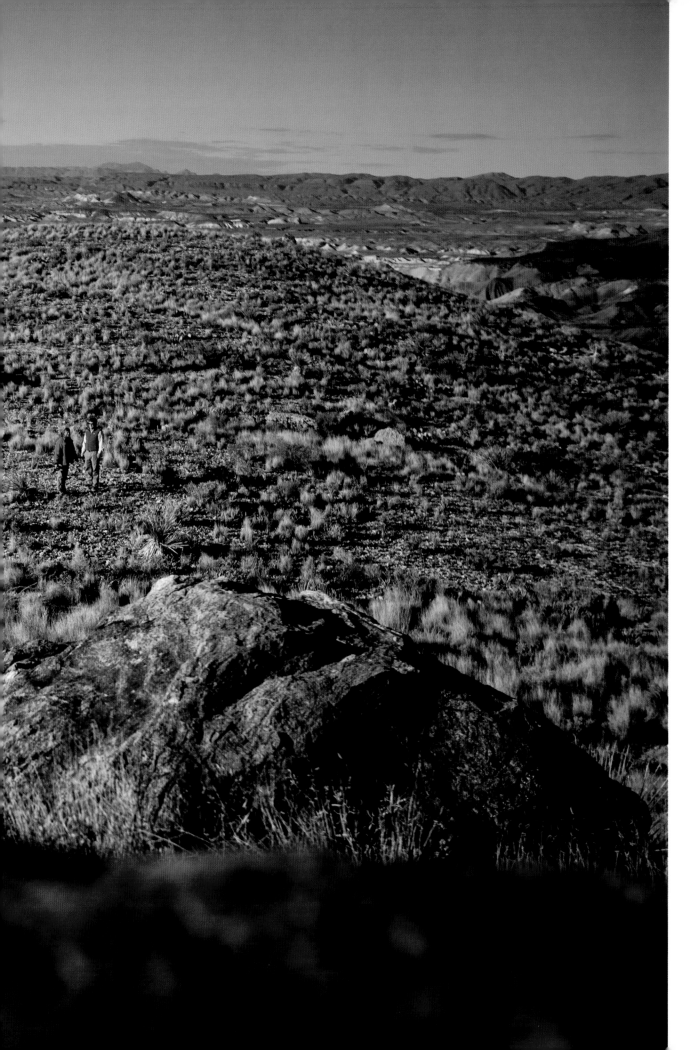

**Far Flung Outdoor Center,
Brewster County, 2010**
Far Flung jeep tours in Terlingua
took me on an old mineshaft
tour, where I shot these incred-
ible views of the desert and
mountains.

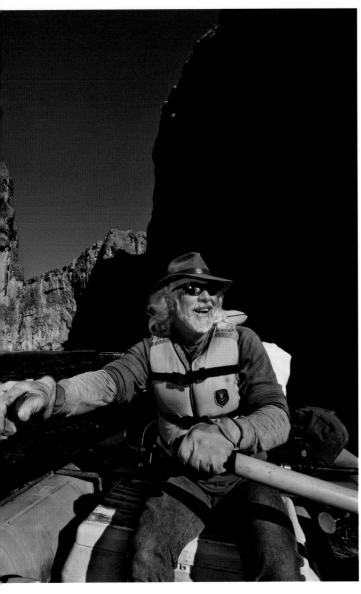

Dr. Fun, the Rio Grande, 2007

I shot this New Year's Eve raft trip down the Rio Grande through Santa Elena Canyon with "Dr. Fun" of Far Flung Outdoor Center. He kept talking about his disco ball, saying he was the evening's entertainment. I told him I had to shoot something with that disco ball. It turned out to be a lot smaller than I imagined, but I was determined to make an interesting photo one way or another. I light painted the canoes in the background with Dr. Fun's help. Still in his plaid party jacket, Dr. Fun held the flash and pressed the cable release, which opened the shutter for the thirty-second exposure. Later, he and I played music together.

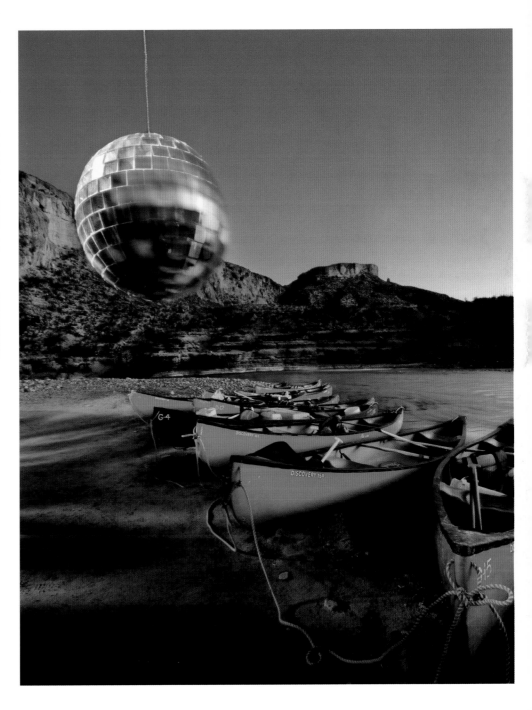

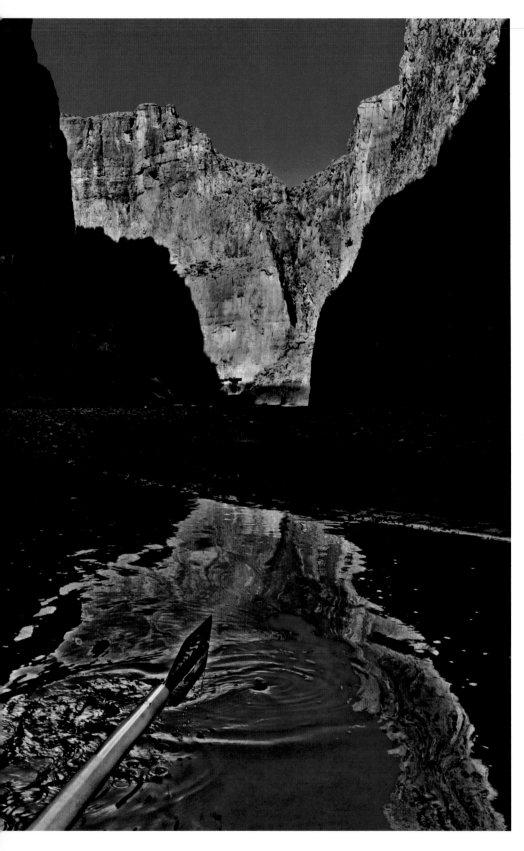

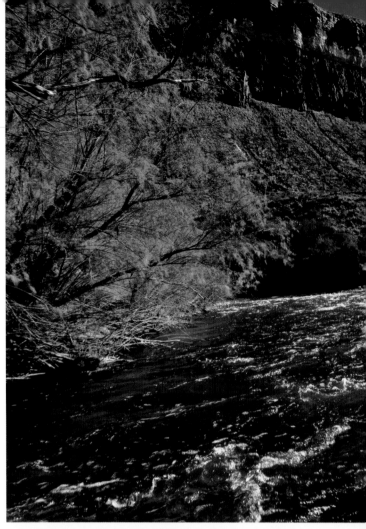

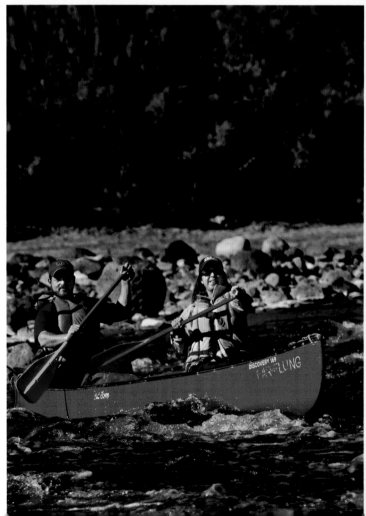

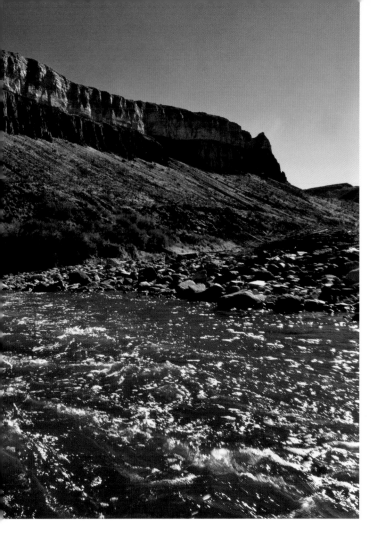

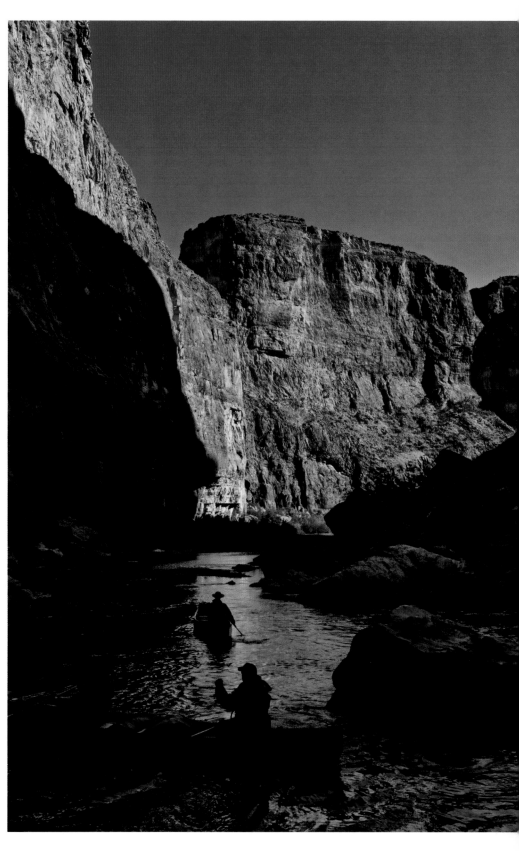

**Santa Elena Canyon, the Rio Grande,
New Year's Day, 2007**

On the first stop of our New Year's raft trip, I met a family with college-age kids from Tyler. I asked them if they knew my cousin Fred, who lives in Tyler. They lit up and said yes; he was their Sunday school teacher. I immediately told the boatmen they might want to be on their best behavior and not party too much. I was betting this group to not be party animals. A few weeks later, my cousin called me to say he had had dinner with this family and they could not understand how we could be first cousins. The yin and yang of my family.

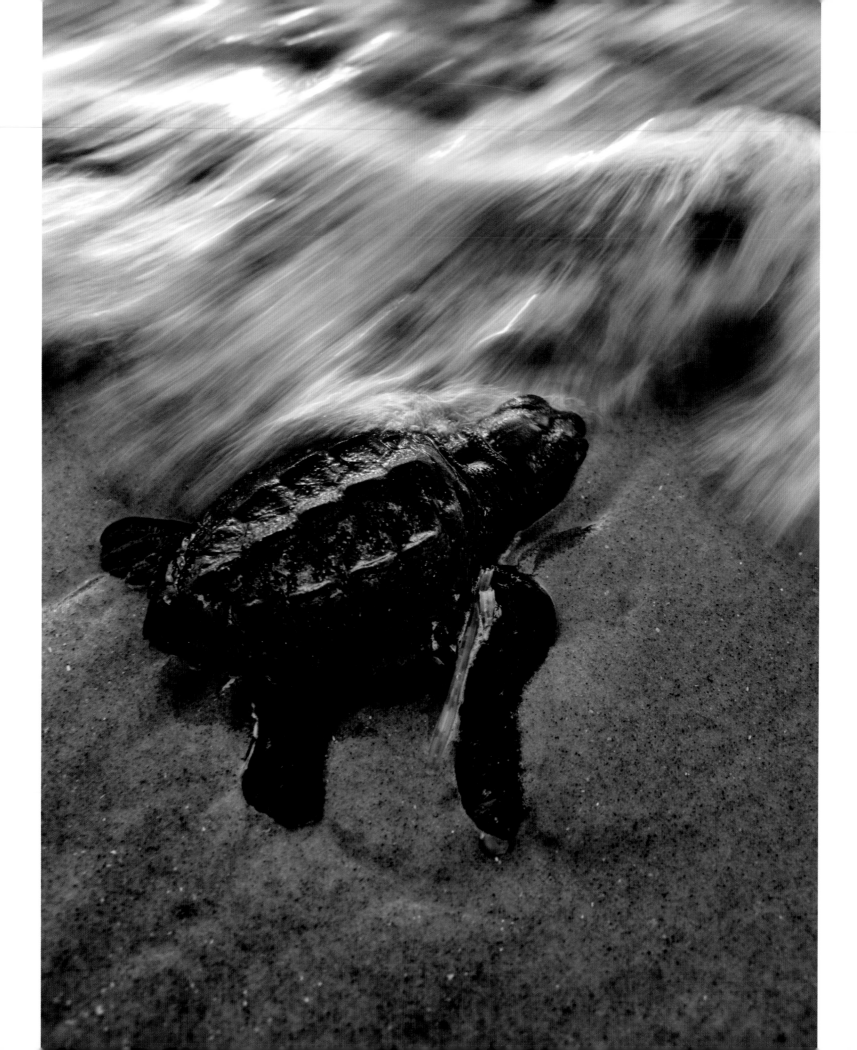

Padre Island, 2007

◄◄ Newly born Kemp's Ridley sea turtle, just about to finish the journey across the beach to the Gulf of Mexico at Padre Island National Seashore.

◄ This turtle came up to the viewing glass in a tank at Sea Turtle, Inc., at South Padre Island and posed for the camera.

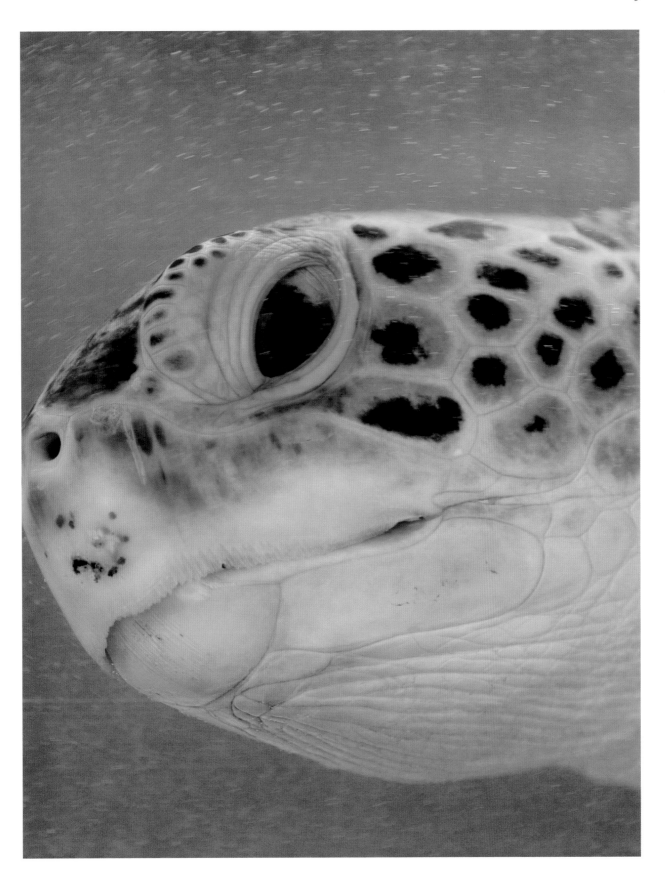

Kemp's Ridley Sea Turtle Release, Padre Island National Seashore, 2007
At 6:00 a.m., I walked into the dimly lit room with rows of ice chests, each holding about 150 turtle eggs. A volunteer was singing a happy turtle song to recently hatched turtles before they began their trek across the beach into the Gulf of Mexico. Kemp's ridley turtles must cross the beach into the ocean waters so the females will know where to return to lay their eggs in about twenty years.

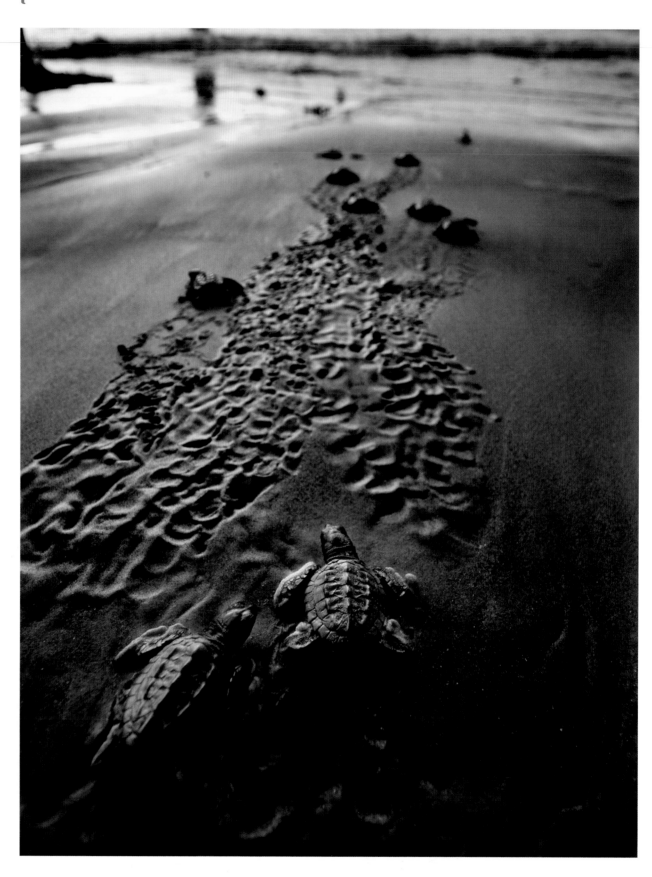

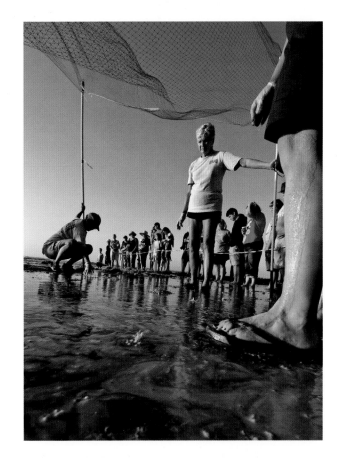

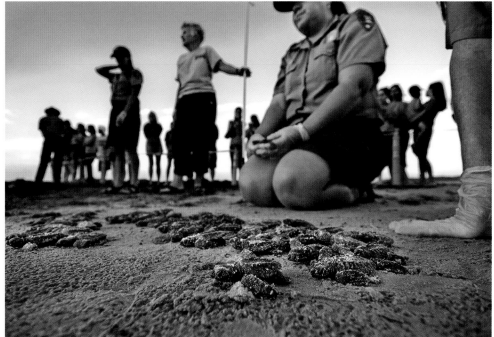

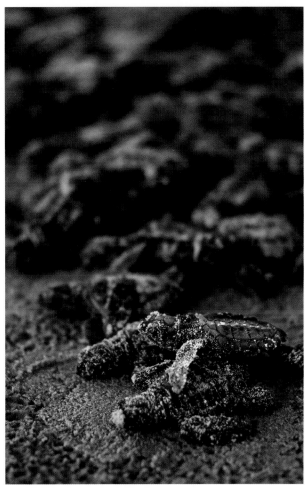

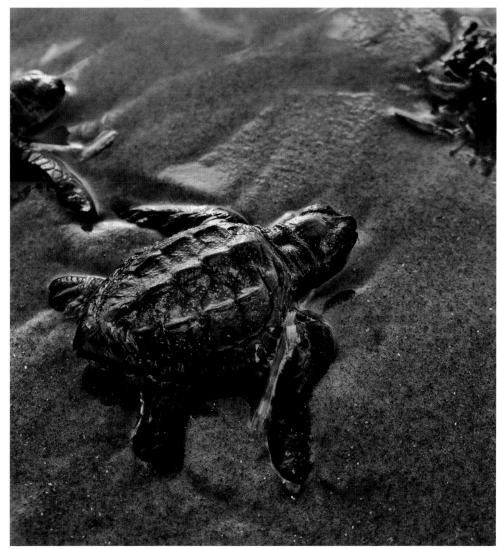

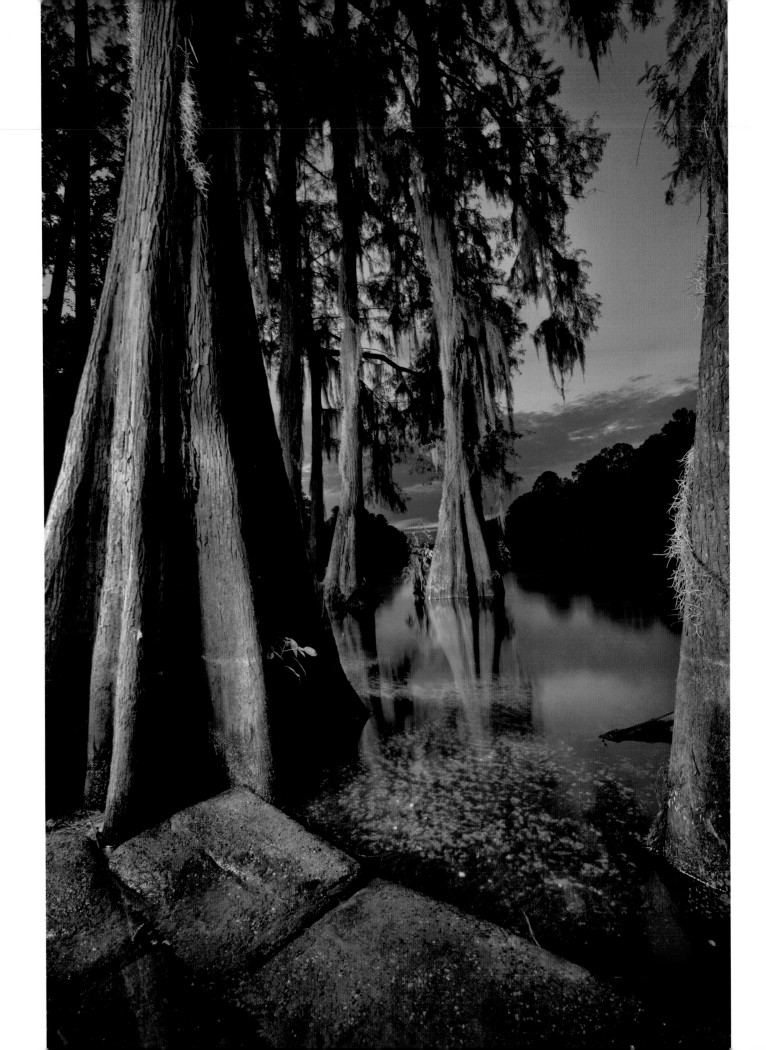

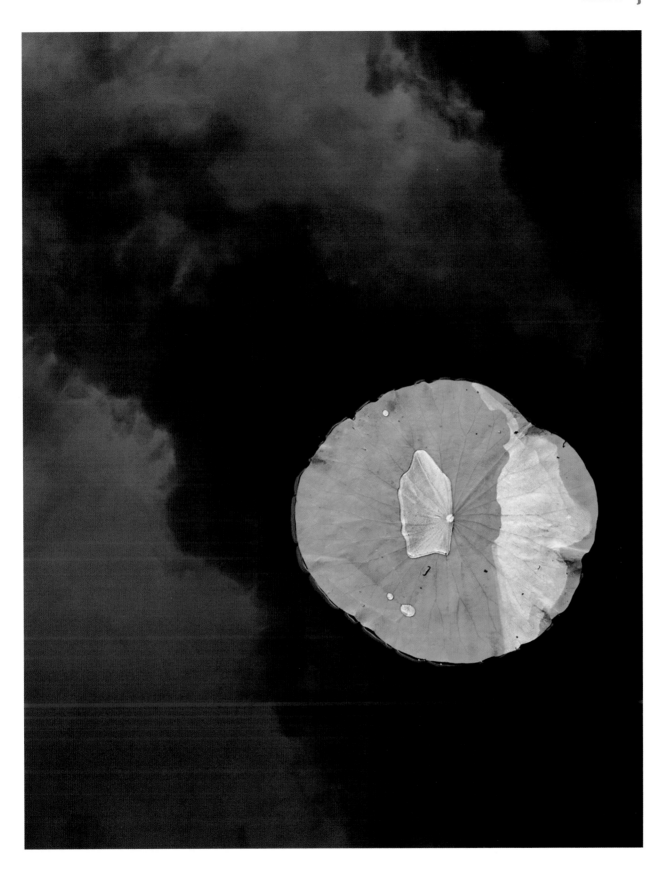

Caddo Lake, 2013
Dusk falls on the still waters and bald cypresses of Caddo Lake— my new favorite place to explore in East Texas. Caddo Lake's dense forest, draping Spanish moss, and murky waters made this spot perfect for our special haunted issue. For this image, some new friends assisted me in light painting these bald cypresses. A lily pad floats dreamily on the lake's surface.

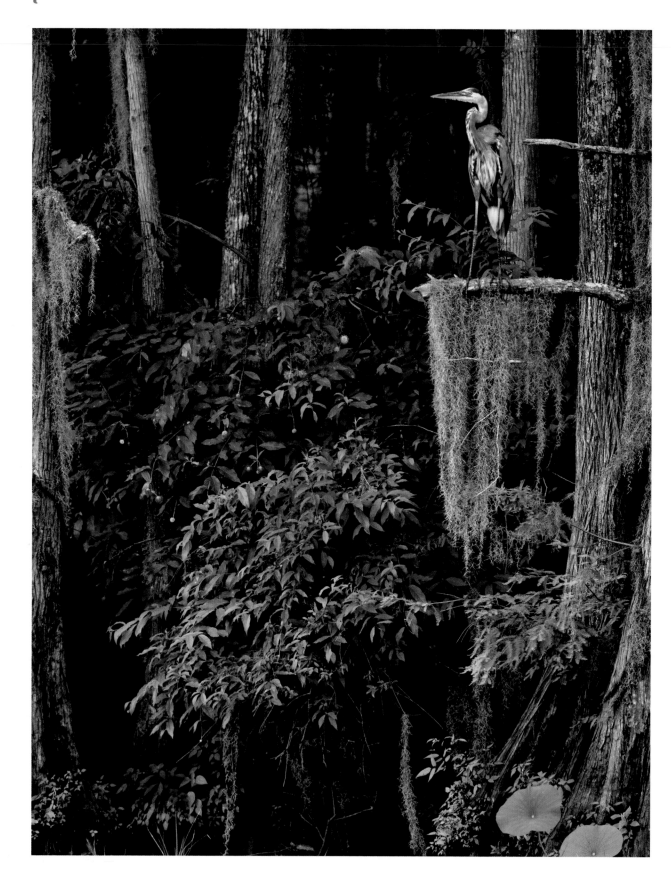

Caddo Lake, 2013
I captured these primor-
dial scenes on a boat tour with
George Cox, a local lake guide
at Caddo Lake. George, who
gives tours of Alligator Bayou,
says the biggest gator he's seen
on the lake stretched some 15
feet.

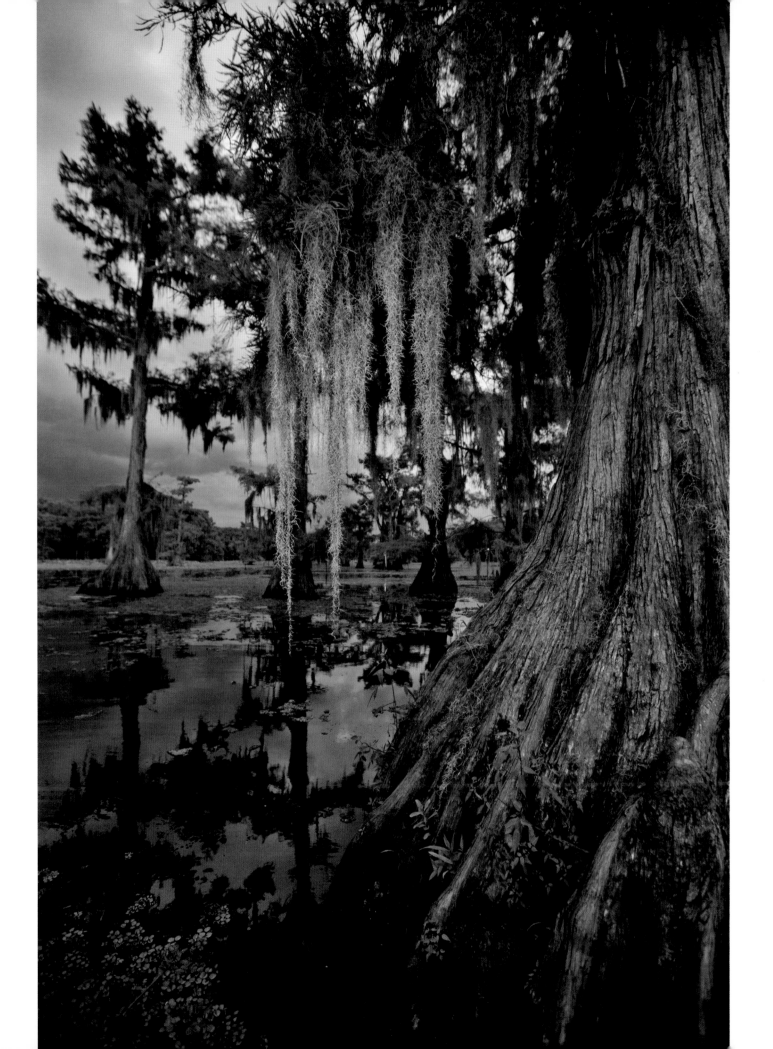

PLACES

I'm one of the lucky ones. It's my job to experience the vastly different places across Texas. Traveling as much as I do, and talking with people who have created destinations that they want to share with the public, has turned me into a real Texas tour guide. I'm always recommending places for my friends to take their wives, kids, parents, or other family members on a trip. And you know what? There are so many types of places in Texas that fit many different, individual personalities and occasions that I never stop finding new destinations to recommend.

In this section is a collection of the more photogenic places I have covered while on assignment for *Texas Highways*, such as Terlingua, Marfa, Jefferson, Mountain Home, Corpus Christi, Canyon, Amarillo, and Cranfills Gap, to name a few.

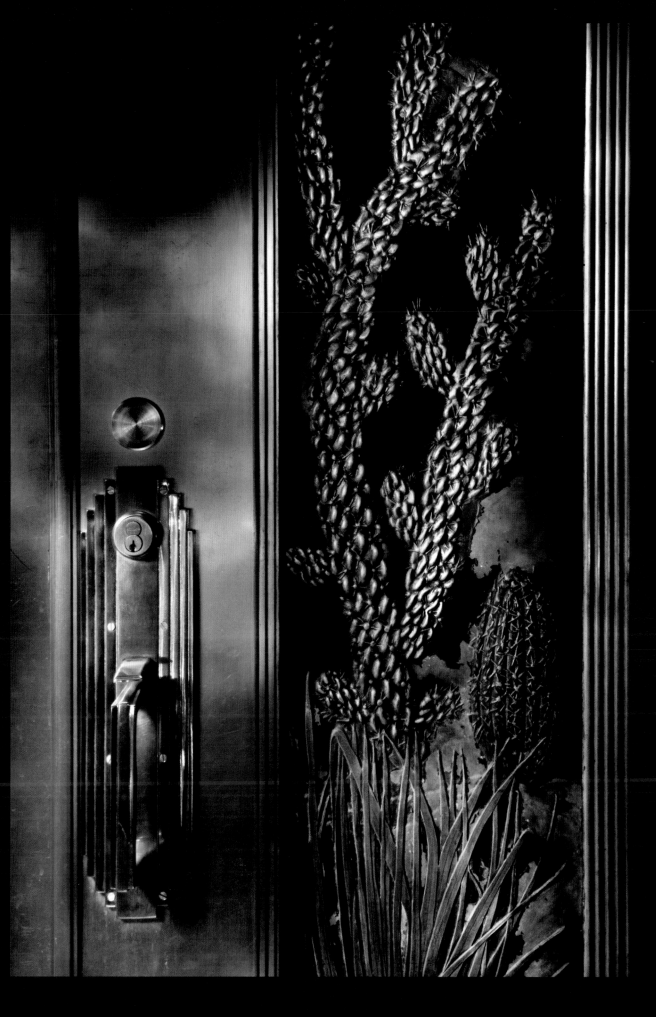

Art Deco Door, 2009
This Art Deco door at the Panhandle-Plains Historical Museum in Canyon is propped open during operational hours, so unless you look behind it, you'll miss this cool carved feature. One of the things I love about my job is having access to these places and experiencing little surprises like this.

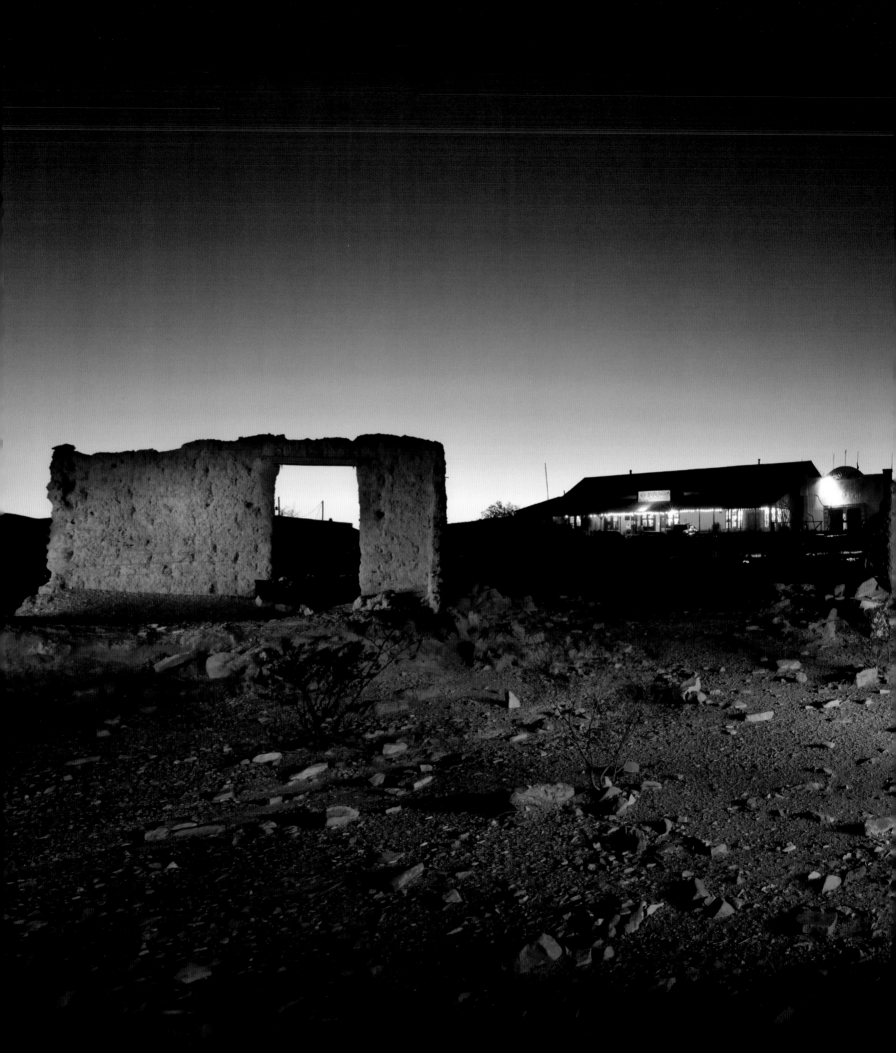

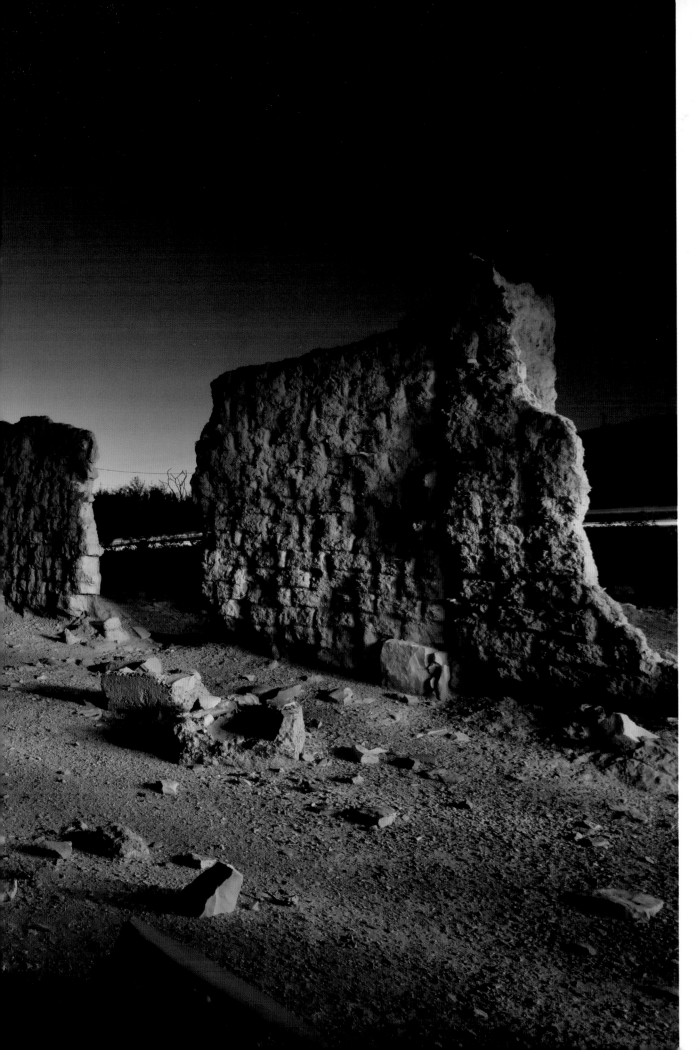

Terlingua, 2010
This is one of my best light painting photographs of Terlingua Ghost Town, taken in 2010. You can see the Starlight Theater in the background. Can you feel the adobe walls?

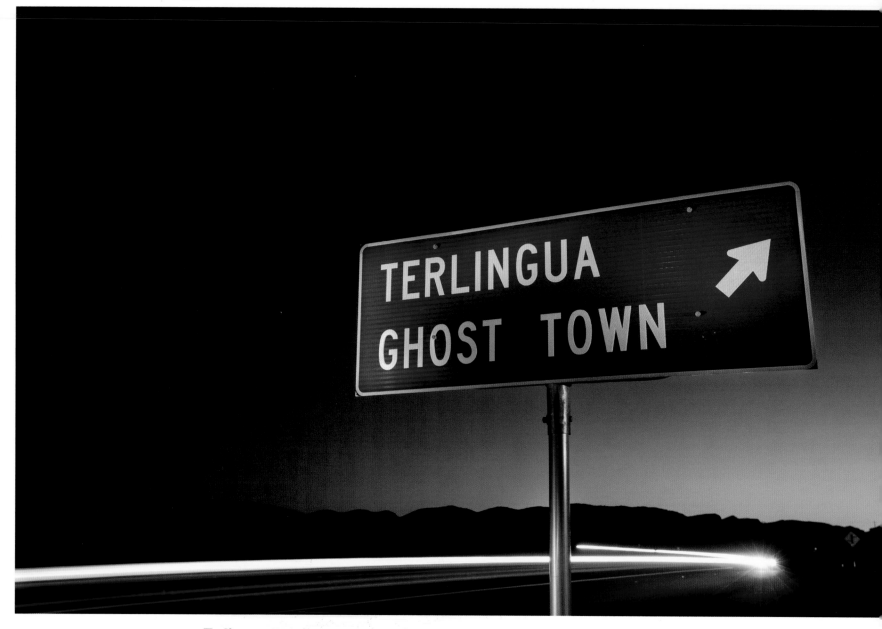

Terlingua, 2010
Terlingua is one of my favorite places to photograph, play
music, visit with old and new friends, and just recharge my
soul.

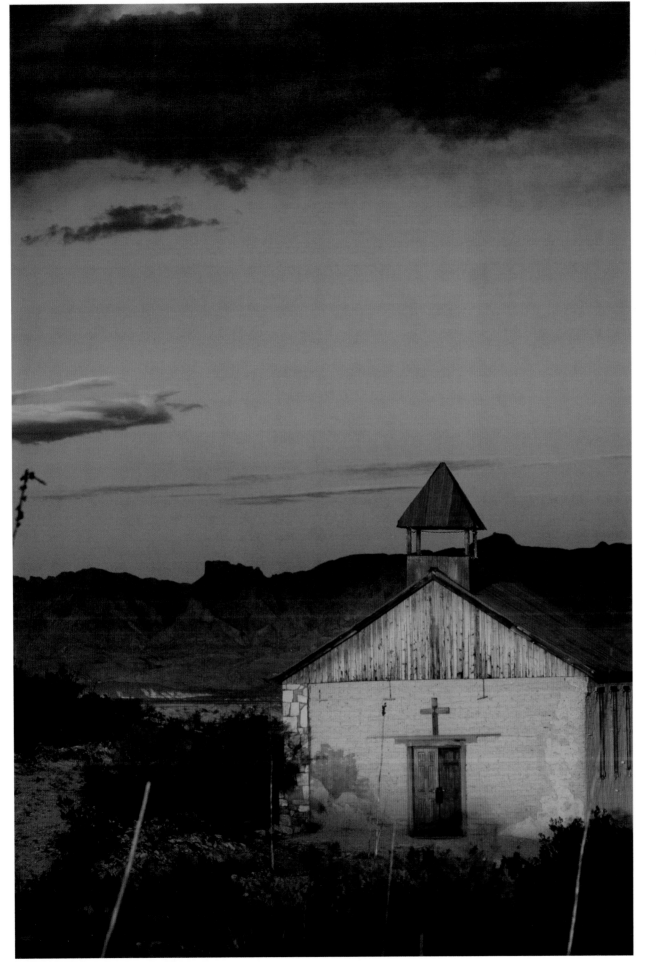

Ghost Town Chapel, 2009
This old chapel in the Ghost
Town stands out in stark relief
at sunset against the Chisos
Mountains.

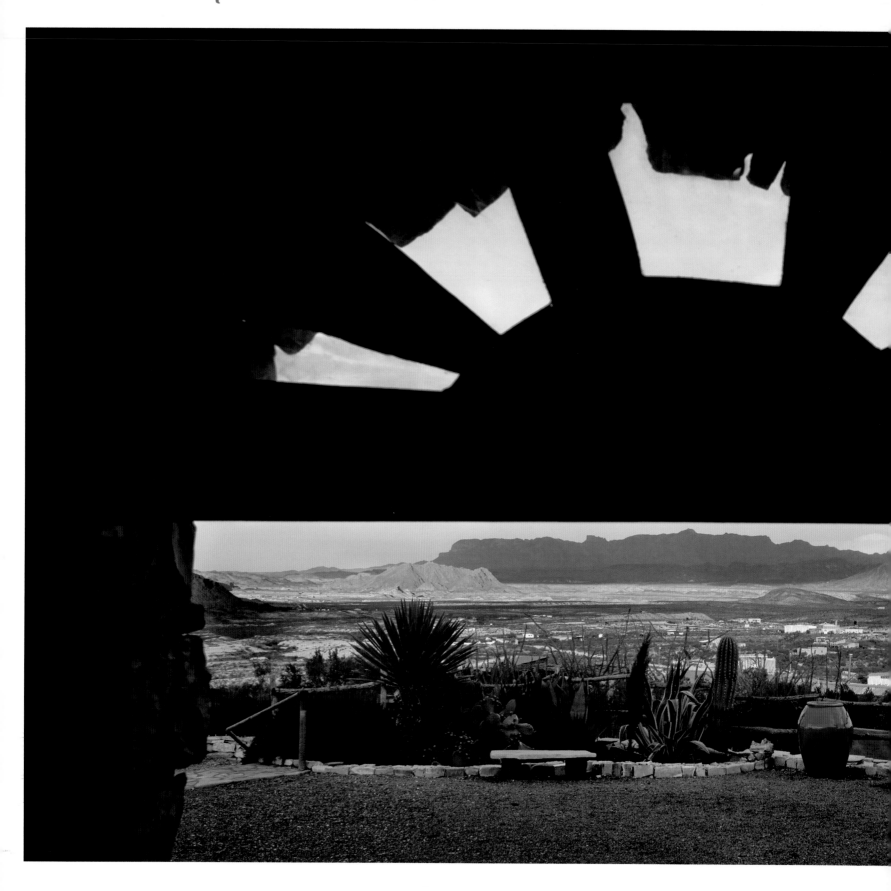

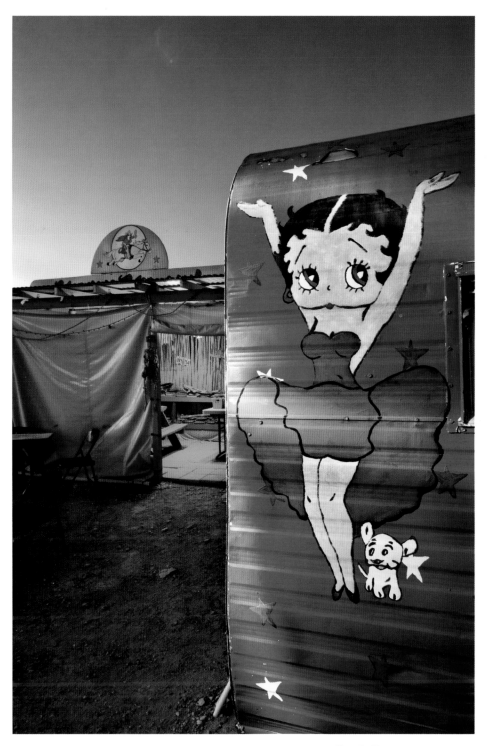

Study Butte, 2009
The Betty Boop trailer at When Pigs Fly BBQ in Study Butte always makes me smile.

La Posada Milagro Guest House, 2007
The view from the door of my room at La Posada Milagro Guest House in the Terlingua Ghost Town is ever fascinating.

Eve's Garden Bed and Breakfast, Marathon, 2007
It was like a psychedelic trip. Colors everywhere, and I love color. I painted my house in Austin deep purple, bright yellow, and teal green, and that's just on the outside.

String Chair, Thunderbird Motel, Marfa, 2007
➤➤ This brilliant orange chair caught my eye. I had no idea what this was going to look like light painted, but I had time to play. I was pleased with the result. My creative well was filled. Notice the geometric lines caught by the spotlight.

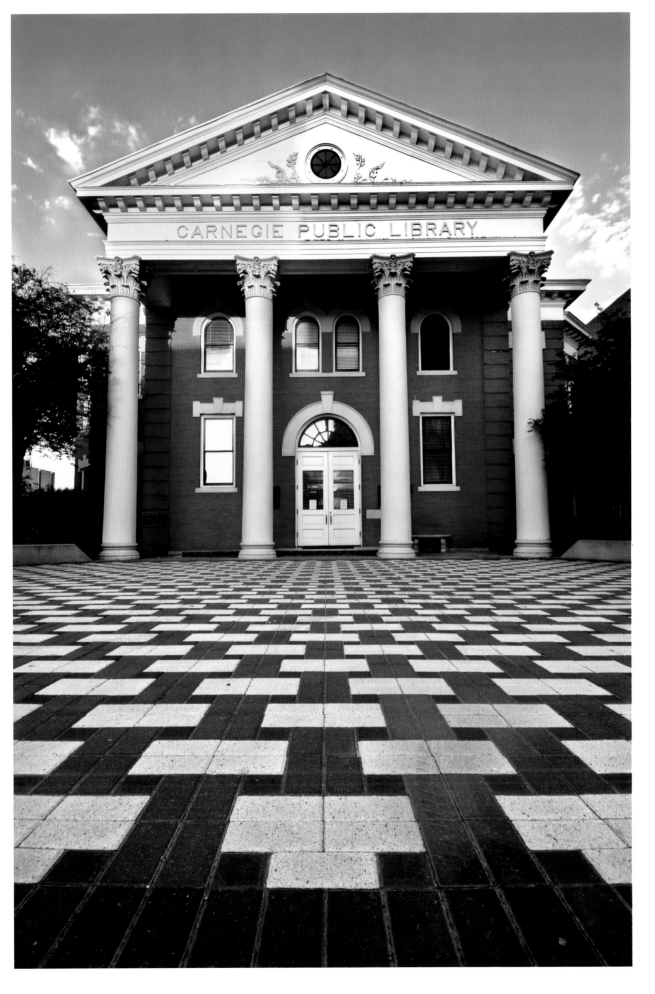

The Universe Provided, Eastland, 2010
◄◄ I was walking around Eastland with my Canon G9 point-and-shoot camera. When I saw this red classic car, the truck pulling a horse trailer, and a historic building with a Texas flag on top of it coming together before my eyes, I knew I had a strong candidate for the cover of our "True Texas" issue in September 2010.

Carnegie Public Library, Bryan, 2008
I used to go to story time at this library in Bryan when I was a small boy. I like all the geometric lines in the photo. I held the camera 5 inches off the ground to shoot with a 16-mm wide-angle lens that stretched the bricks in the foreground. Catching the last rays of sunlight on the edge of the building really played up that warm and cool color combination that I look for when composing my photographs.

The Art Museum of South Texas, Corpus Christi, 2009

The Dobson Café at the Art Museum of South Texas in Corpus Christi offers a sweeping panorama of the bay, the Texas State Aquarium to the left and the USS *Lexington* to the right. I did wonder whether these two people were playing hooky that day.

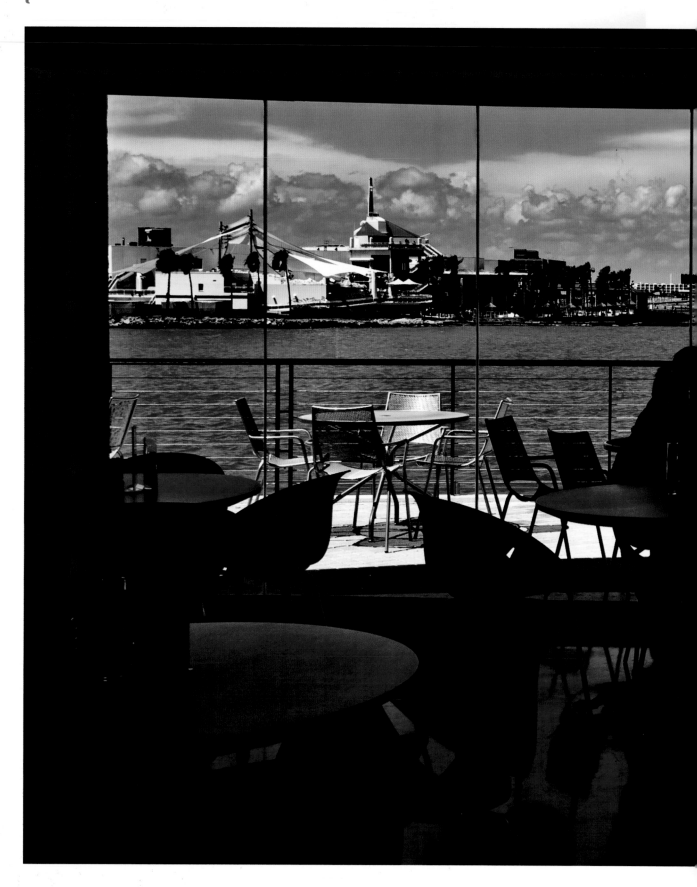

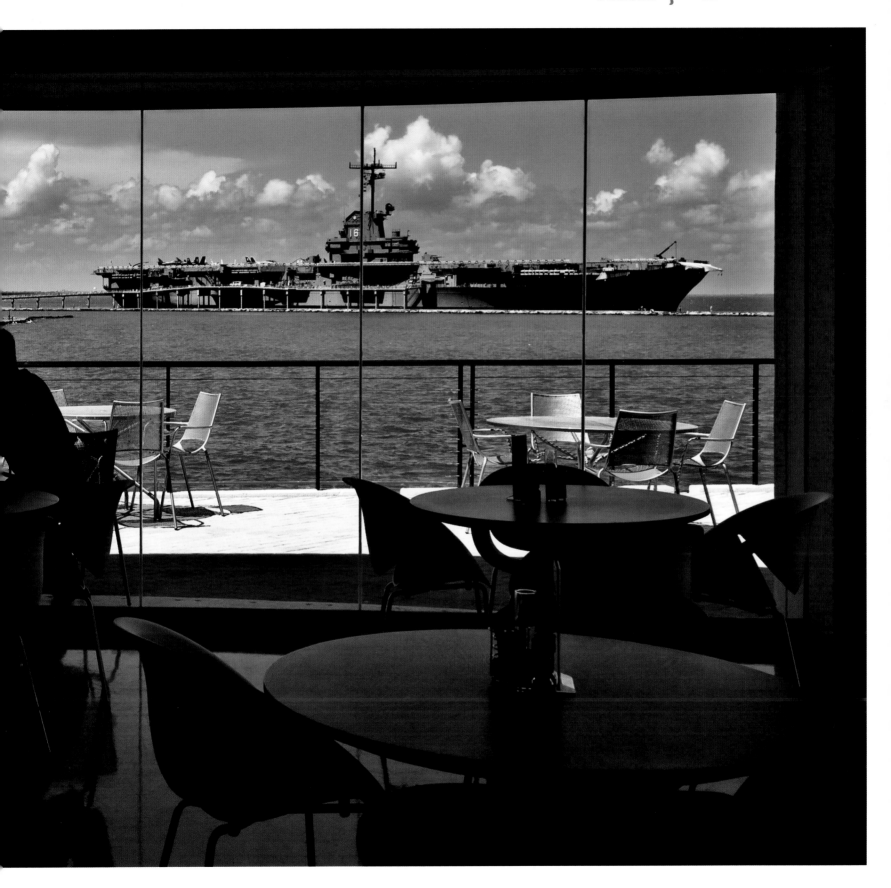

**Cibolo Creek Ranch,
Marfa, 2011**
You can take a jeep tour, go
horseback riding, swim, relax in
the spa, and enjoy the food. It is
quite a place to visit.

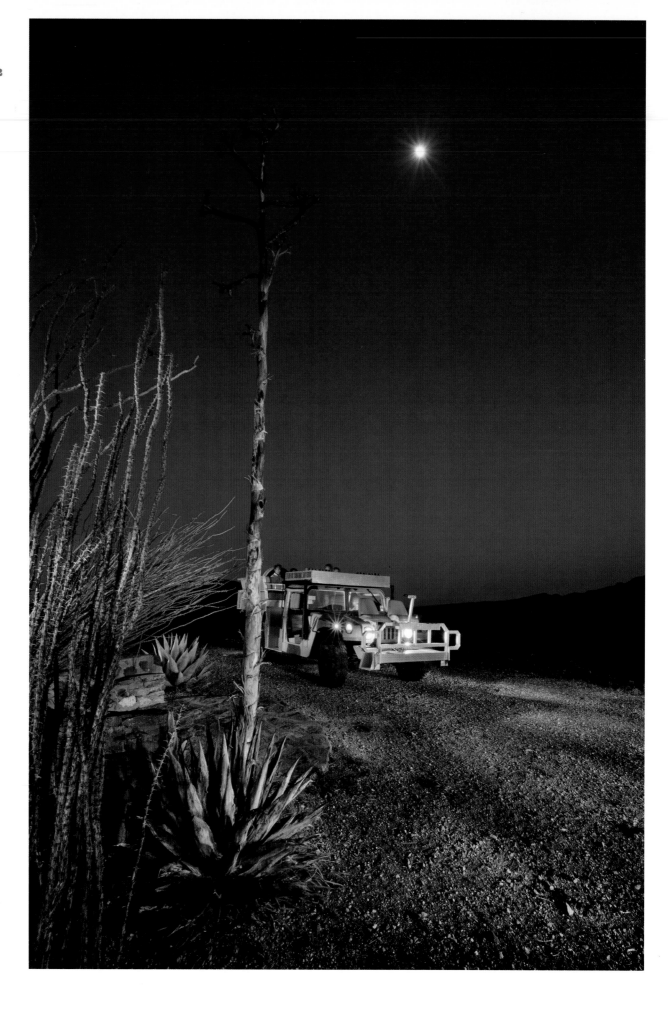

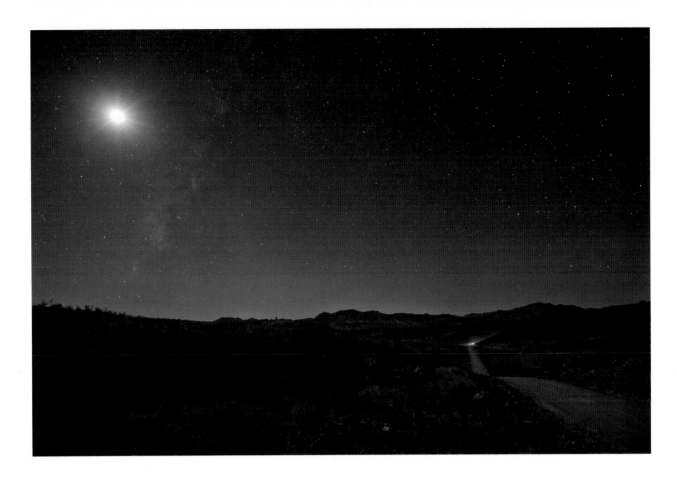

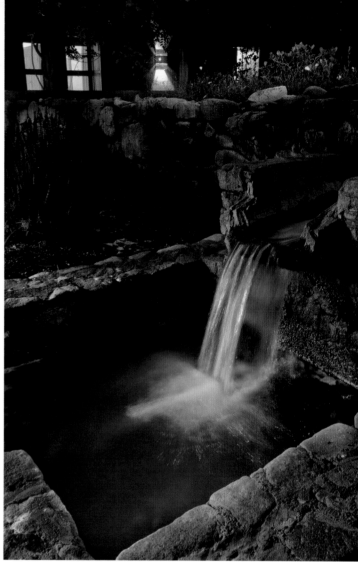

Cibolo Creek Ranch, Marfa, 2011
There are historical rooms with Native American artifacts, guns and artillery, paintings, and even a tiny chapel with a very impressive altar. The ranch is a place to recharge and move at whatever pace you want. The sound of continuously running water in the main courtyard was very soothing to me.

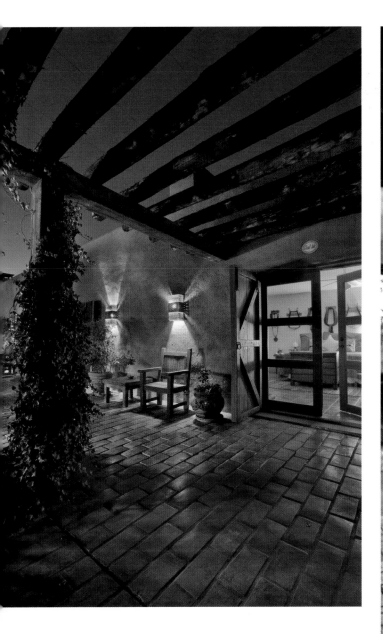

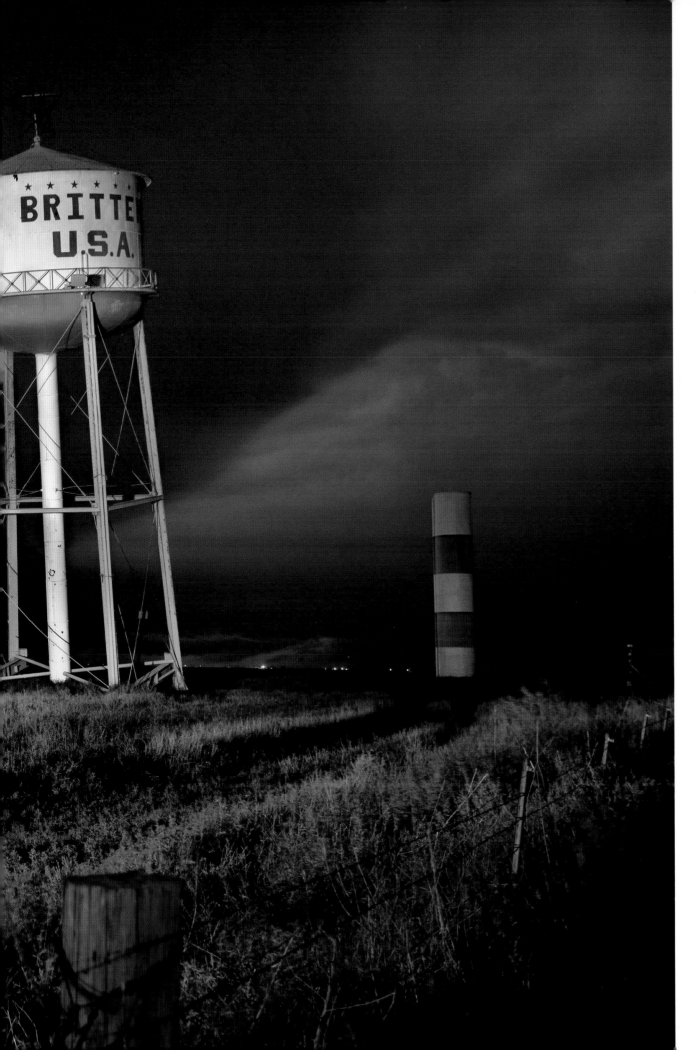

Groom, I-40, 2009

While I was shooting a story about Route 66, I kept having to dodge hailstorms. When I saw the sky turning dark, I would turn and head in the opposite direction. On my way back to Amarillo, I met up with one of those storms and used it as a backdrop to photograph the leaning water tower. I was concerned that the sheriff might stop—as they have in the past—and ask me what I was doing running back and forth, shining my two spotlights on the tower at 10 p.m., and risk starting a conversation that might last long enough to miss the light of the storm. After I got the shot, I realized I probably should have been more concerned about snakes in the tall grass. I was lucky.

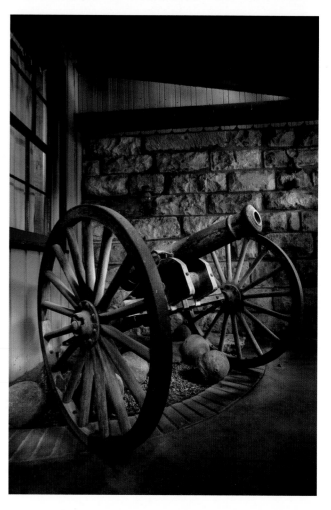

YO Ranch, Mountain Home, 2010

I had a blast light painting some of the walls and rooms at the YO. I was so tired I could barely stand up. While I was there, I rode in an SUV that had a gun rack installed between the driver and passenger seats. The driver told me it was a hunting rig. My thought: "Wow, you can shoot from the window." Not something I want to do, but interesting.

There's a lot of history and wonderful textures to photograph at this exotic-game ranch. Ostriches have kind of a fin on the back of their feet that can really hurt a person. I shot this very aggressive ostrich from inside the truck at about four feet away.

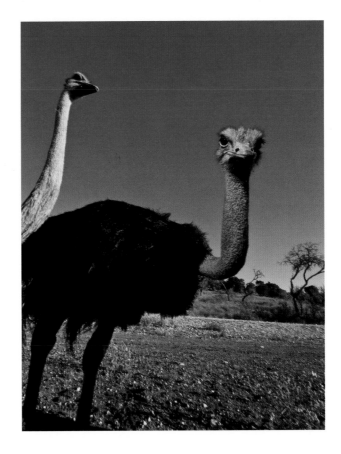

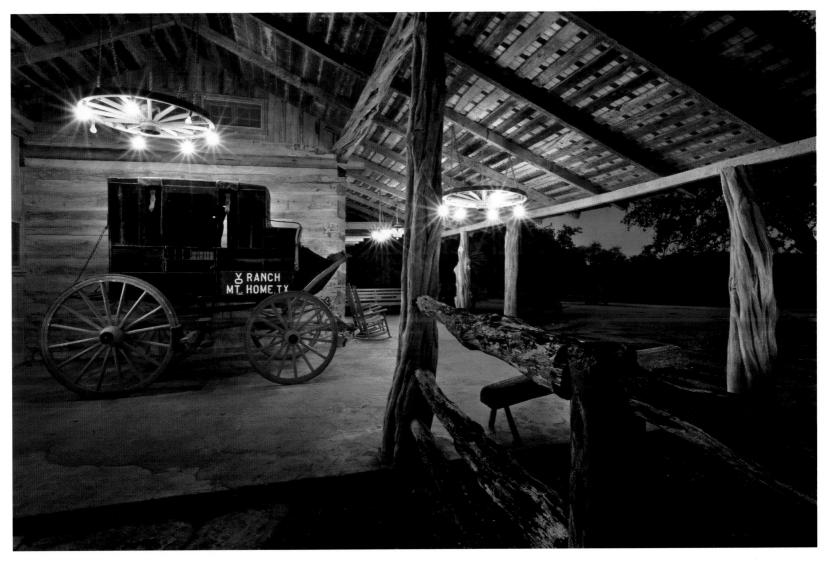

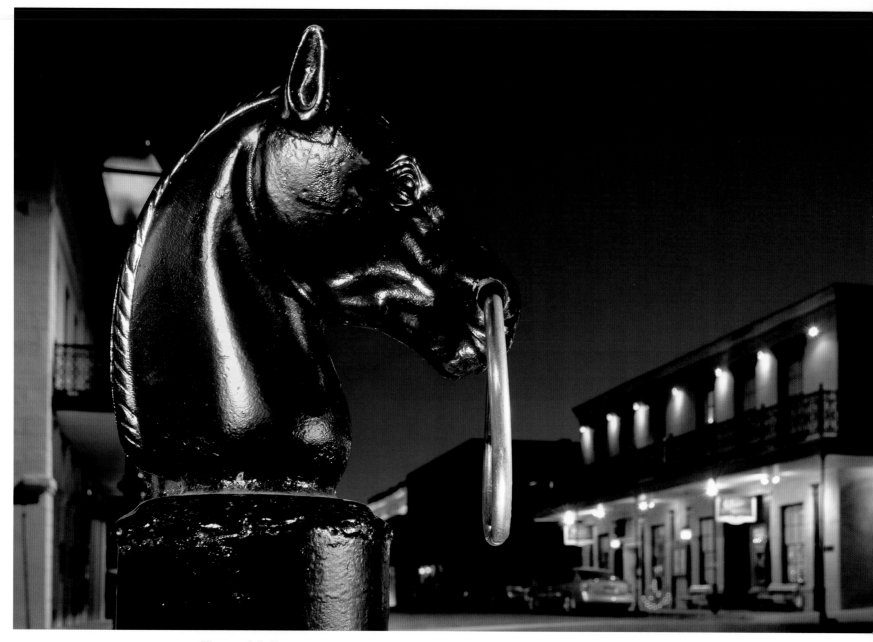

Haunted Jefferson, 2007
A horse tie in downtown Jefferson with the supposedly
haunted Jefferson Hotel in the background across the
street.

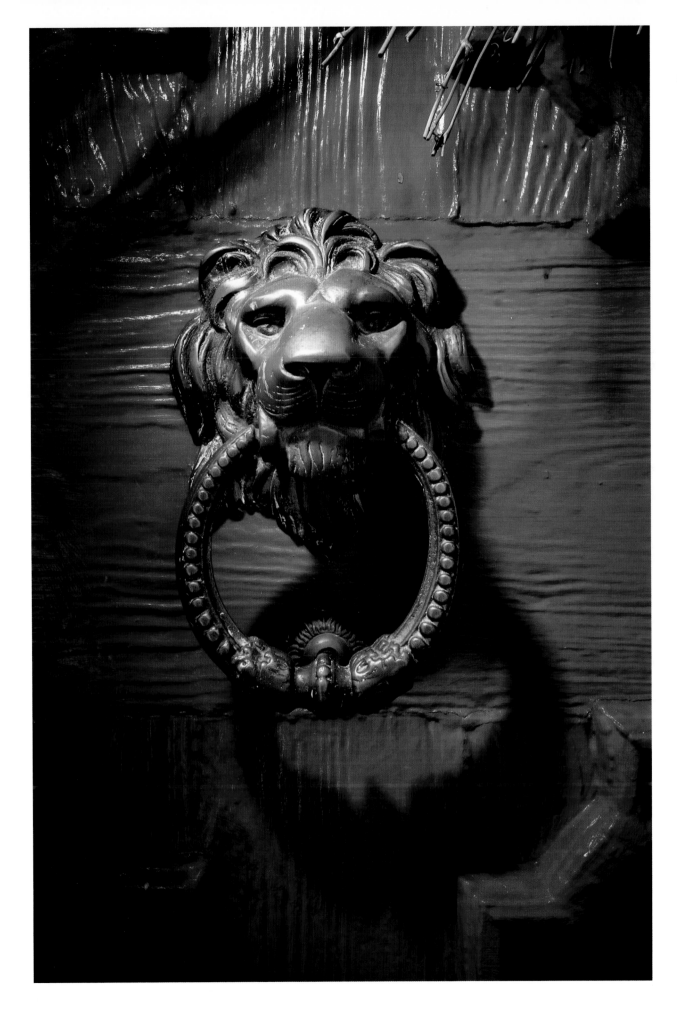

The door of one of the haunted houses in Jefferson. The restored Claiborne House, built in the 1860s, is a bed and breakfast where guests have felt strange vibes. I had an experience like that at a B&B in Milford. I woke up at 3 a.m. feeling as if someone was rocking me back and forth. As I sat up in bed, an icy feeling engulfed me. Some ghost busters I know told me a ghost had passed through me. I hope that spirit did not leave anything behind.

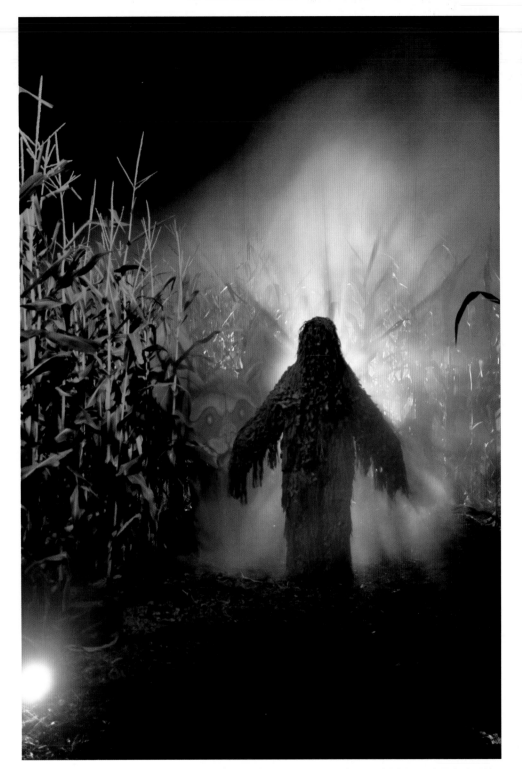

The Jefferson Scream Train, 2007

While I was working on the haunted Jefferson story, I became very frustrated because I couldn't get a good shot of the train, and the guy I thought was going to help me set up lights couldn't make it. A man walked up very calmly and asked, "How's it going?" I began to complain about no help and the briar patch I was having to work in. He said, "I'm the owner. What do you need?" Then all was good.

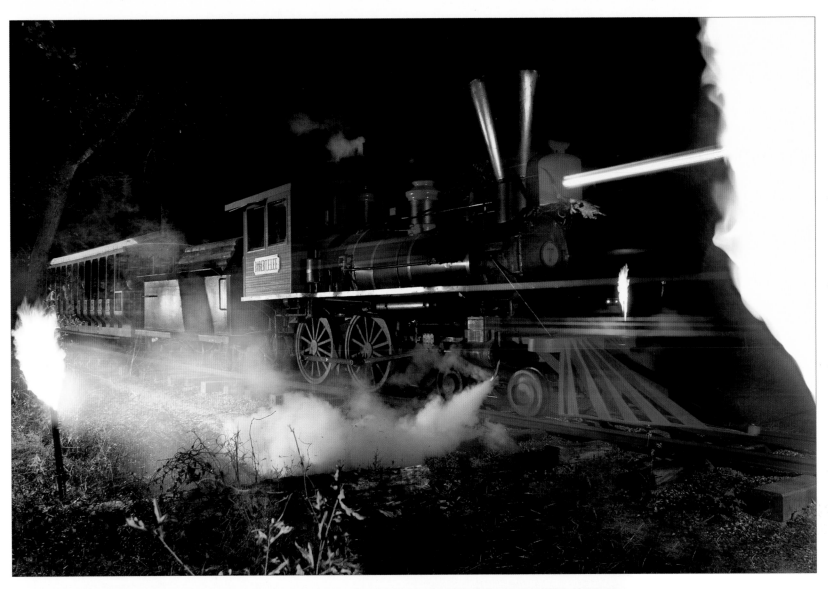

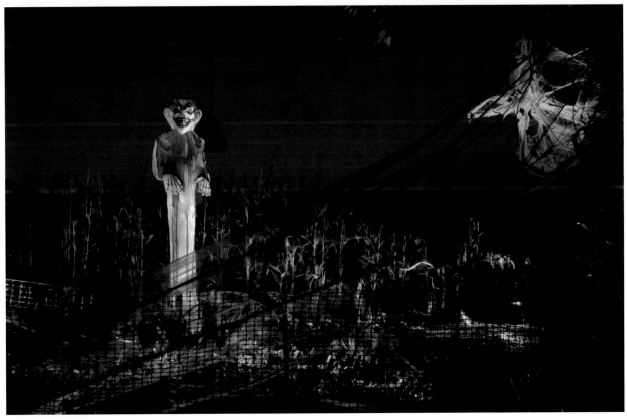

King William District, San Antonio, 2001
I lit this room at The Oge House B & B like a movie set complete with a CTO neutral-density gel over the backdoor window to balance the color of the daylight with the color and level of the interior lighting.

Norton-Breckenridge House, San Antonio, 2001
▸▸ People thought I was crazy when they saw me running out into the street with my spotlights to get this photograph of the Norton-Breckenridge House. Notice the Tower of the Americas' needle just barely visible in the background.

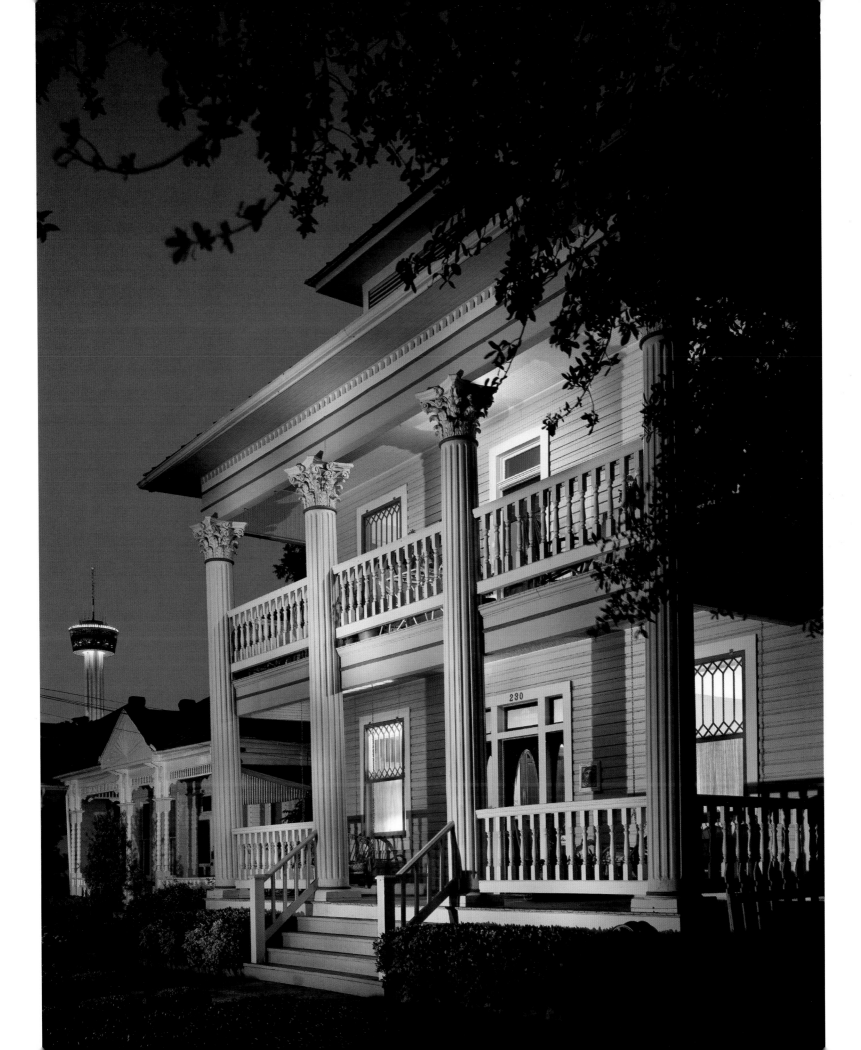

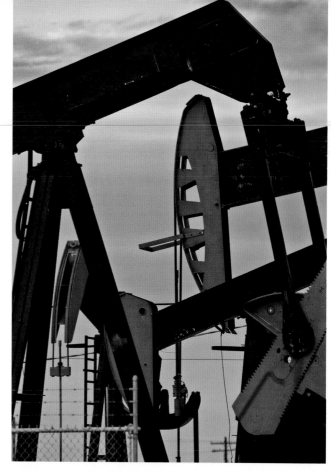

Monahans, 2009
Main Street in Monahans complete with oil wells, painted
sidewalks, and toenails.

Million Barrel Tank, Monahans, 2009

The Million Barrel Tank is a concrete pool that contained a million barrels of crude oil until it all leaked out in 1928. In 1958, Wayne and Amalie Long bought the tank with the thought that they could seal it, fill it with water, and have a lake or pond. The water was gone the next day. I suggested to the staff at the Million Barrel Museum that they get a water-balloon launcher, fill the balloons with paint, and charge folks by the balloon to paint a Jackson Pollock–like mural on the concrete walls. You should have seen the looks on their faces.

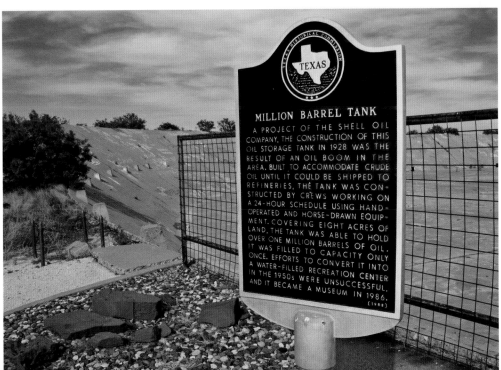

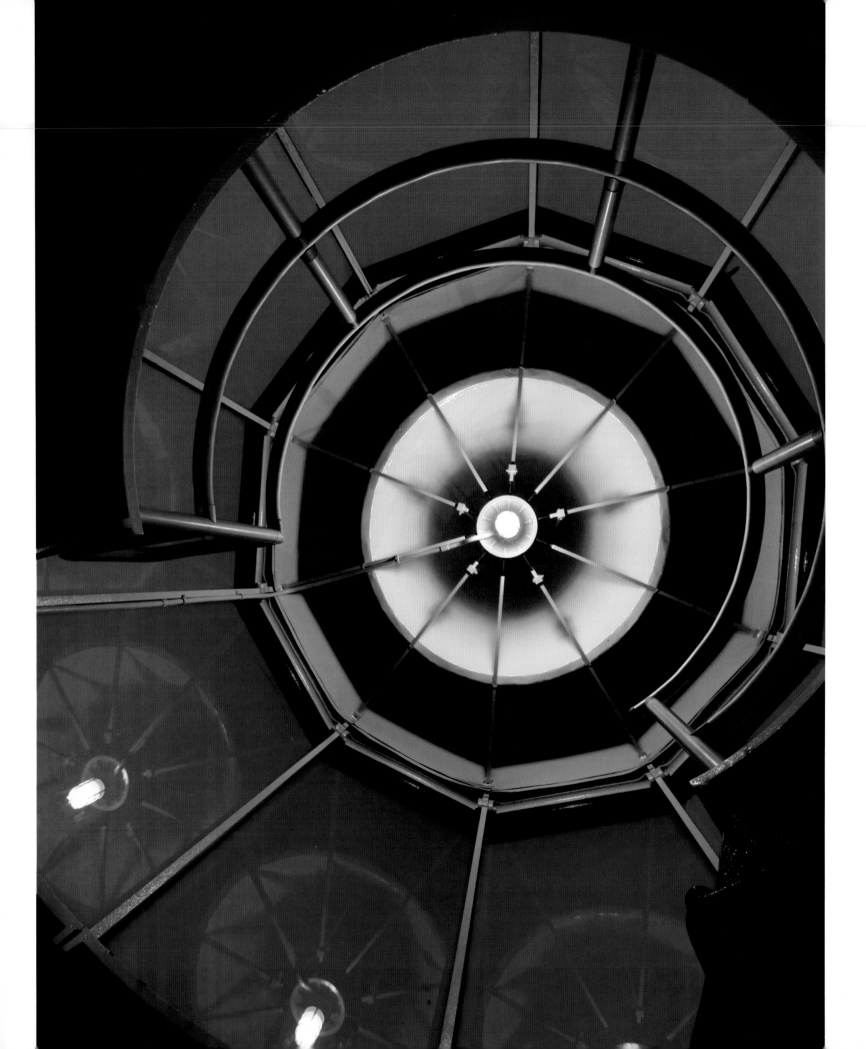

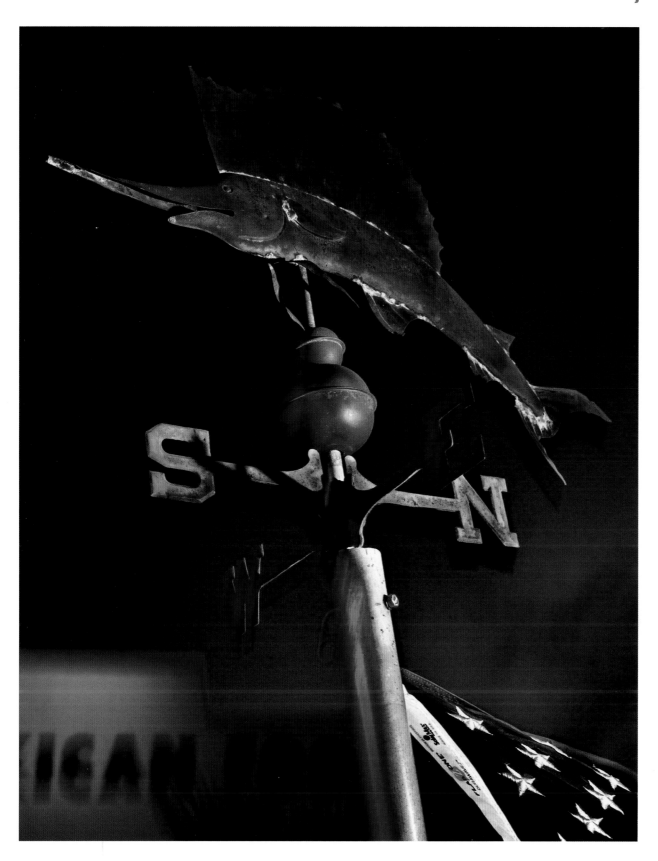

Cap'n Roy's Seafood, South Padre Island, 2007
I wanted a more interesting look, so I lit this weather vane/ flagpole with the flash from my camera during a slow, hand-held exposure that cast a shadow against the sky. Later, I indulged my other passion as I played lap steel to a few of Cap'n Roy's original songs.

Port Isabel Lighthouse, Port Isabel, 2007
◀◀ I love architectural details. I placed the camera on the floor of the Port Isabel Lighthouse looking straight up at the ceiling and sky. Wow, this shot made my day!

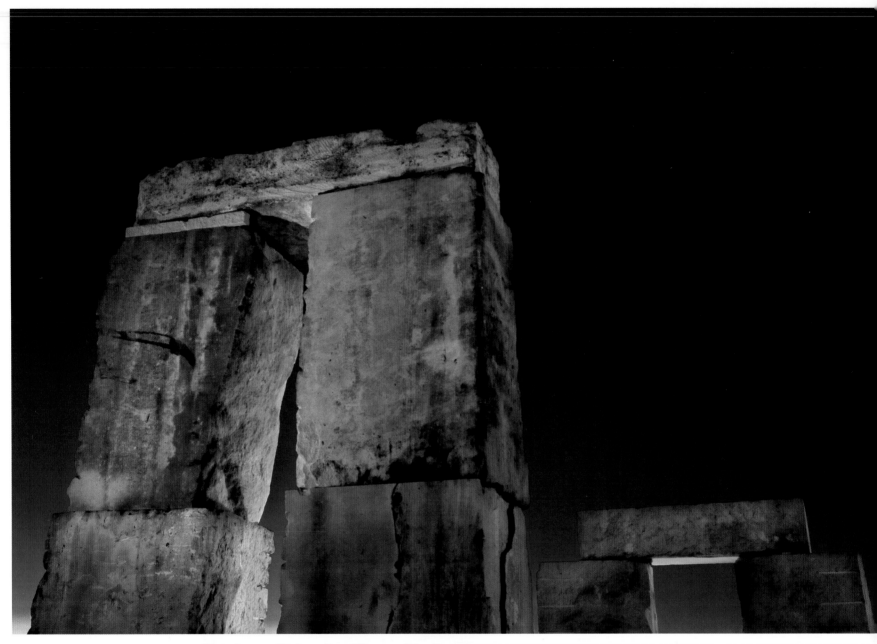

Stonehenge, University of Texas of the Permian Basin, 2003
This is the only light painting I've done where I popped a flash off several times as I walked around the structure.

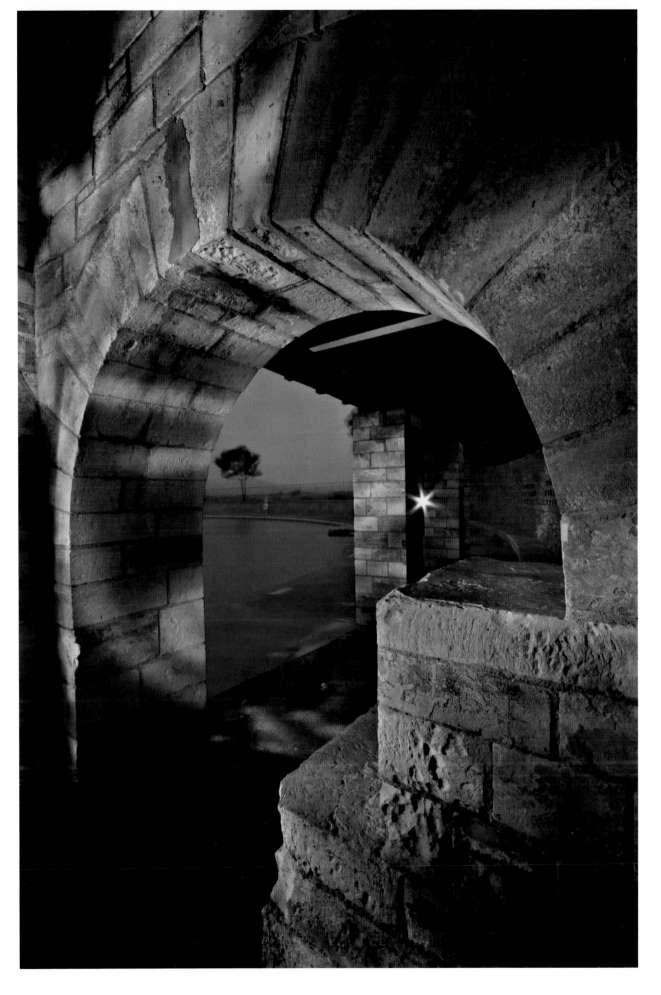

**Bathhouse, Balmorhea
State Park, 2003**
During this thirty-second expo-
sure, I light painted this image
with a spotlight while I continu-
ously moved around the scene. I
suggest that photographers keep
the light moving and run to ei-
ther side of the tripod to light the
scene to show as much texture as
possible with sidelight.

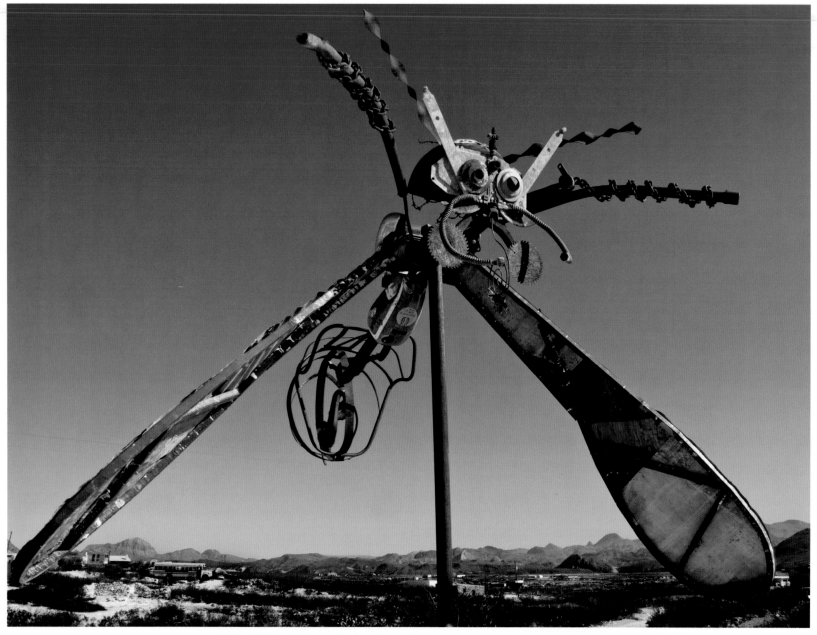

Basketball Goal, Transformed into Mosquito Sculpture. Terlingua, 2010

When I was on assignment in Terlingua, a group of news and documentary photographers were in town for a gathering/party. I was invited to join them, and in between shoots I would visit with them. Late Saturday night around a fire pit, one of them started talking about wanting to shoot for *Texas Highways*. He said that after shooting for thirty-one years, he wanted to get inspired again. I said I had been shooting that long and I still loved doing it.

He started talking about shooting this basketball goal for a project in the Ghost Town. I said, "Let's go light paint it." He said, "You mean set up lights?" "No," I answered, "that's too much work. I use spotlights and a tripod." He couldn't believe I'd been working all weekend and still wanted to do more. I told him, "I love showing people how to light paint. Let's go now."

When these seasoned news shooters saw my first exposure, they let out a long, loud WOW. I asked the guy I was talking to earlier if he wanted to talk more about shooting for *Texas Highways*. He said, "I don't know if I want to work for you or not. You are a freaking animal." He made my day.

The next year I noticed the basketball goal was gone. In its place was this giant mosquito sculpture. Only in Terlingua.

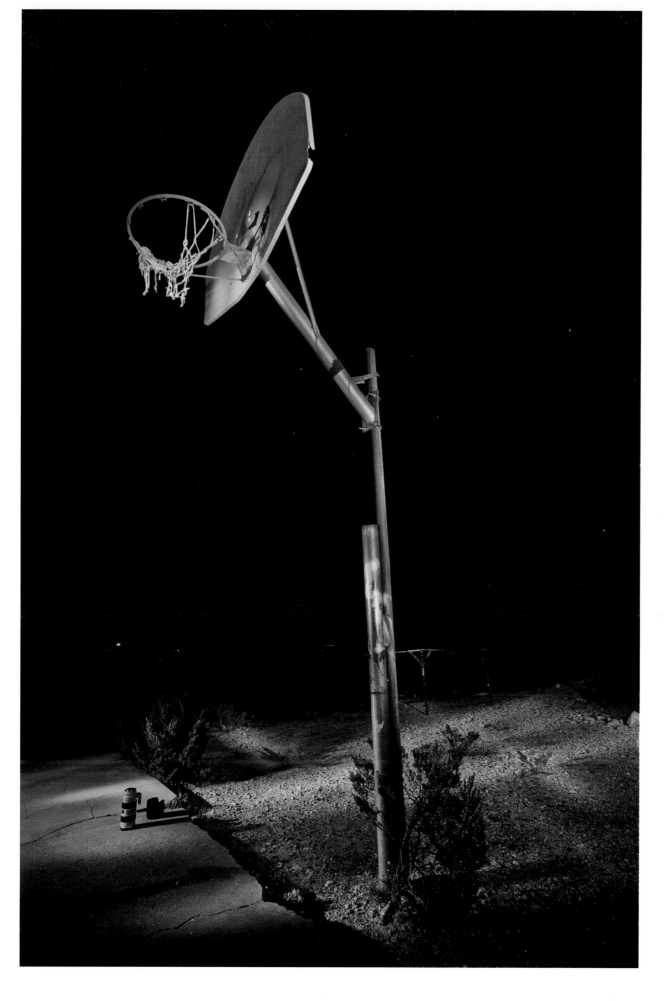

Basketball Goal,
Terlingua, 2010.

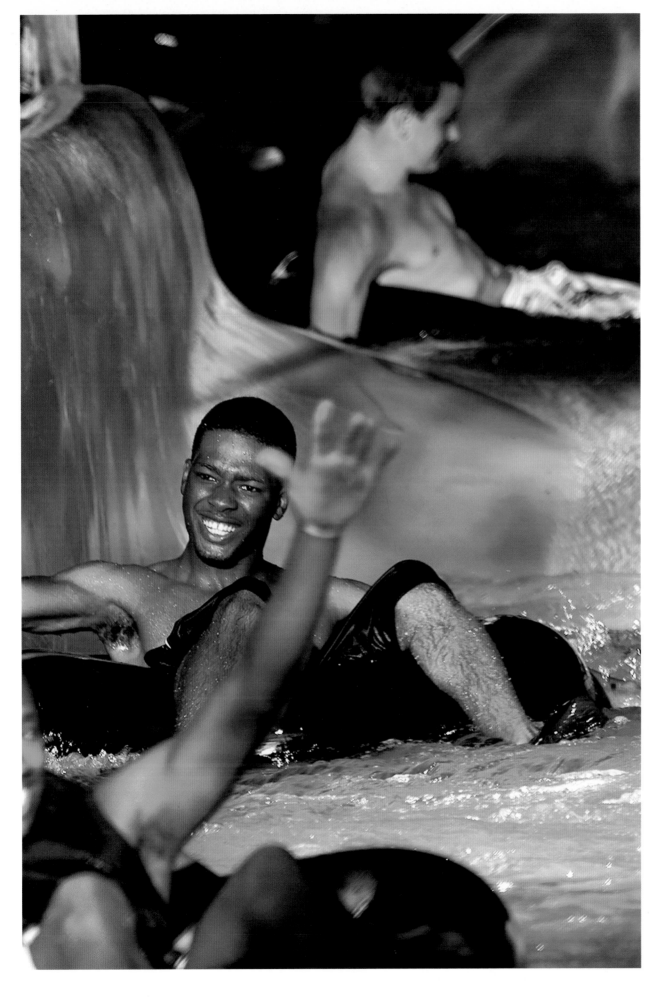

Schlitterbahn, New Braunfels, 2007
I really like it when all walks of life come together to have a good time. Schlitterbahn is a true melting pot of humanity. Maybe that description of this water park is a little too deep, but I do a lot of thinking.

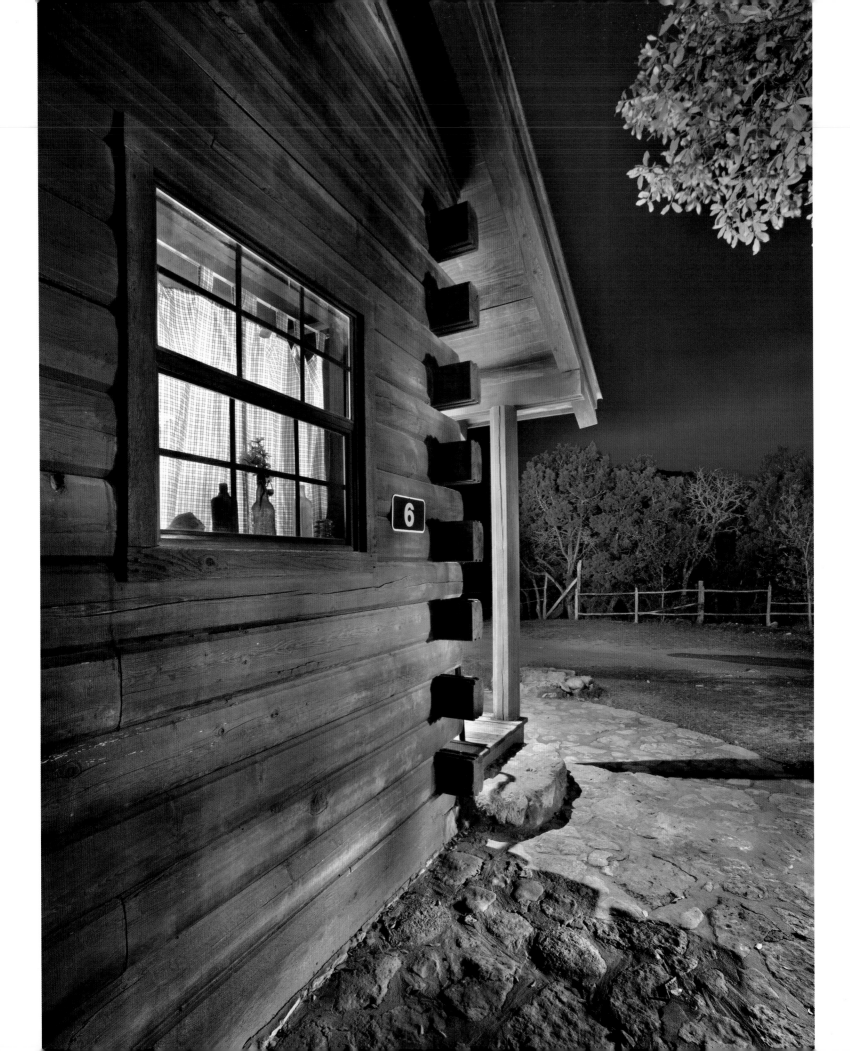

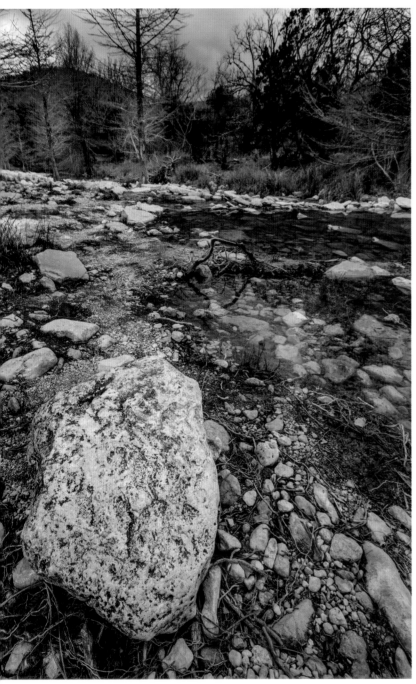

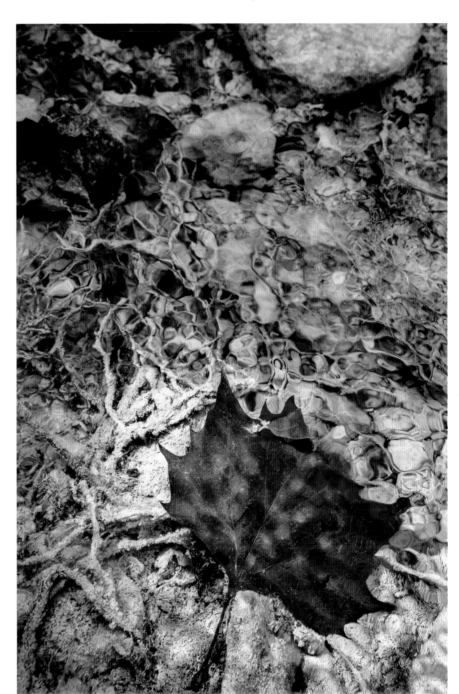

Foxfire Cabins, Vanderpool, 2013
Beautiful area, even in overcast conditions. In order to compensate for the cloudy gray day, I decided to shoot one of the cabins at twilight to get that dark blue tone in the sky and used flash to highlight the leaf and rock on the Sabinal River. I strive to do the best I can in all weather conditions.

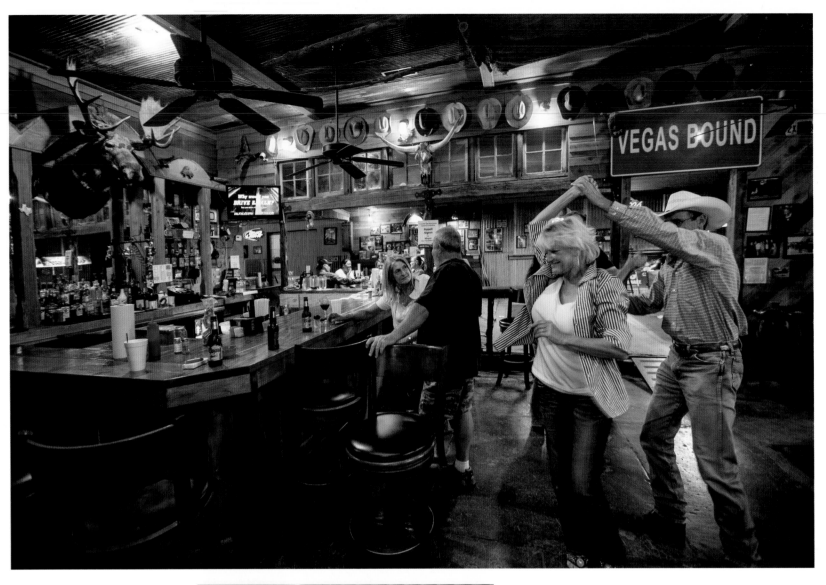

**The Horny Toad Bar and Grill,
Cranfills Gap, 2013**
Locals night is every Wednesday. I made friends for life in
that bar and was invited by several folks to stay with them on
my next visit to Bosque County.

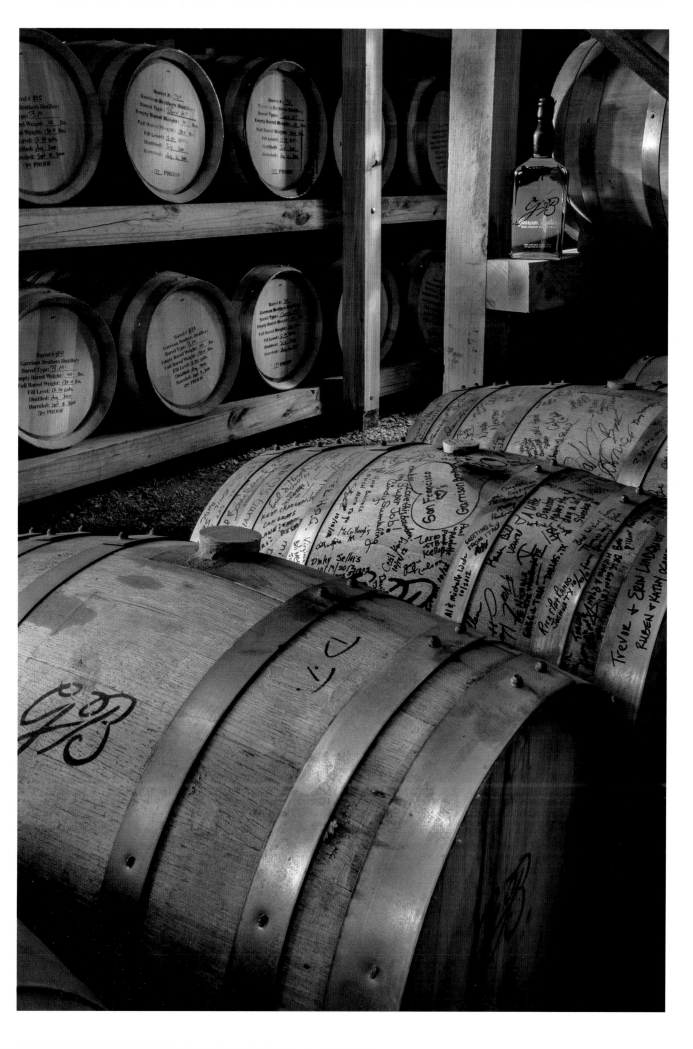

The Garrison Brothers Distillery, Hye, 2013
I placed a white card behind the bottle to reflect light through the bourbon, making it stand out from the dark wood and shadows in the barrel room. One of the employees suggested I paint an empty bourbon bottle and place it behind the full bottle. It was a good idea and worked well for some of the shots. I will remember that idea and use it again when needed. Even this old dog can learn new tricks from anyone. Photography is a practice.

The Heights, Houston, 2010
This old movie house, now an art gallery, has one of the original projectors at the entrance to the building.

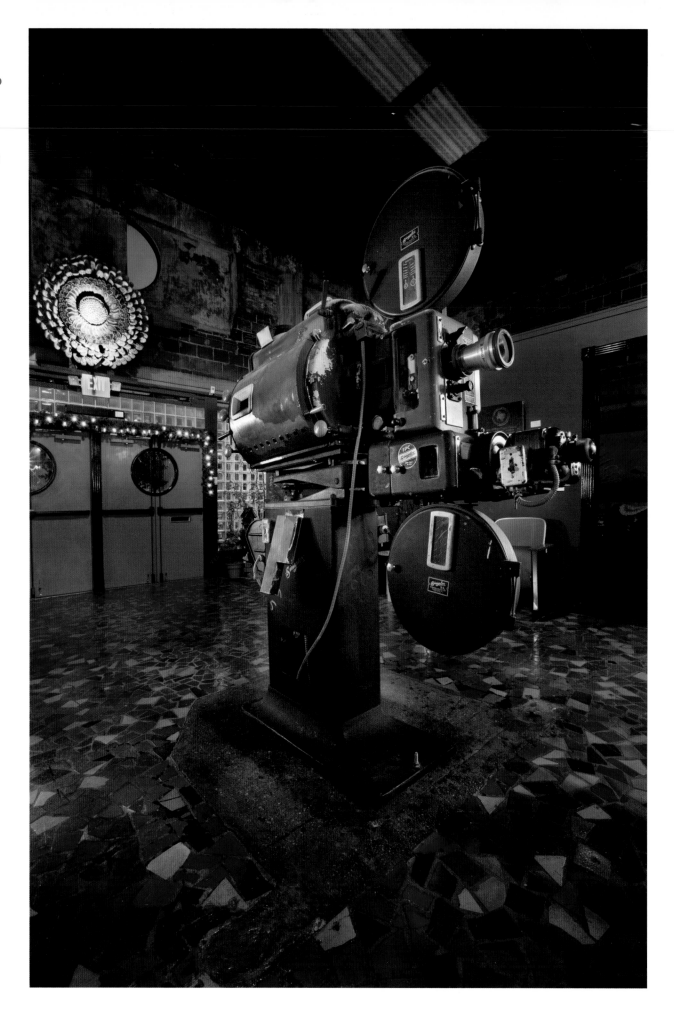

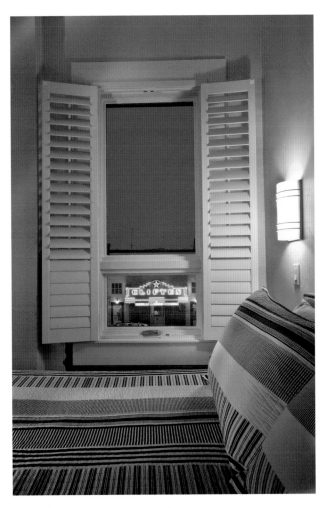

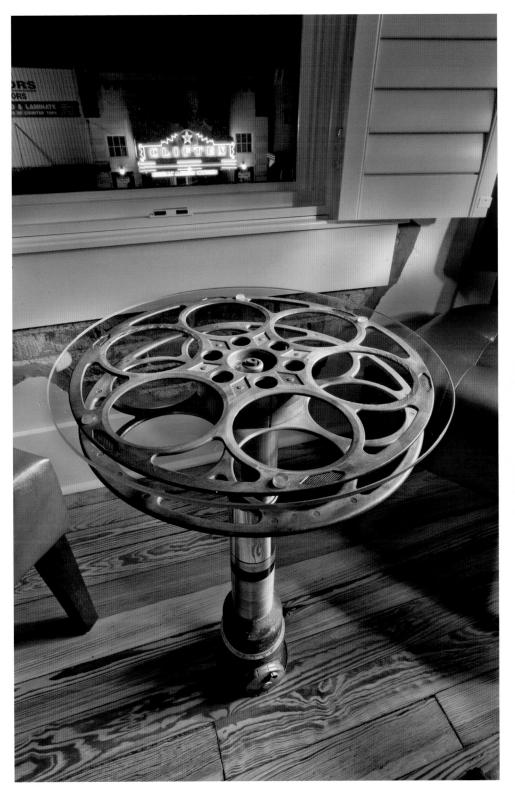

The Screen Door Inn, Clifton, 2013

If you stay in the Marquee Room at the inn, you get free movie passes to the Cliftex Theatre across the street. I really like the end table made out of an old movie projector and film reel. One of my first jobs as a kid was to load the film reels and put them in a case ready for transport on the bus to the next movie house in another town.

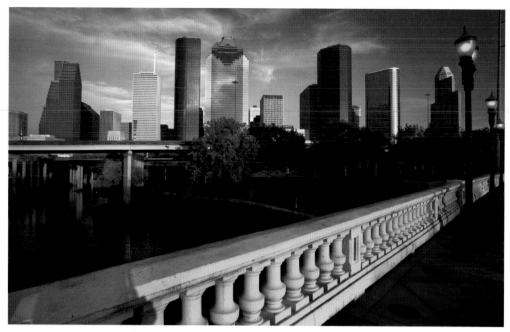

Houston, 1993–2008

On a shoot of downtown Houston, carrying my expensive equipment, several transients walked up and asked for money. I obliged—and I think they really watched my back. For *Virtuoso*, by David Adicks, I placed a flash behind an adjacent fence to create a sense of depth.

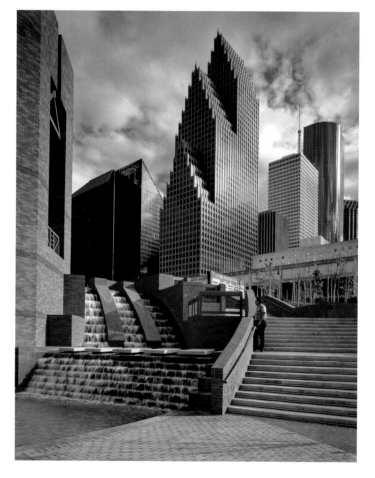

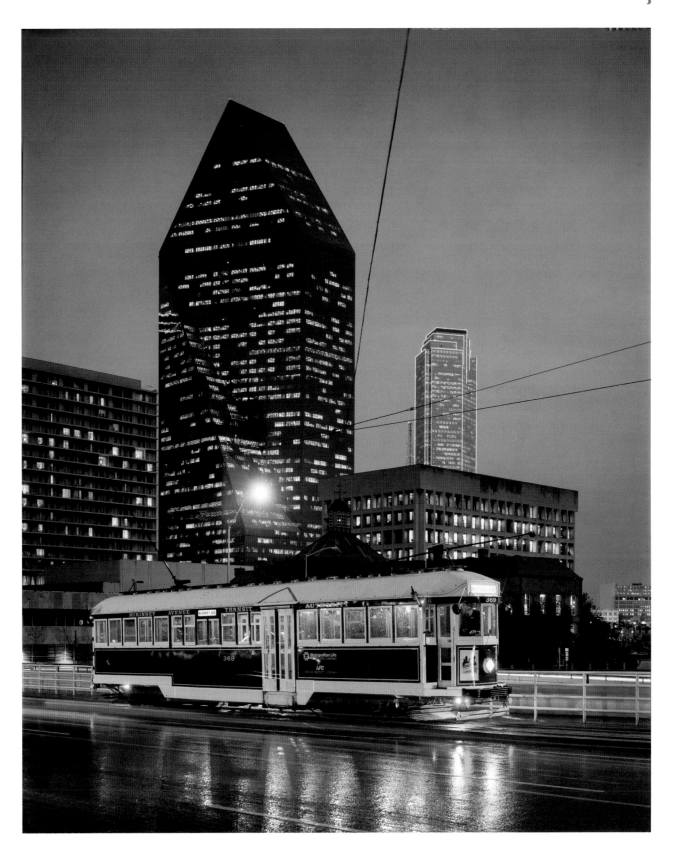

Dallas, 1994
Dallas in the rain. I stood under an umbrella so the camera would stay dry. The reflection of the McKinney Avenue Trolley on a wet Pearl Street really made this shot work.

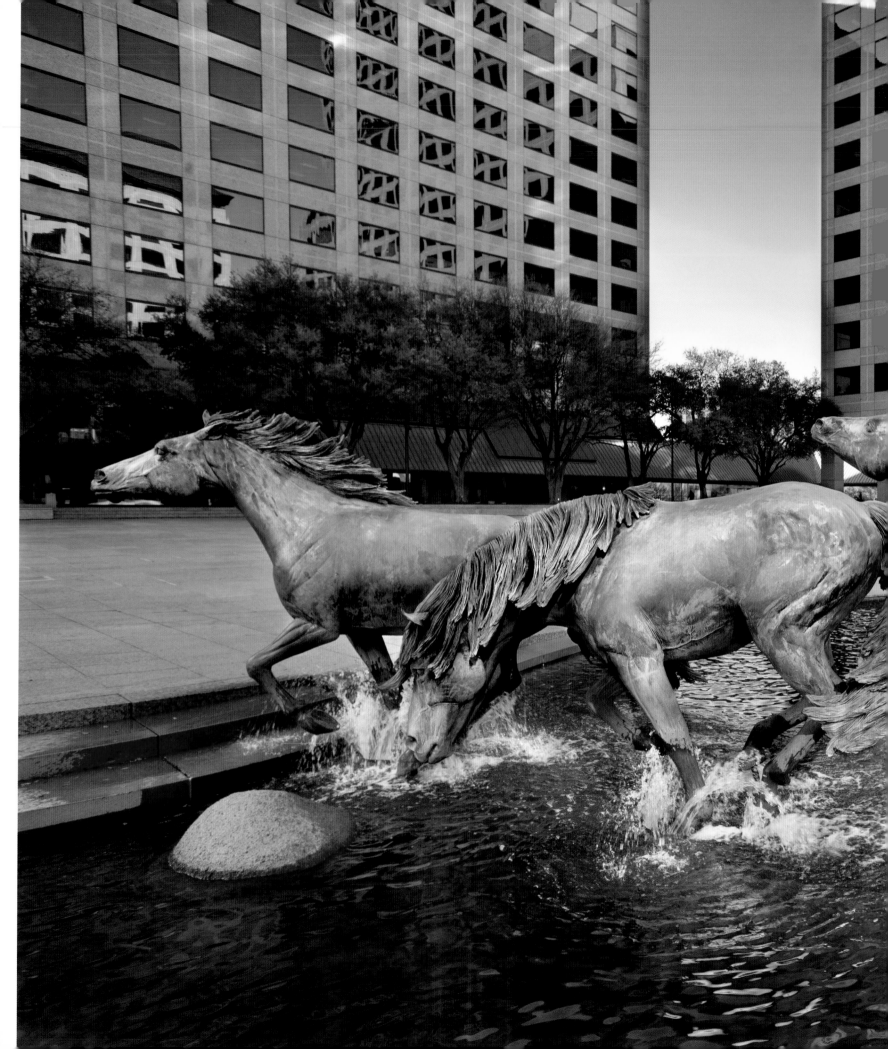

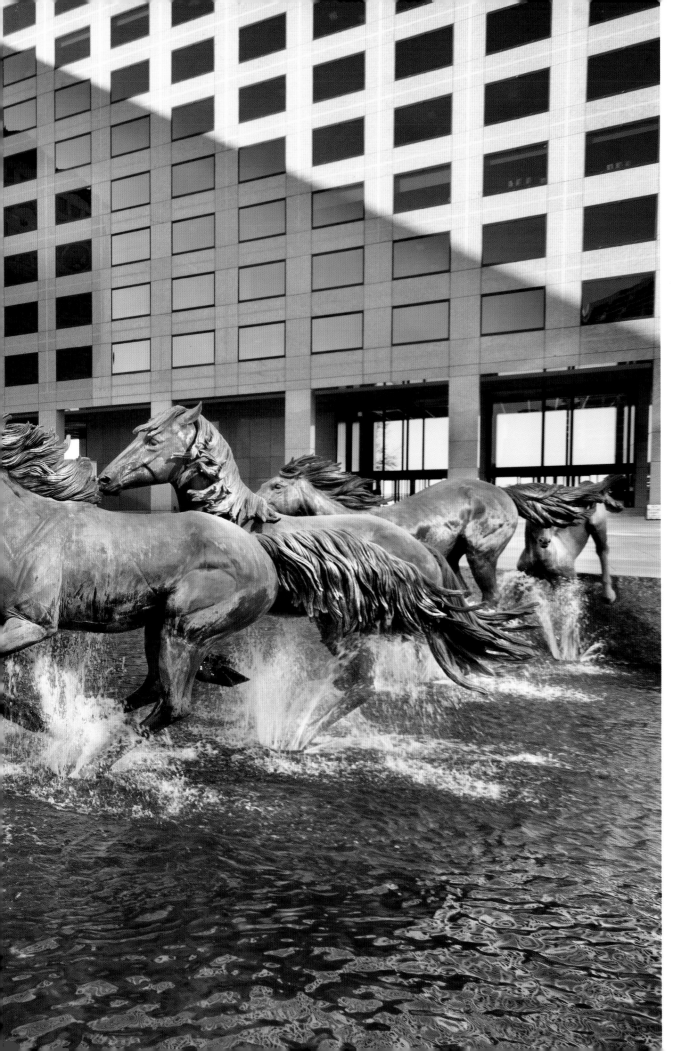

Wait for it . . . , Las Colinas, Dallas, 2011
Wait for just the right light. And in this case, I had to wait for the sun to go behind a building to capture the energetic *Mustangs of Las Colinas* sculpture at Williams Square by Robert Glen.

Weslaco, 2007
The textures, the colors. I'm always inspired by the vibrant Rio Grande Valley and its cultural influences.

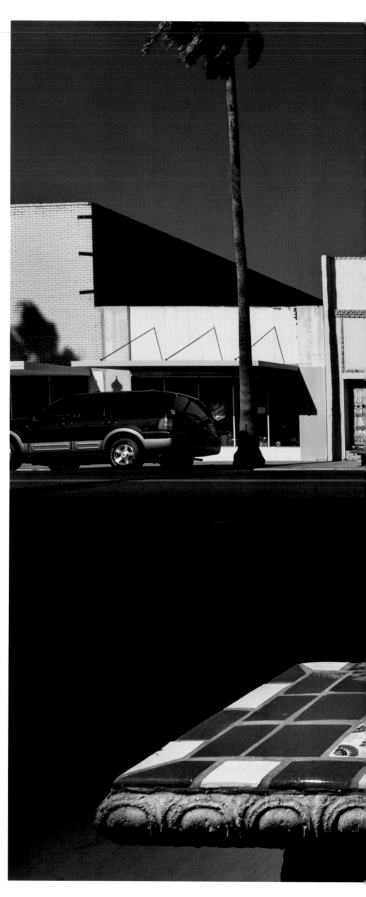

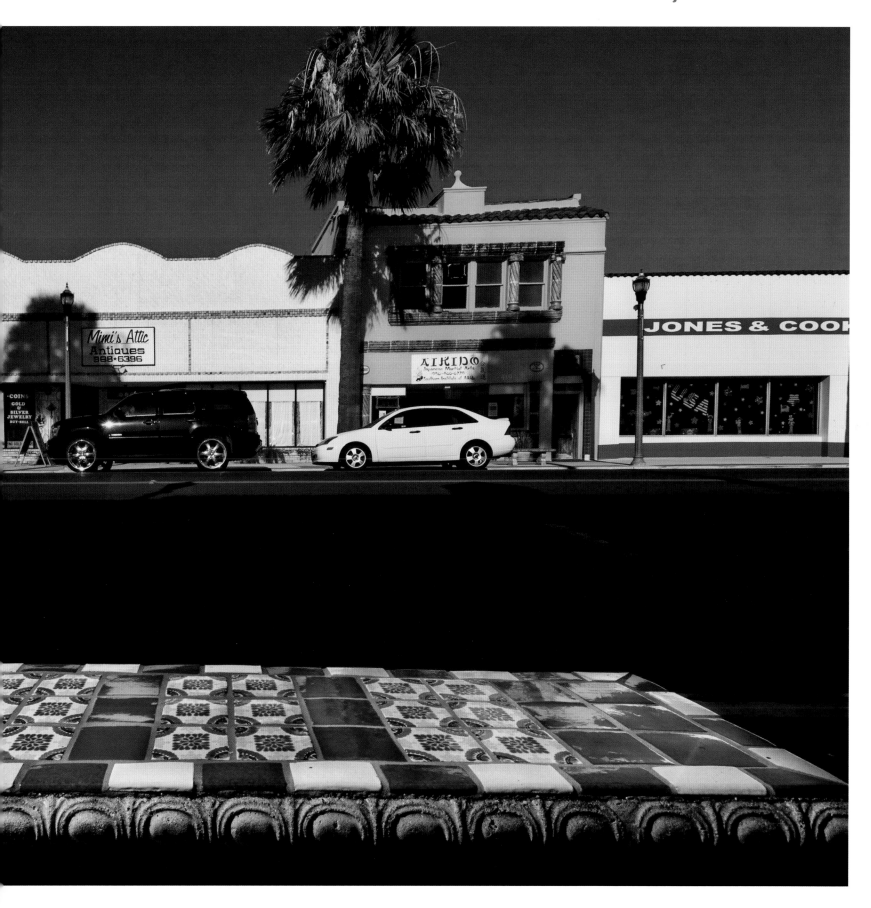

PEOPLE

Some of the most interesting and unique people in the world live right here in Texas, and I love photographing them on their turf, doing what they love in their element. Everybody has a story, a passion, or a talent to share. To get the best people shots, I create rapport by asking lots of personal questions. Sometimes I have the person stand in front of the camera and ask them questions about their passions—and stories—until I see them relax into their own natural stance. I start shooting then, doing my best to keep them in their mental happy places, so their personalities come through in the photographs.

In this section are some of the many different types of Texans I have had the pleasure to photograph, such as Tom Perini, Gary Clark Jr., Arkey Blue, Johnny Bush, Jimmie Vaughan, and a bunch of zombies. One of my favorite subjects is trick-roper Kevin Fitzpatrick, whom I have photographed on many occasions. No matter how hot it is and how much I'm sweating, Kevin is always smiling and cool as a cucumber.

Dude Ranch, Bandera, 1999

Austin, 2002
I was assigned to photograph several magicians across the state. I chose to shoot them outdoors in their hometowns. This is Brian Brushwood of Austin.

San Antonio, 1999
➤ The Popcorn Popper in San Antonio was pretty sterile looking when I arrived. I noticed lots of decorative cans and a big mound of popcorn. We constructed a wall of colorful cans behind owner George Porter. A couple of his employees dropped scoops of popcorn around him to create the illusion of popping corn.

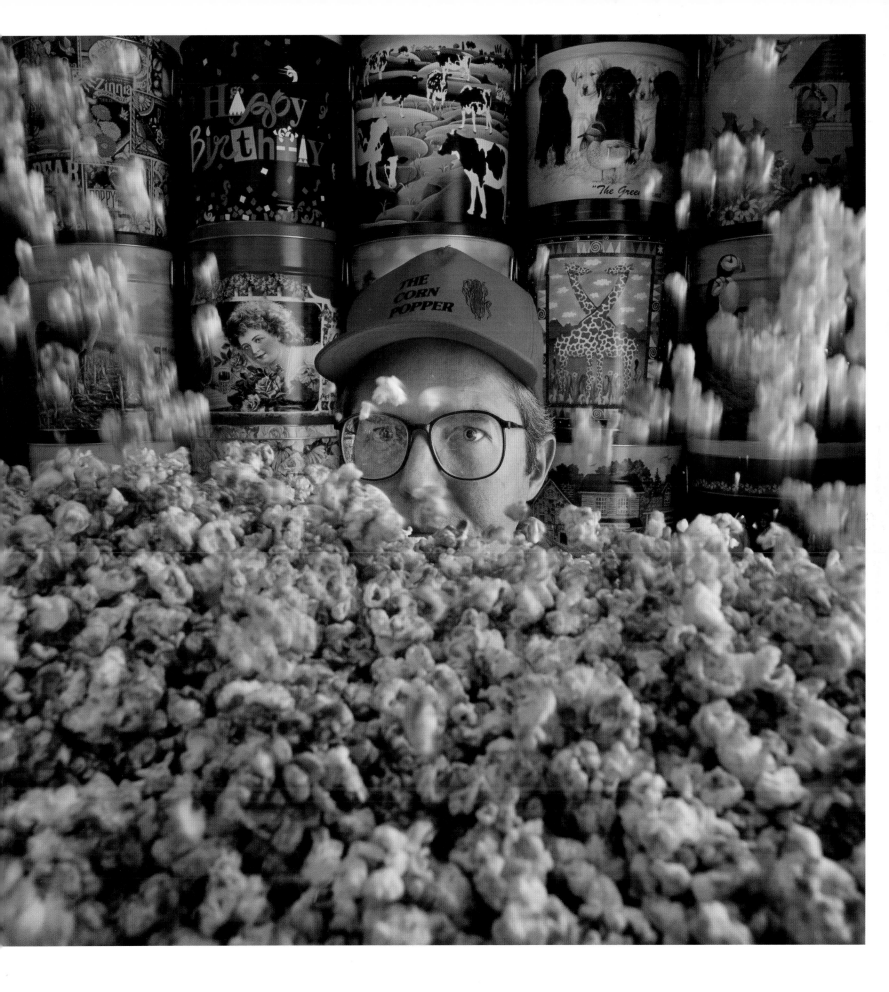

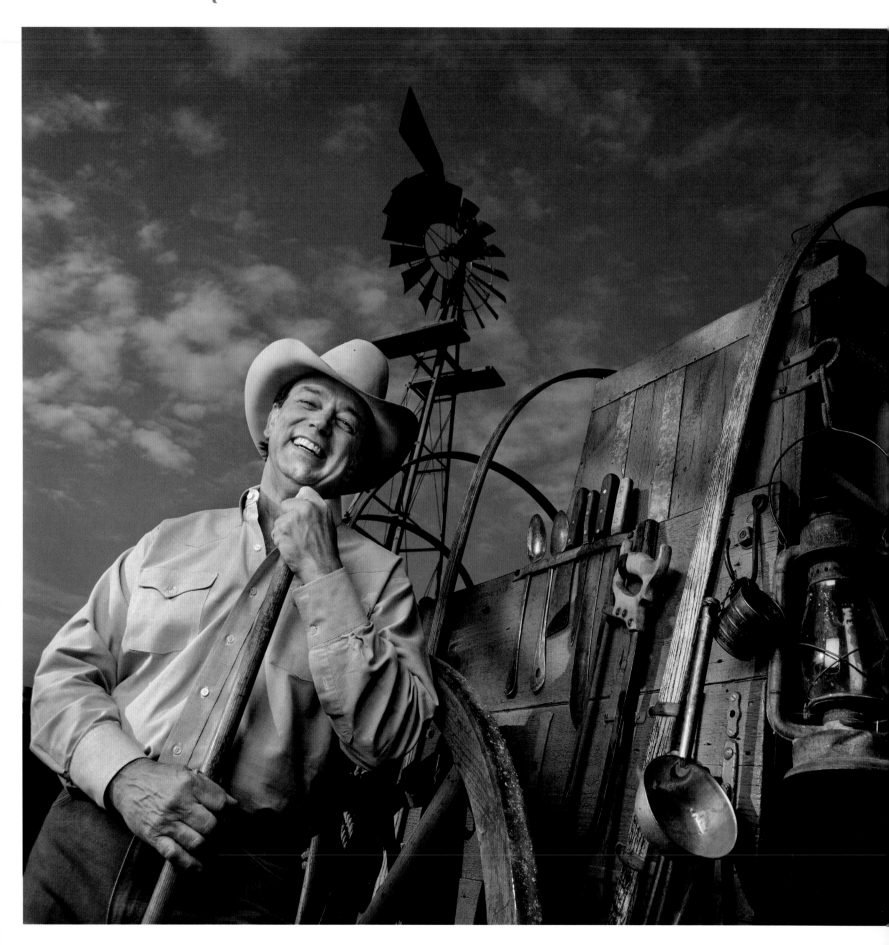

Perini Ranch Steakhouse, Buffalo Gap, 1997

◆◆ Steakhouse impresario Tom Perini, photographed at his restaurant in Buffalo Gap, has hauled his chuck wagon all over the world, grilling beef and making his famous bread pudding. I have always enjoyed going out to visit with Tom over the years. A true Texas character.

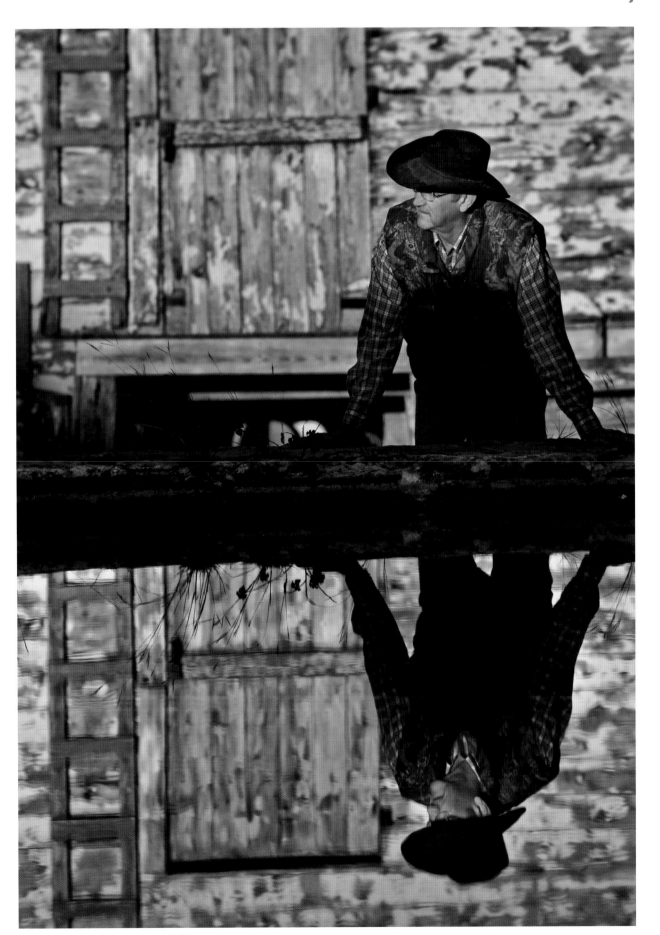

YO Ranch, Mountain Home, 2010

While at the YO Ranch, I asked foreman Jim Murff to walk around this pool of water. I told him that through my lens he looked like the Marlboro Man. A non-smoker, he replied, "If I had looked natural holding a cigarette, I would have been the Marlboro Man." Jim had been among a group of finalists sent to New York to audition for Marlboro.

Tigua Indian Reservation, El Paso, 1985

As a rule, photographers rarely shoot in the midday sun. But while I was waiting for the keys to the bread-bakers' room at the Tigua reservation, I turned around and saw Hermina Silva enveloped by this dramatic grouping of shadows. I broke the rule, and it worked! This is still one of my favorite photos.

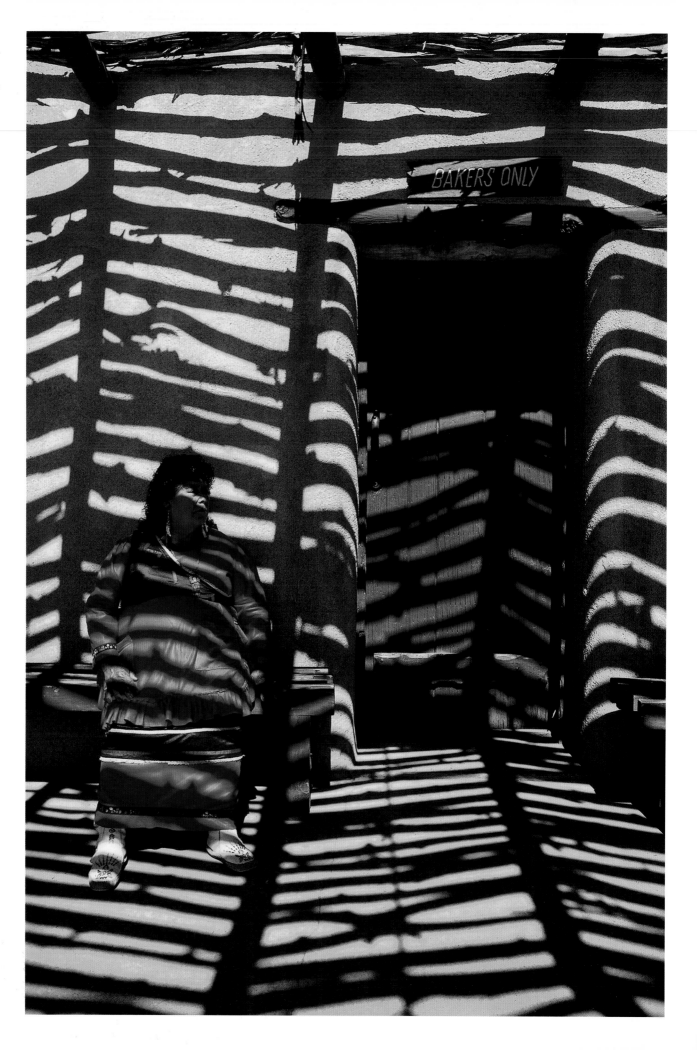

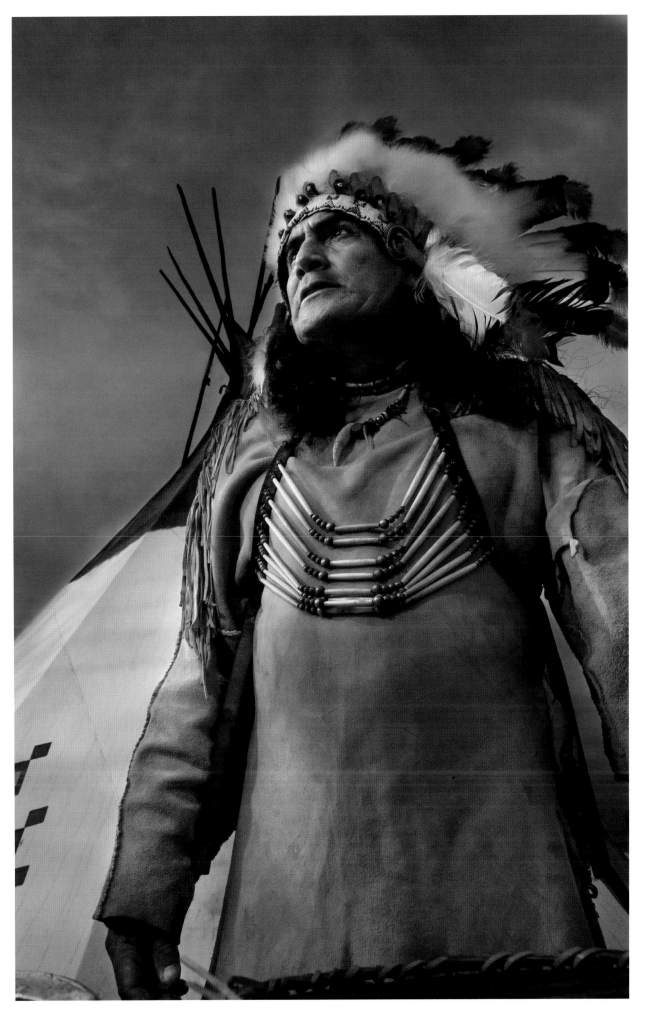

San Angelo, 2007
At the Fort Concho Christmas celebration in San Angelo, I didn't even look through the lens. I simply put the camera on the table and took the photo without this man even knowing. I love it when I get the shot without even looking through the camera. It's a gift from the universe!

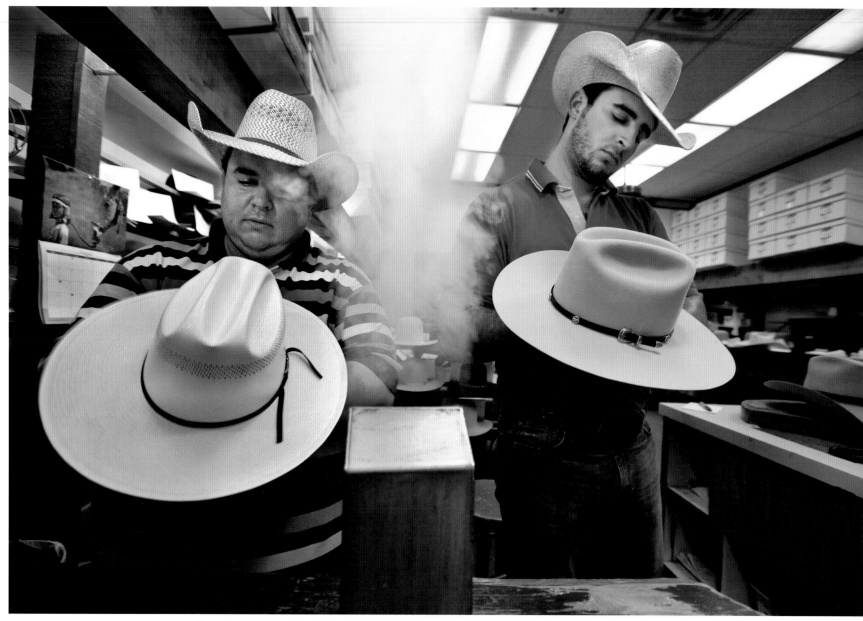

Bryan, 2010
At Catalena Hatters, brothers Travis and Scott Catalena
both wanted to be in the picture. I like it when I have willing
models. These guys will shape your hat for free while you
wait. What a deal.

Galveston, 2007
This was the last Dickens on the Strand before Hurricane Rita hit the next summer, causing much devastation in the area.

Austin, 2003
Gary Clark Jr., who lived across the street from me, walked over with guitar in hand. We jammed for a while and then took photos in my backyard.

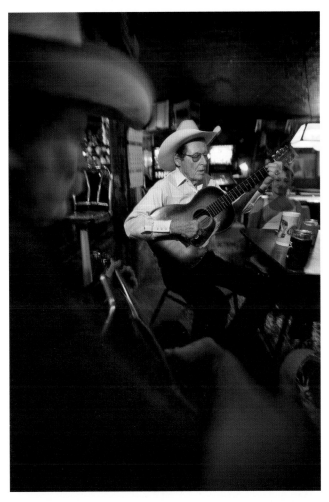

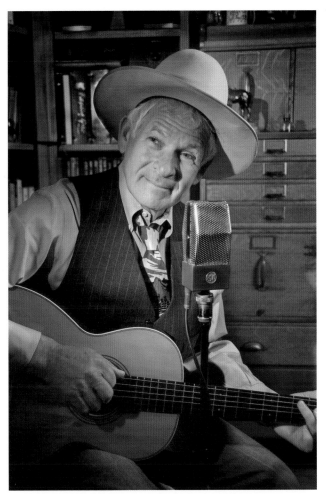

Bandera, 2010
◄◄ Arkey Blue playing in a small songwriters circle at Arkey's Silver Dollar Saloon in Bandera. Arkey told me once, "Griff, anytime you're in Bandera, you can stay in my motorhome out back."

Weatherford, 2003
Don Edwards, cowboy poet, musician, and the original horse whisperer, at his house outside Weatherford.

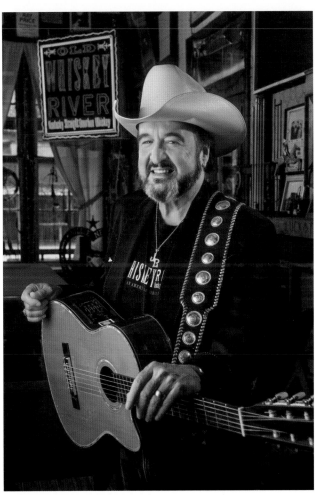

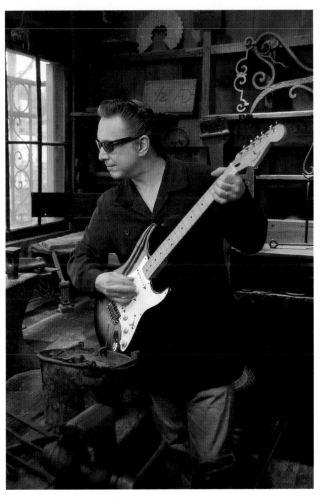

Willie's Place, Luck, Spicewood, 2003
◄◄ Lynda Bush said, "Griff, I've always wanted a picture of Johnny with the Whiskey River neon sign at Willie's place."

Austin, 2003
Jimmie Vaughan said, "Griff, watch out for the turkey neck" when I photographed him at the Iron Works BBQ in Austin.

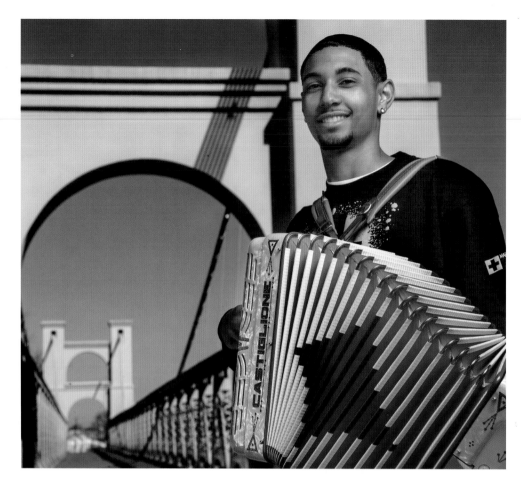

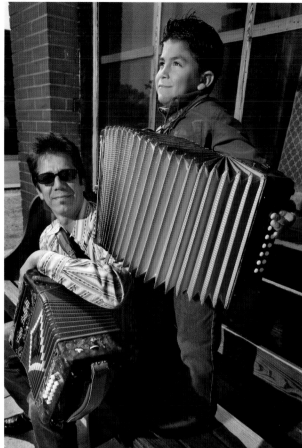

Accordionists across Texas, 2004

⬆ Cedryl Ballou and his accordion at the Waco suspension bridge, 2004.

⬆➡ I caught a special moment between Joel Guzman and his son Gabriel on a bench in downtown Buda. Musician Guzman teaches his son to play the accordion just like his father taught him. He also gives accordion lessons to kids in San Antonio.

➡ Sarah Fox and Joel Guzman playing together at the Conjunto festival in San Antonio.

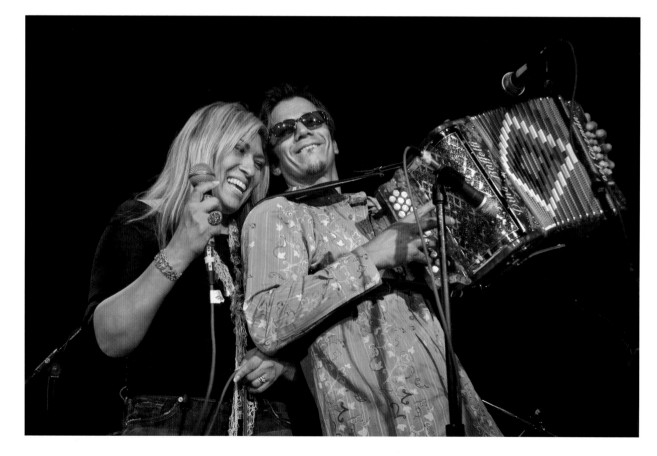

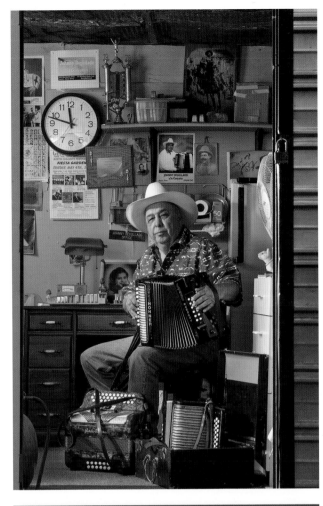

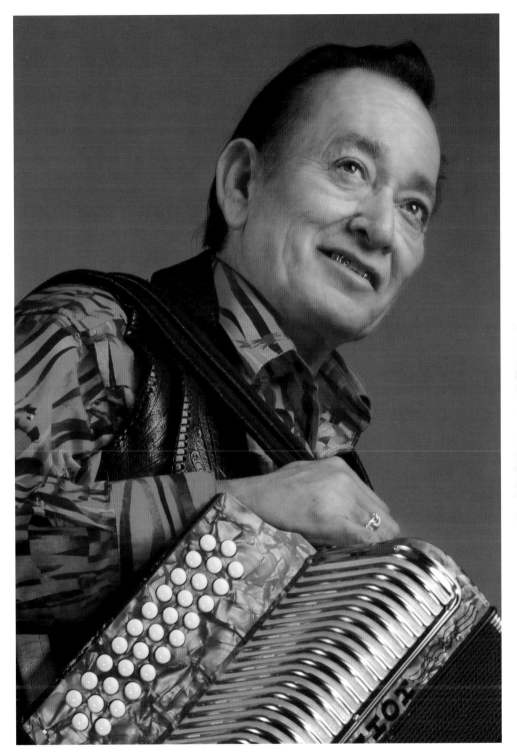

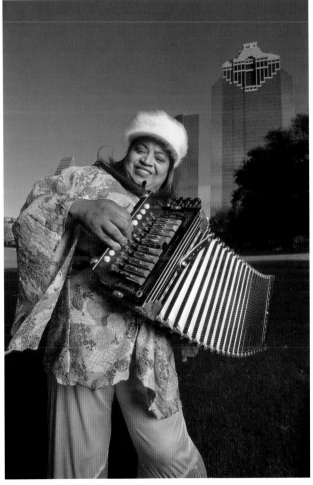

⬆ Grammy-award winner Flaco Jiménez at John T. Floore's Country Store in Helotes.

⬆⬅ Johnny Delgado repairs accordions in his shop in Austin. He came to my office one day and played his accordion while I processed some of the photos I had taken of him. I tried to play, and it was much harder than I thought.

⬅ Lady D, the Zydeco Queen, in Houston.

Seguin, 1997
Janice Woods Windle, author of
True Women, and her mother,
Virginia Bergfield Woods, pose
at their family home in Seguin in
1997. Janice invited me to a party
at photographer Harry Benson's
home in Hollywood to meet my
then–dream girl Dana Delany,
who starred in the movie *True
Women.* Who knows what might
have happened if I'd gone?

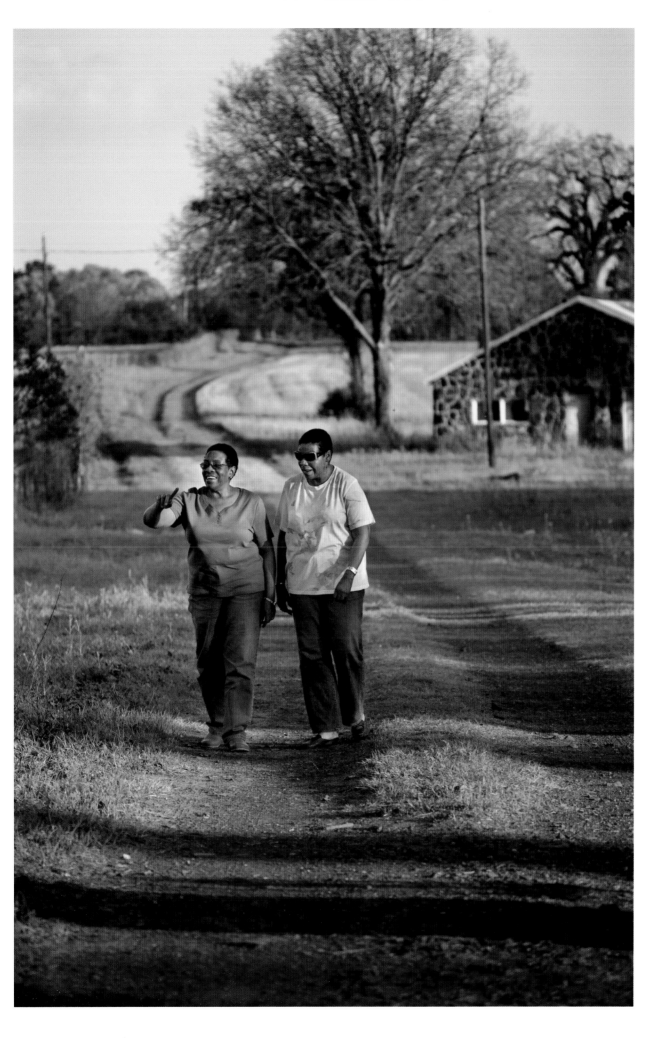

Wheeler Springs and Halls Bluff, 2010
I shot this photo for a story about several African-American Freedom Colonies established after the Civil War. These communities took care of their own during the Jim Crow days. They produced their own food, made their own clothes, and educated their children, some of whom went on to college and received bachelor's, master's, and doctoral degrees. This was a fascinating and inspiring assignment.

**Broken Spoke,
Austin, 1989**
Alvin Crow and James White,
owner of the Broken Spoke in
Austin, photographed in 1989.
I have always enjoyed working
with these guys. I knew I would
get all the cooperation I needed
to make a good photograph.

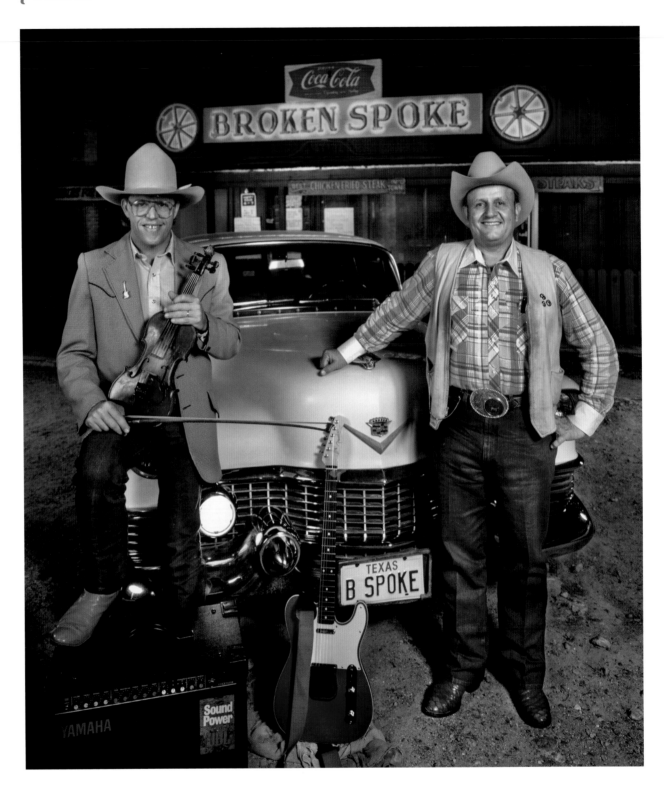

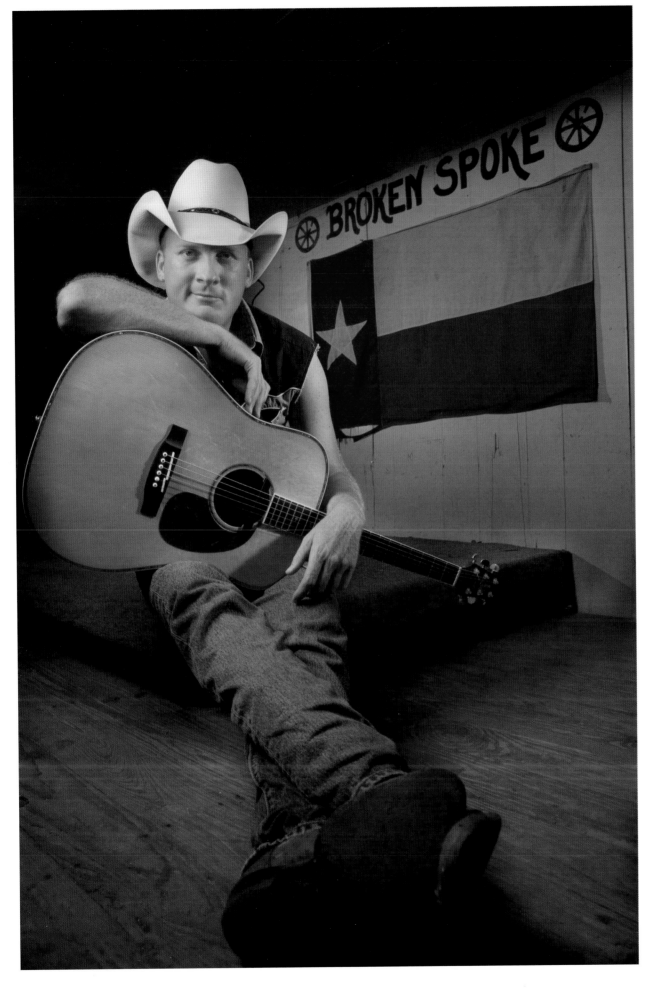

Kevin Fowler at the Broken Spoke, Austin, 2004.

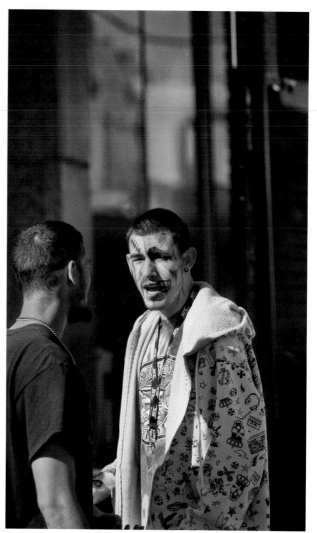

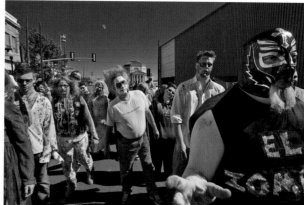

Zombies in Paris, 2012

Zombies came from all over to walk through the Pumpkin Festival in Paris. We got several letters from readers threatening to cancel their subscriptions because they felt like we were promoting Halloween and its pagan rituals. I guess I should have included the handful of protesters with their posters talking respectfully to folks throughout the day. Fun was had by all.

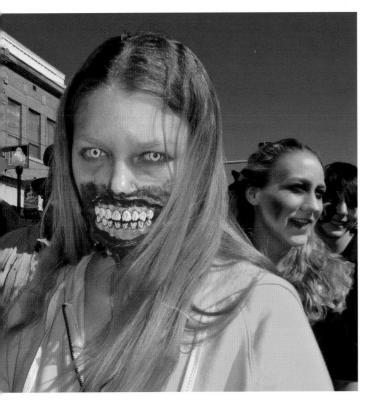

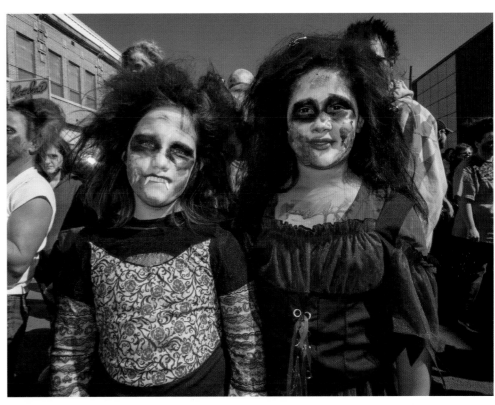

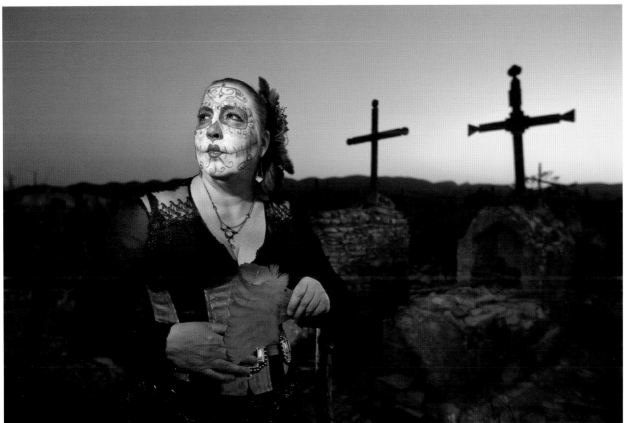

Day of the Dead, Terlingua, 2011
◄ One of the many unique people I've met over the decades, Miz Peach, a Wild West performer, posed for me in the ghost town cemetery during the town's Day of the Dead celebration.

HISTORY

Texas history is all around us. Working as a photographer for *Texas Highways* has opened the doors to such historical sites as the Alamo, Goliad, the San Jacinto Monument, and the Sixth Floor Museum in Dallas. The emotions stirred by the significance of what transpired in these places helped me create compelling images. For this section I have included the best of my historical storytelling photographs.

Sixth Floor Museum, Dallas, 1989

Just after the Sixth Floor Museum opened, I was able to show the view from the Book Depository Building that Lee Harvey Oswald probably had of the president's motorcade passing by Dealey Plaza on November 22, 1963.

I was five years old when President Kennedy was assassinated. I knew it was a big deal because the news about his death was all that was shown on TV that weekend. I was watching TV when Jack Ruby shot Oswald that Sunday morning. The whole time I was making this photograph, I had a very strange feeling.

Years later, I was assigned to shoot the story again. I was really looking forward to reshooting the window because I knew I would shoot it very differently. However, the museum director and curator had sealed off the room for preservation purposes. No amount of my sometimes-charming personality was going to persuade them to give me access.

Just a case in point: access is paramount to my work.

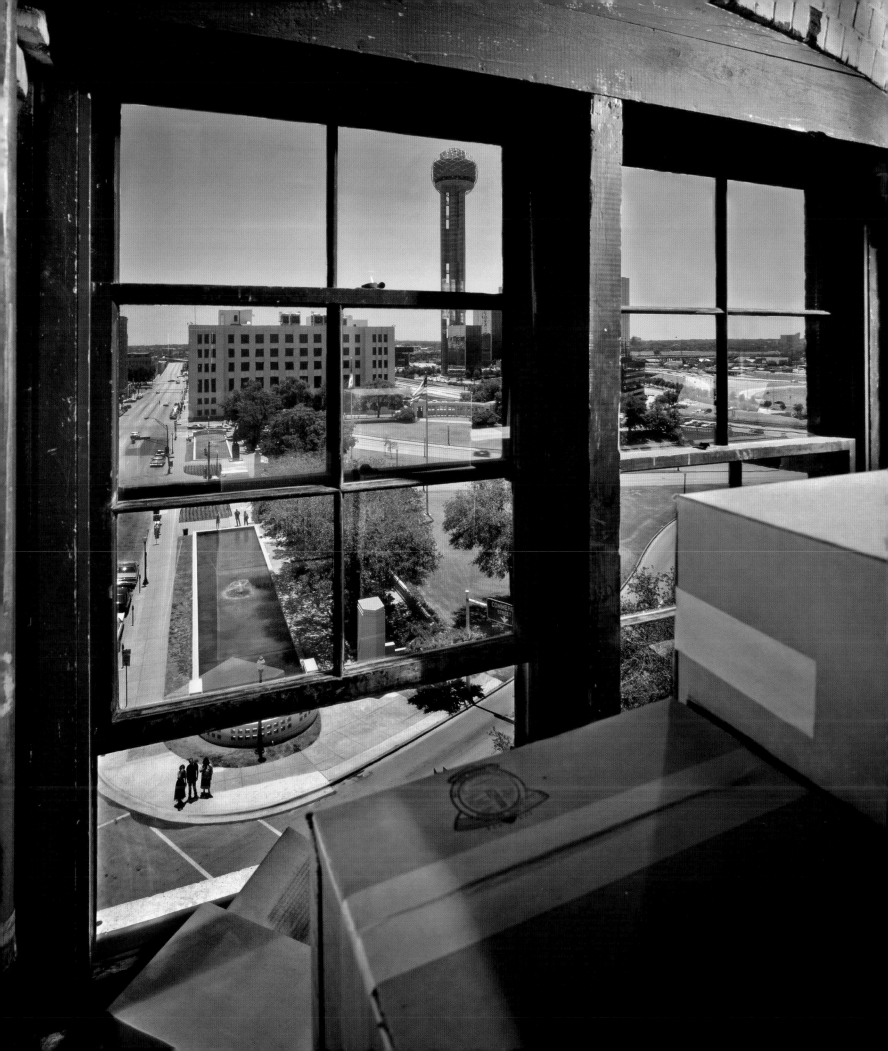

Fair Park, Dallas, 1989
The 1936 Hall of State at Fair Park in Dallas.

Bullock Texas State History Museum, 2001
← Texas neon sign in the main room at the Bullock Texas State History Museum in Austin.

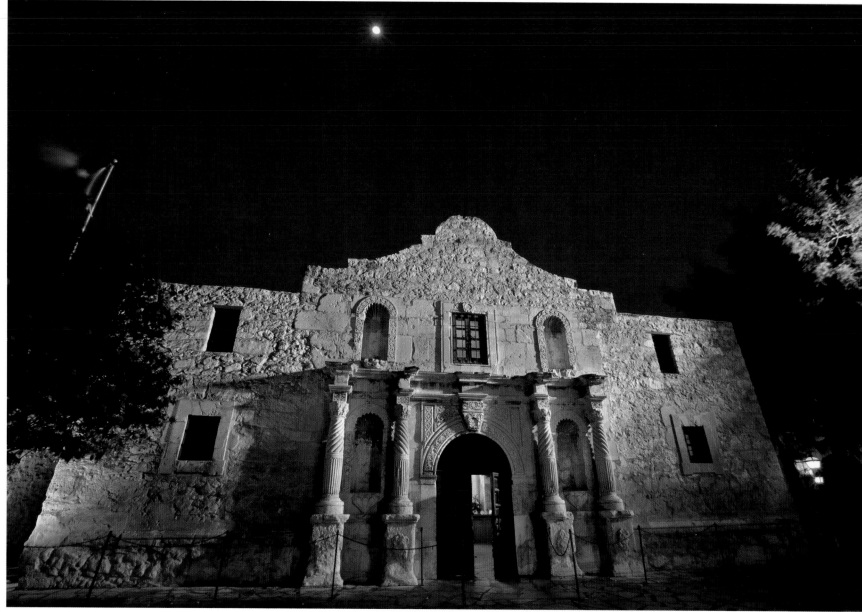

The Alamo, San Antonio, 2009
I was left alone in the Alamo to photograph for about an hour. It was awe-inspiring to reflect on all of the lives that were lost there.

➤ Priest in a case, San Antonio de Padua, for whom San Antonio is named.

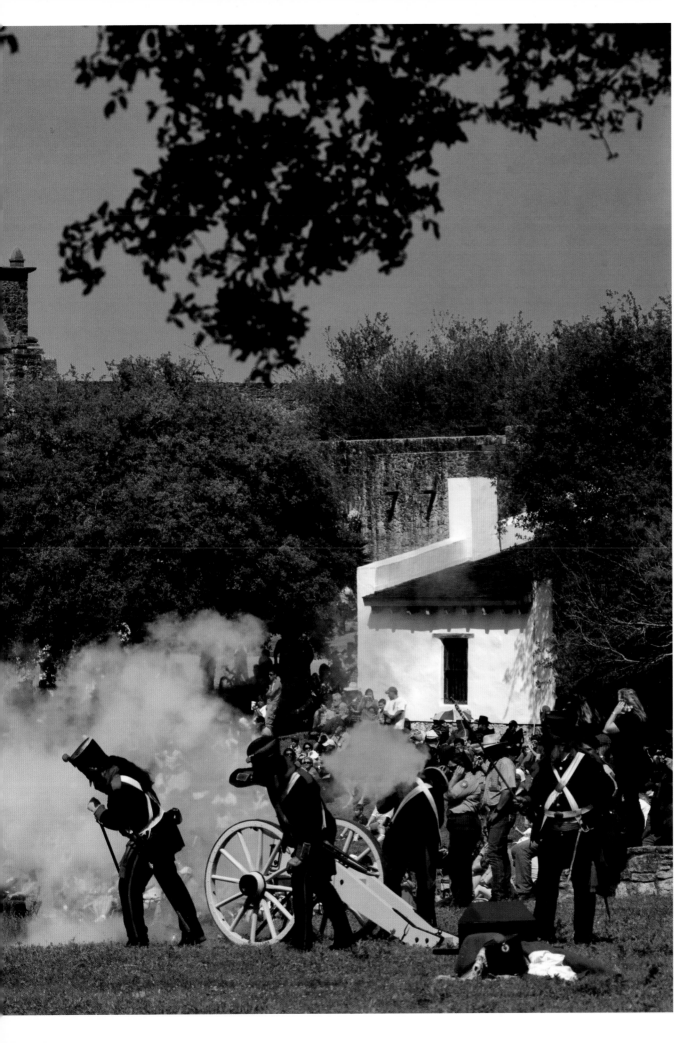

**Presidio La Bahía,
Goliad, 2010**
Gaining access to find the best
vantage point is vital. The park
ranger at this reenacted battle in
Goliad was refusing to give me
the access I needed to get "the
money shot," as I call it. With
minutes to spare, I convinced
the director of Presidio La Bahia,
Newton Warzecha, to persuade
the ranger to let me in.

Goliad, 2010

I have photographed Goliad many times over the years. While at Texas A&M, I worked on a documentary, *Restoring Texas*. It became a book published by Texas A&M University Press about Raiford Stripling, who restored many historic buildings across the state, including several in Goliad. I feel very comfortable at Goliad. Going there is almost like a homecoming. On this trip, I spent the night in the fort and was able to take advantage of some great light in the morning, and I light painted one of the cannons that evening.

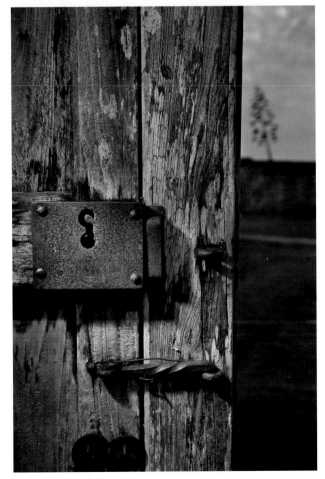

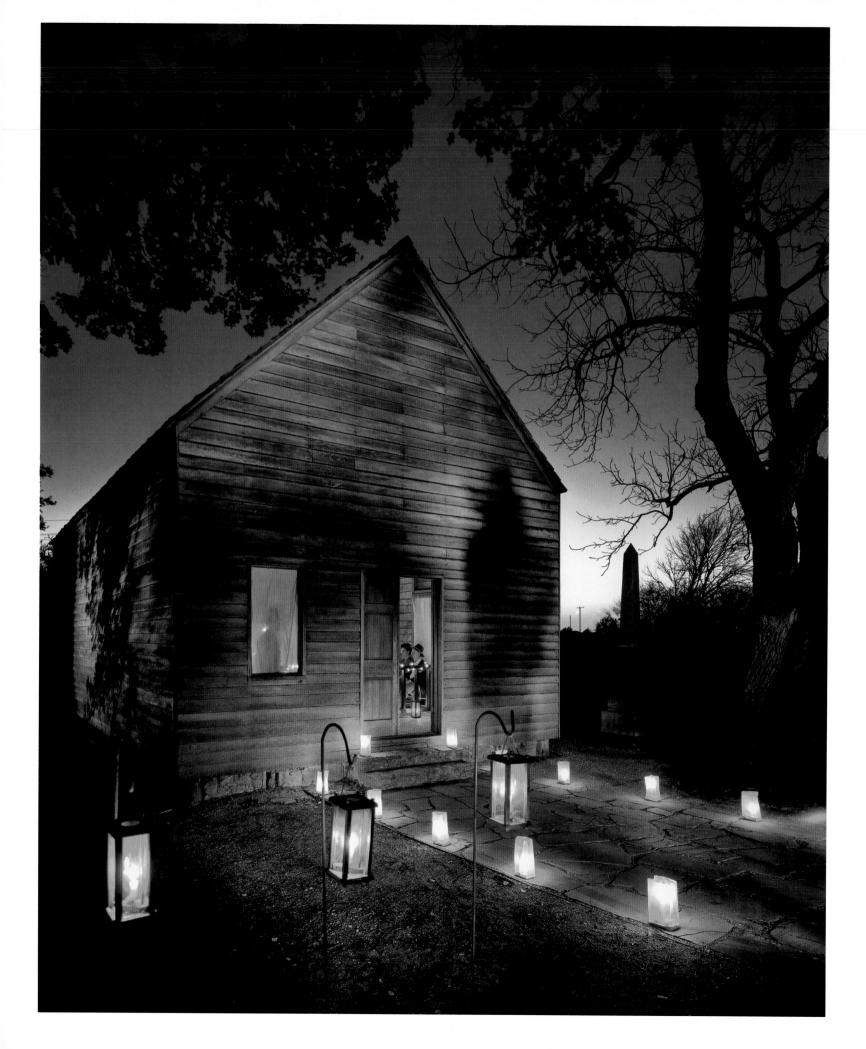

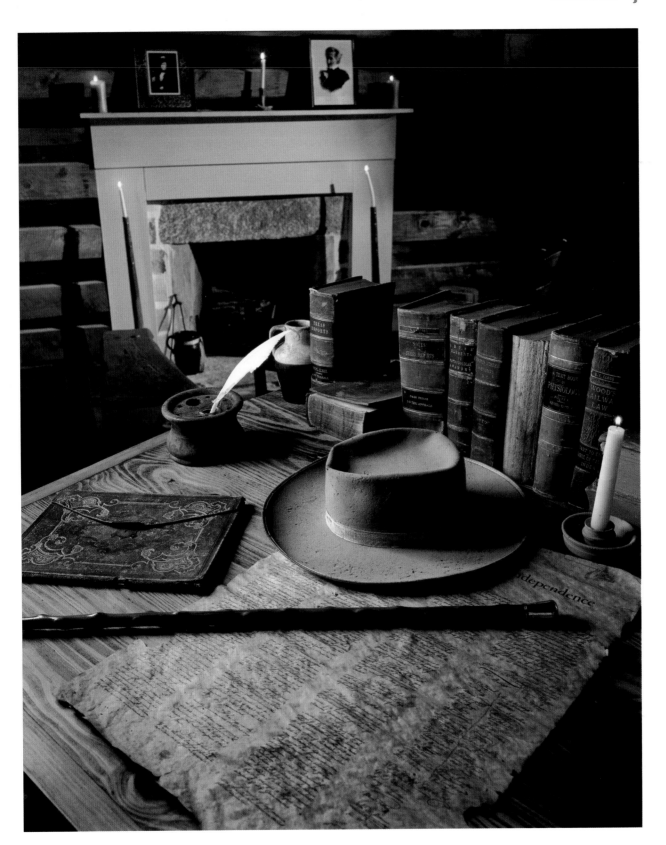

Huntsville, 1998

I persuaded the staff at Huntsville's Sam Houston Memorial Museum to place Sam Houston's hat and cane, which weren't part of the actual display, on the table in his law office. I wanted the photo to look like Sam might have just placed his hat and cane on his desk.

Washington-on-the-Brazos State Park, 2000

◀◀ At Washington-on-the-Brazos' Candlelight Christmas event, I asked a park employee to stand near the historic cabin where the Texas Declaration of Independence was signed for this cover shot. It was a challenge to come up with a creative and interesting way to photograph such a plain building.

San Jacinto, 2009
The biggest Texas flag I have ever seen is the one draped over the base of the San Jacinto Monument for the annual celebration of the battle that won Texas' independence from Mexico. I shot this image days before April 21, 2009.

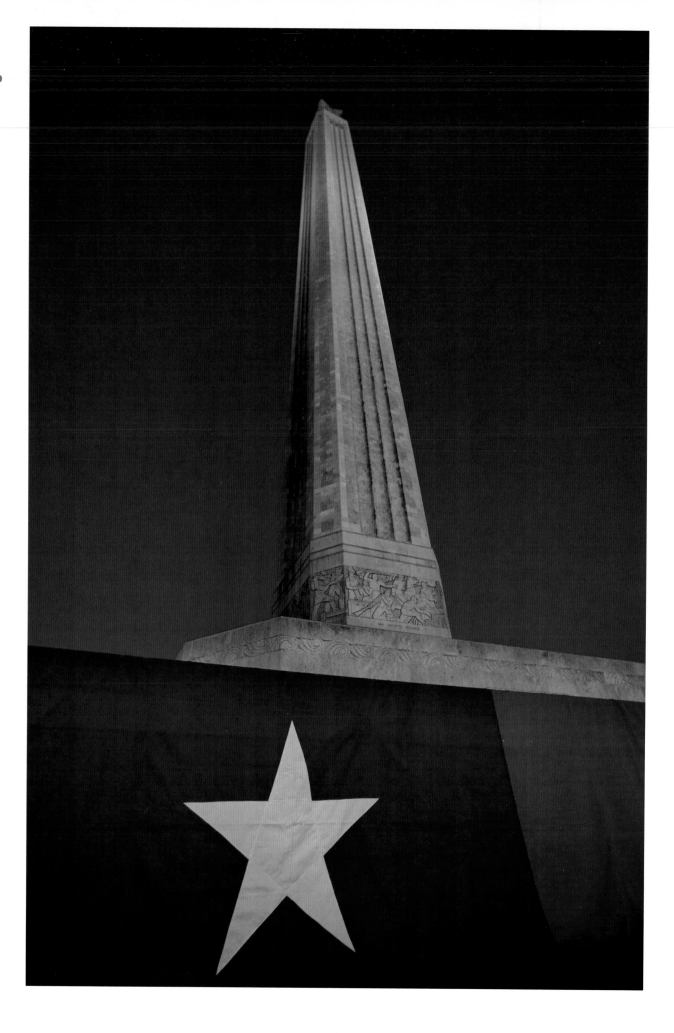

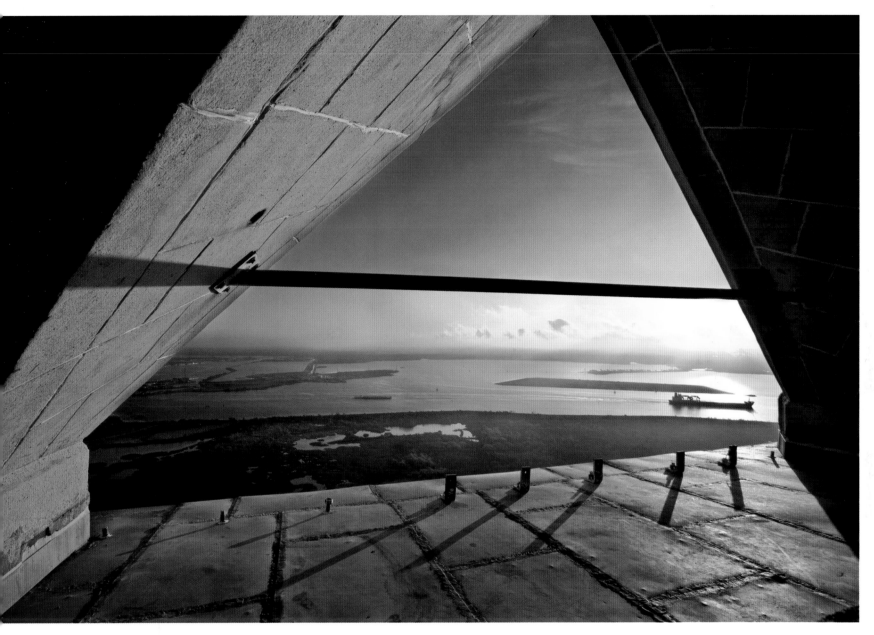

Having a camera in my hands allowed me to face my fear of
heights so I could photograph the view from directly under
the star at the San Jacinto Monument in 2009.

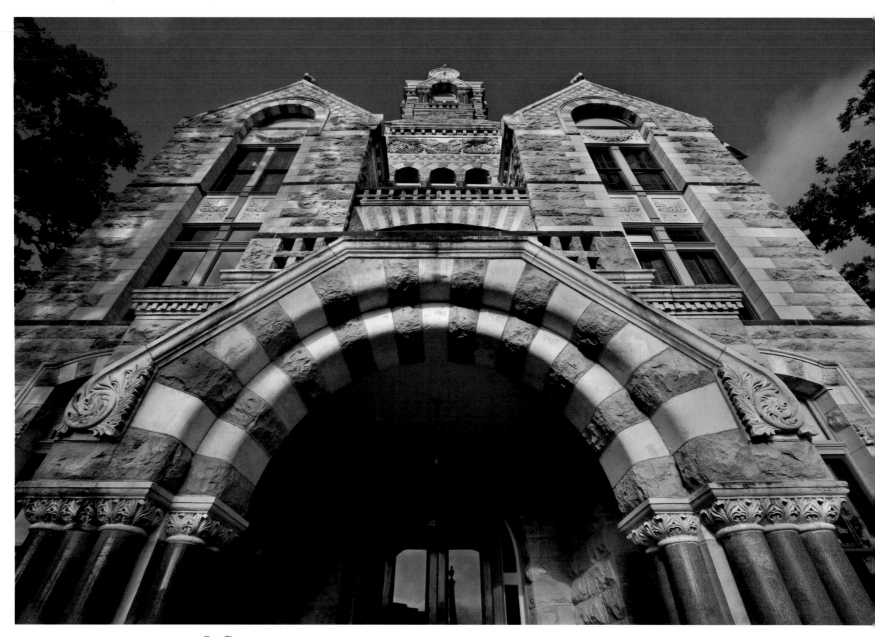

La Grange, 2010
The Fayette County Courthouse in La Grange had just
been cleaned and was beautiful in the morning light.

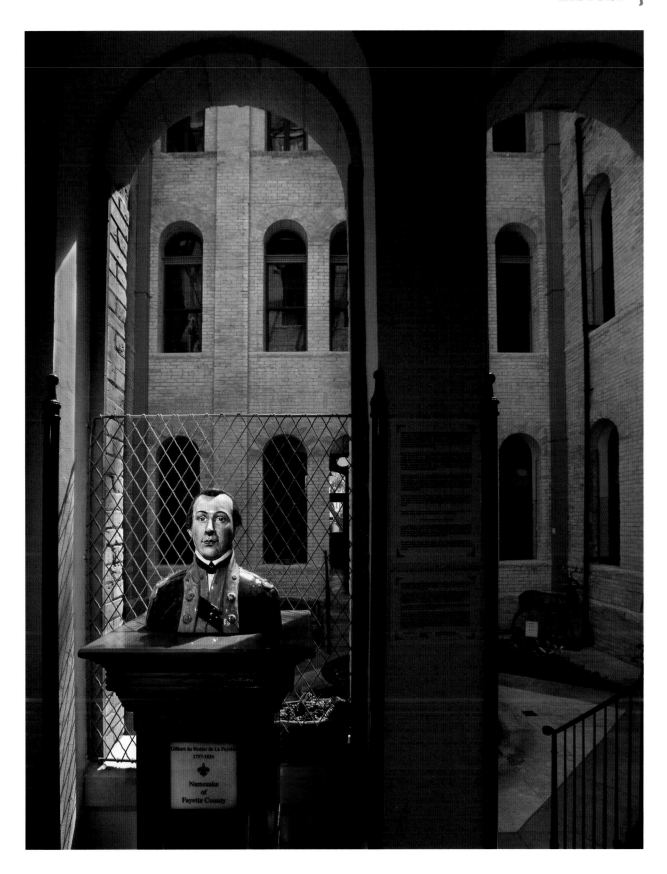

When I saw this colorful bust of Marquis de Lafayette (for whom Fayette County is named) in La Grange's courthouse atrium, I had to photograph it. I worked on this shot for about thirty minutes to get the lighting just right on the sculpture.

Presidio County, West Texas, 2010
Indigo Ranch Cemetery, on RR 170 between Presidio and
Ruidosa.

Fort Stockton, 1994
➤ I composed a double exposure on film of these re-enact-
ment soldiers at Fort Stockton to make them appear like
ghosts of the fort. I had to do something different with all
the texture of the adobe wall.

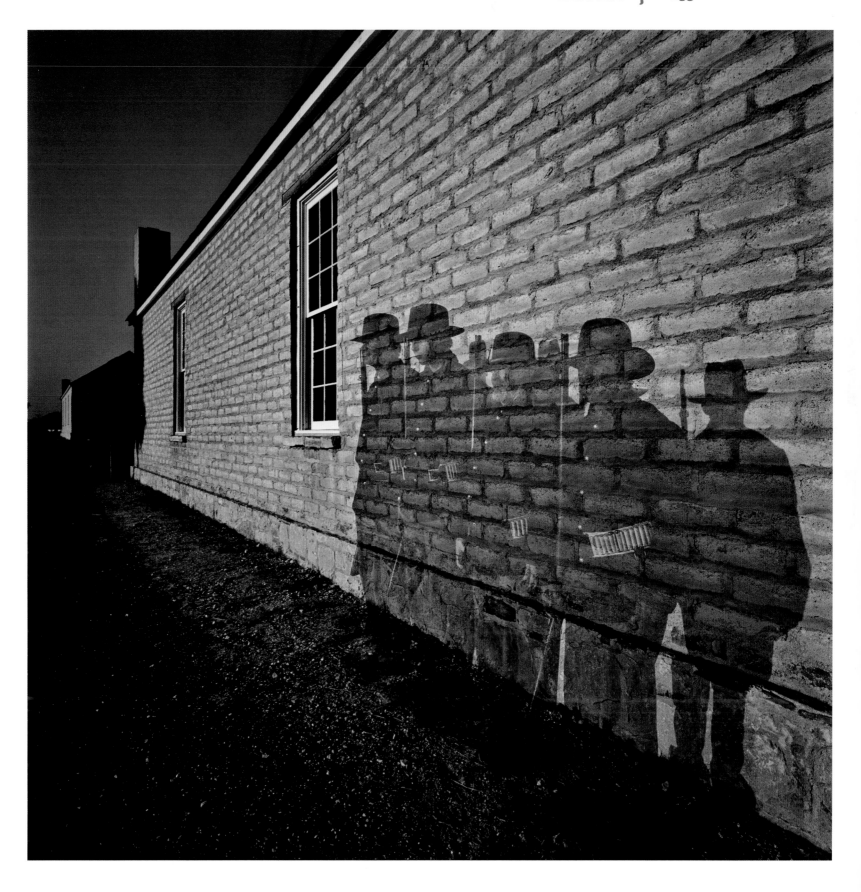

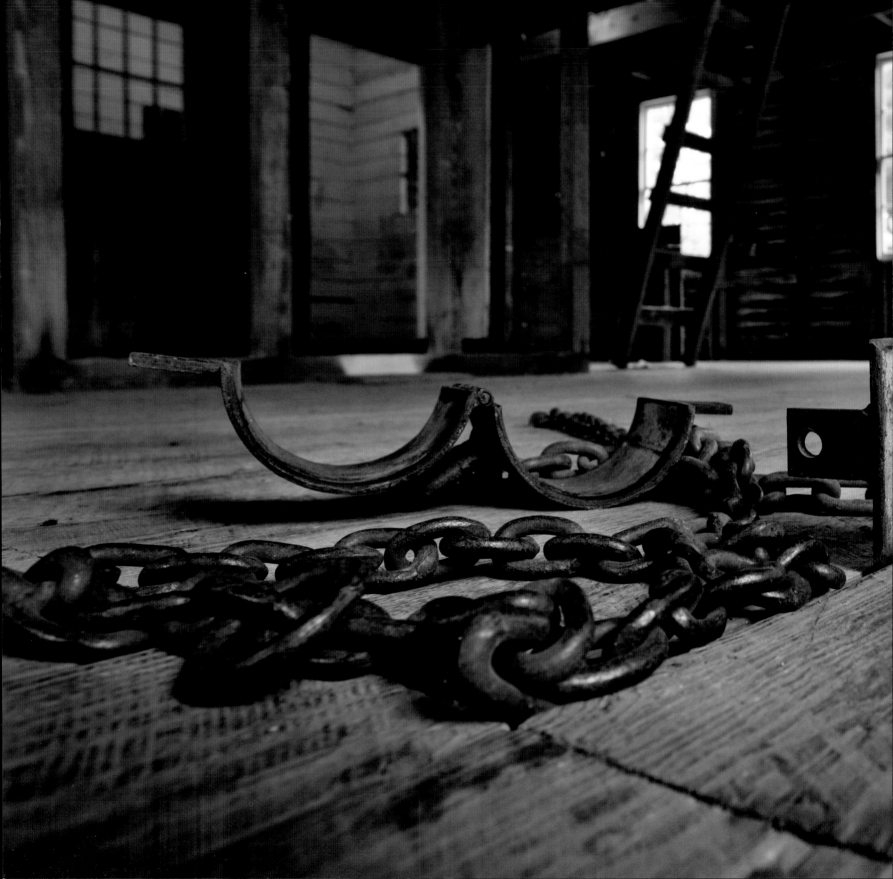

Fayetteville, 2010
The jail is above the courtroom in a Fayette County precinct house. In Fayetteville, if there were more than two prisoners, the third would be chained and shackled to the floor in the middle of the room. I showed this shot to a resident of Fayetteville. He really did not like it and wished we could just forget about those days.

Fayetteville, 2010
The Red & White, originally
a silent movie house, is now a
private residence on the historic
town square. The whole town
of Fayetteville is in the National
Register of Historic Places.

Fayette County Precinct House, 2010
This is the view from the Fayette County Precinct House window during an art fair on the square. Using a telephoto lens, I was able to distinguish the lantern from the street action outside.

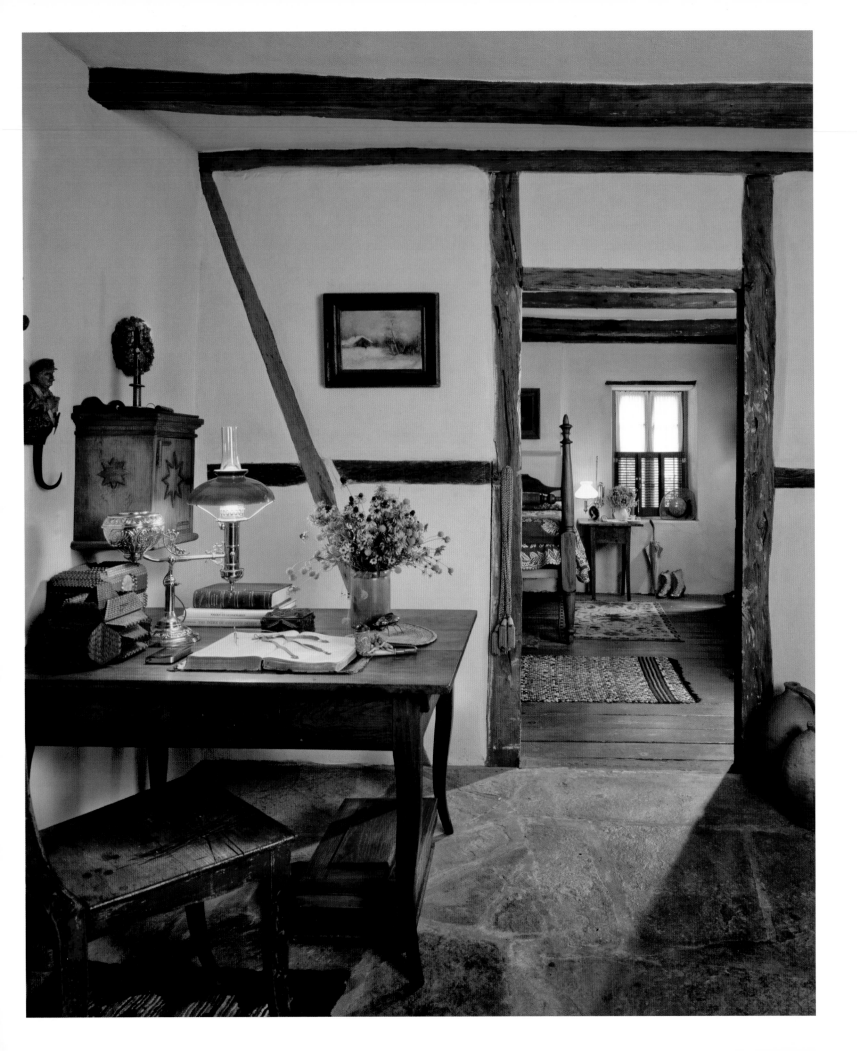

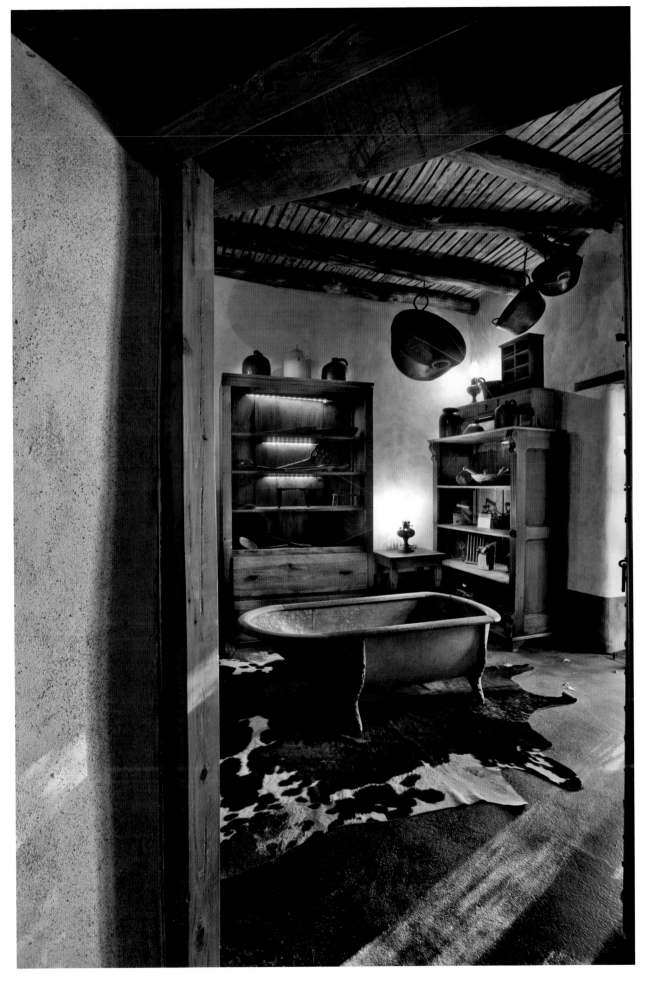

Cibolo Creek Ranch, History Room, Marfa, 2009
One of several rooms at the ranch filled with tools, guns, pottery, and even an old washtub for the viewing pleasure of the guests.

Castroville, 1990
◄◄ At a bed and breakfast in Castroville, this lady set up the room wonderfully, just like she had for photographers who had come before me. All I had to do was set my camera up. A fellow photographer told me he had the exact same shot and asked whether I was going to keep it in my portfolio. I said yes because I shot it and had not been influenced by his photo. I had never seen his photograph, so I did not feel like I was copying him. It felt awkward having that conversation.

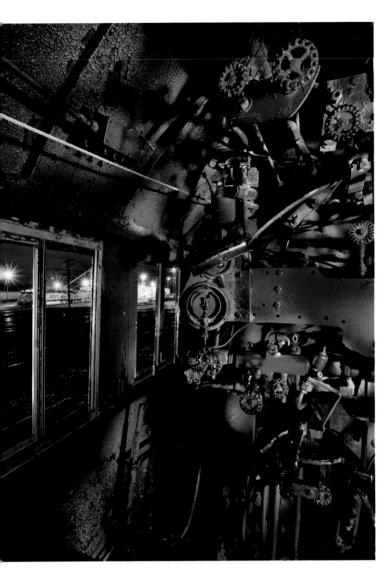

Railroad and Heritage Museum, Temple, 2009
I love to photograph light reflecting off of metal, and trains offer a lot of opportunities for me to do just that. After I took my last shot of the steam engine's interior, six to eight pre-teens rushed toward the train. My assistant and I were in the way of their climbing on the engine, so we quickly got off the train. While we were loading our cars with gear, the kids began to throw small rocks at us. We promptly got on the road.

Alpine, 2009
I had just arrived in Alpine and was on a quick tour of locations on my shot list when I saw a couple of conductors waiting for the train. I asked, "When is the next train?" They responded, "In three days." Well, all I had was my Canon G9 point-and-shoot, but I had to get one of my assigned shots right then or not at all. I just love figuring out how to get a good photograph with little point-and-shoot cameras.

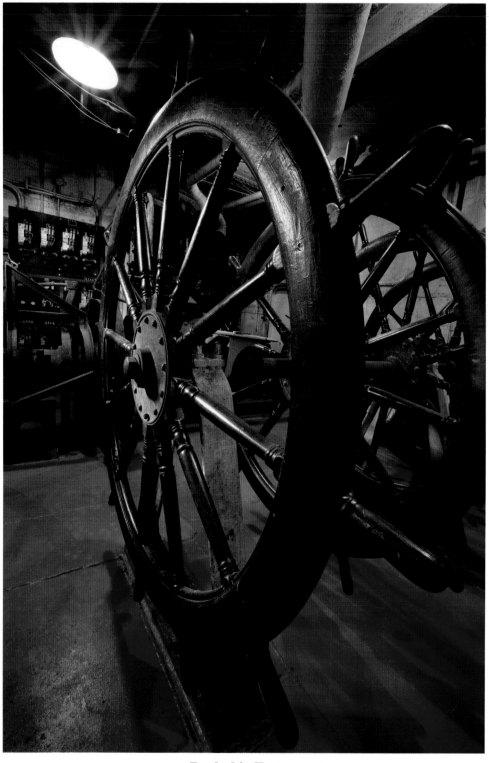

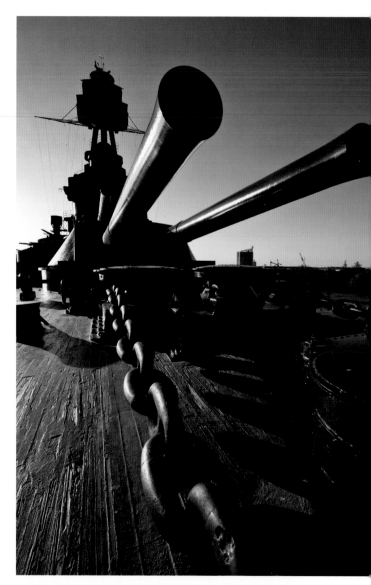

Battleship *Texas*, 2009
During a personal tour of the ship after hours, I got these dramatic shots of the deck and guns at sunset, along with the wheel room, where the ship could be steered manually if needed.

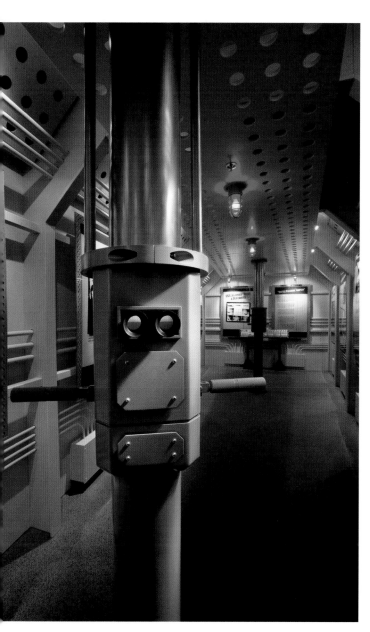

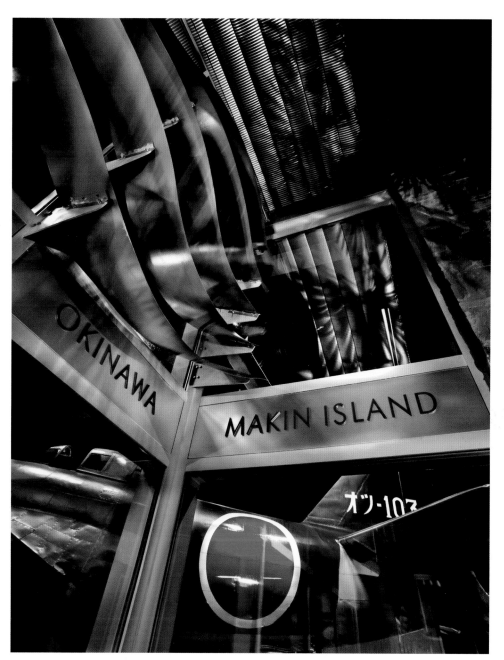

Fredericksburg, 2010

Up Periscope! is one of the exhibits at the National Museum of the Pacific War. I liked this museum so much I took my dad to see it. He told me his World War II story about how a bullet had gone through one soldier's neck, killing him, and then bounced off of a tank, finally lodging in my *dad's* chin, giving him what was called a Hollywood wound—and the Purple Heart. I will never forget that trip.

A window showing one of three Japanese biplanes at the National Museum of the Pacific War in Fredericksburg. I really liked the way the light reflected off of the metal and the aircraft.

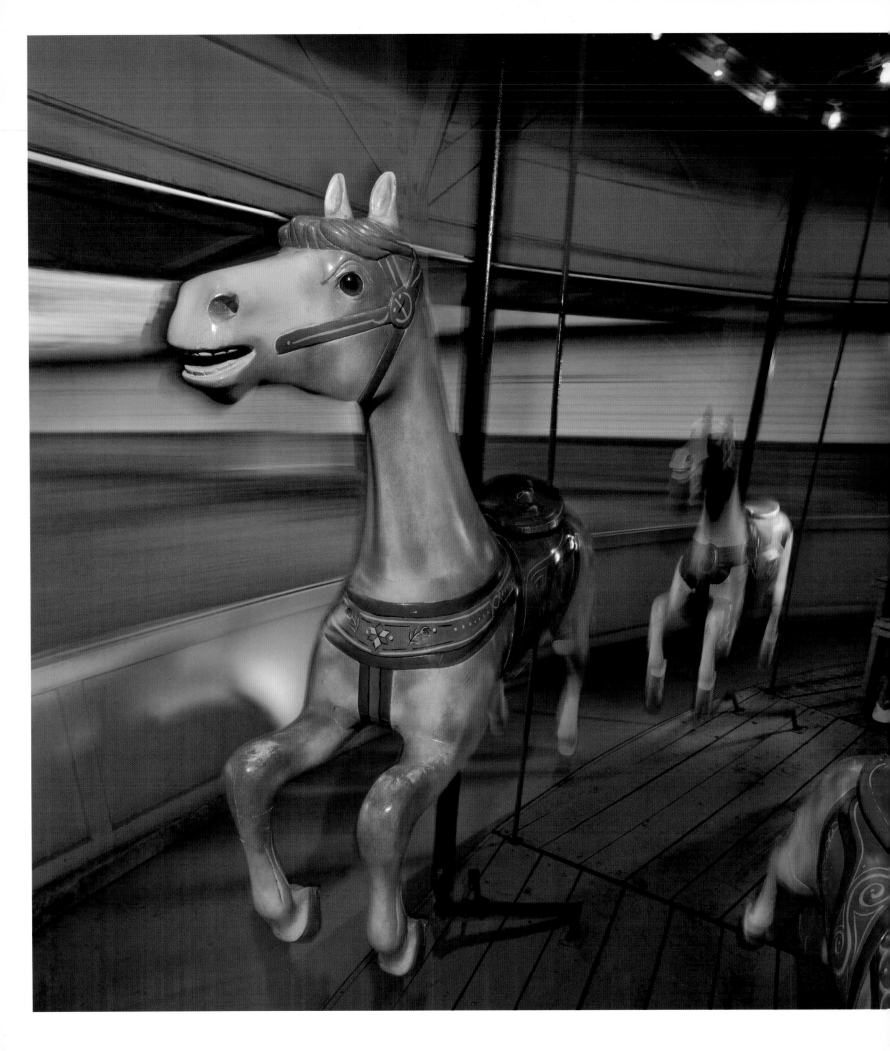

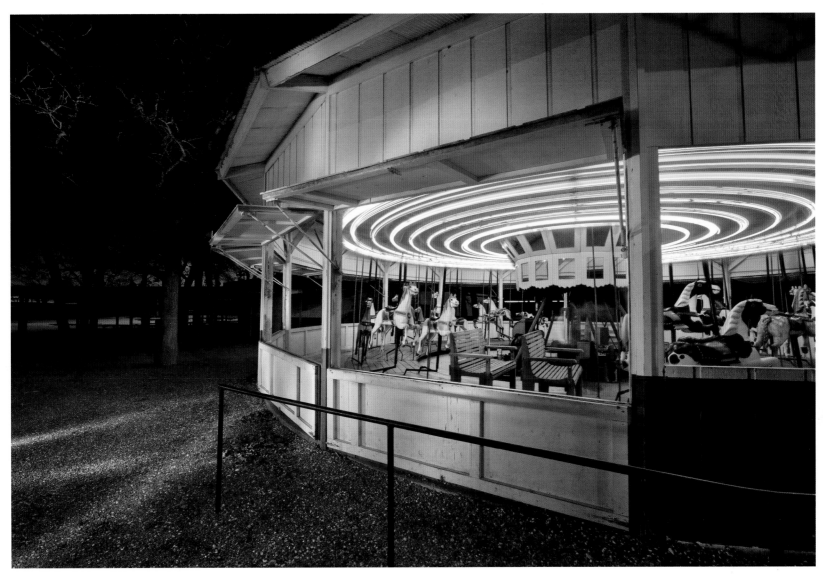

Firemen's Park, Giddings, 2013
This 1915 C. W. Parker Carousel was left by a traveling
carnival in 1931 as payment for a debt owed to Lee County. I
almost got dizzy trying to shoot this one.

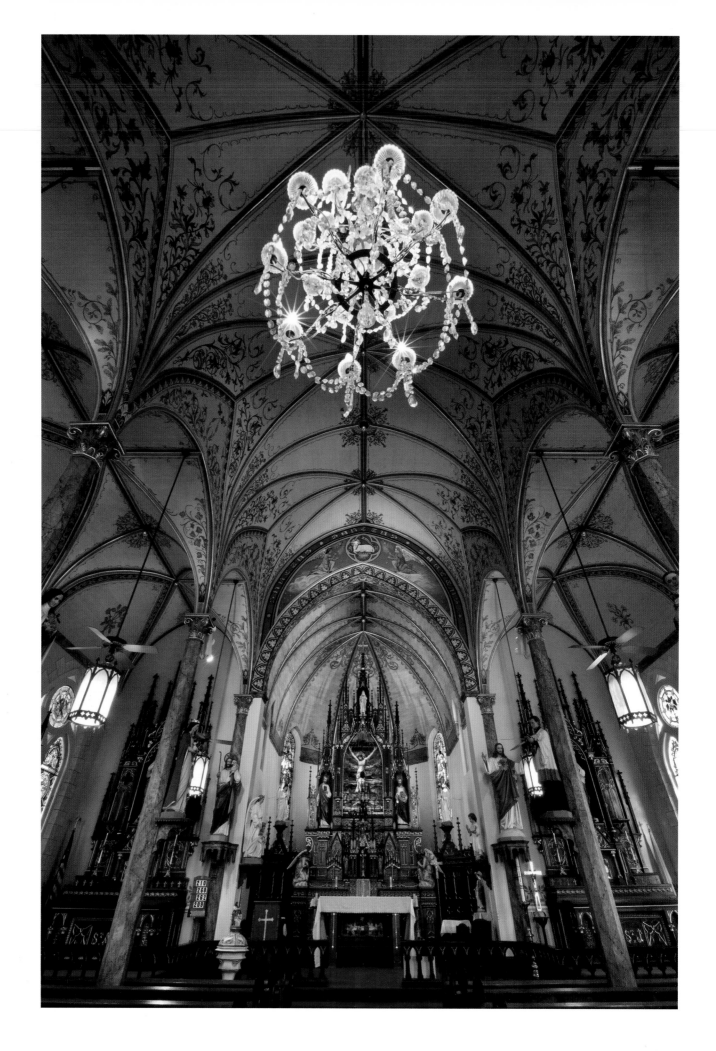

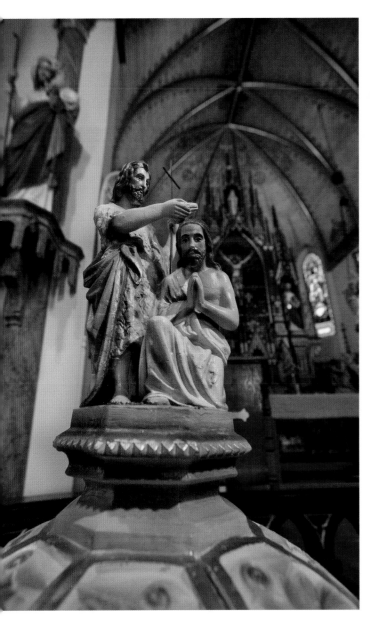

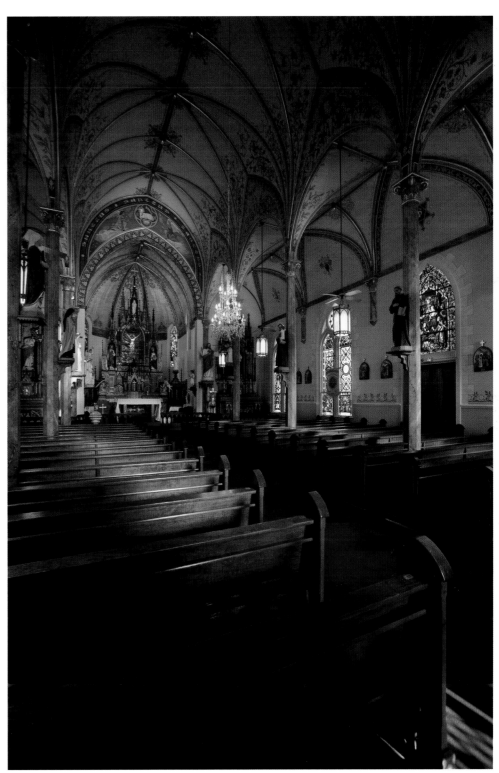

St. Mary's Catholic Church, High Hill, 2013
The light was special that day. We kept trying to pack up and leave, and then I would turn around, see the changing sunlight shining in through the windows, and have to stop and set up the tripod again. Those are the moments that make me a happy photographer.

Lone Star Motorcycle Museum, Vanderpool, 2013
Close-up of a medallion on an Indian motorcycle. The owner had so many motorcycles. It was amazing for this collection to be in such a remote area near Lost Maples State Park.

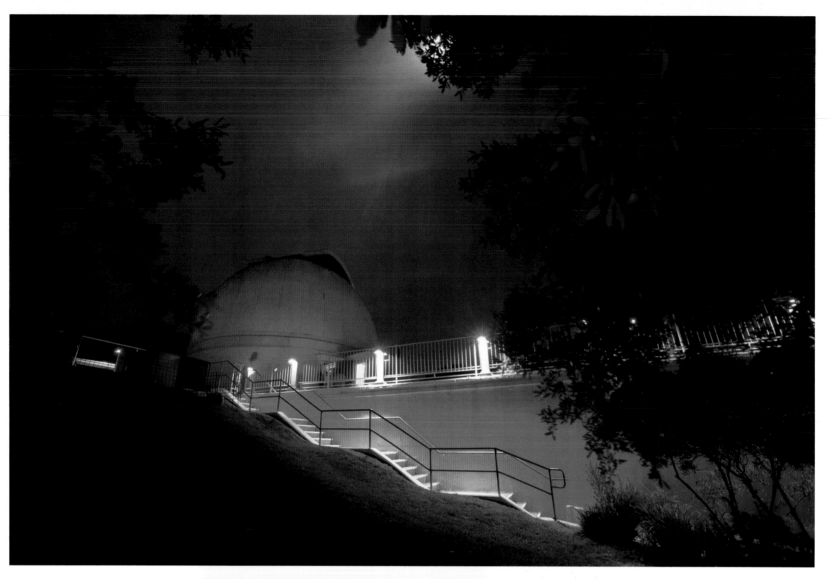

George Observatory, Brazos Bend State Park, 2012
The 36-inch Gueymard Research Telescope is the largest telescope in the state available for public use. Though the celestial viewing was amazing, the croaking bull frogs outside—the loudest I'd ever heard—quickly brought me back down to earth.

Fairfield and Teague, 2013
➤ Where there's a will, there's a way. While demonstrating light painting for a photo workshop at Fairfield and Teague, I realized we could not open up the Teague Hotel to turn on the inside lights. But one of the students offered up some big work lights, which we shined through the windows to make it appear that the lights were on.

CULTURE

The art, music, and food created by unique
and talented Texas artisans, along with spec-
tacular and unconventional venues, come
together to create the culture that is Texas.
Going to these venues and photographing the
artisans and their labors of love oftentimes has
inspired me in the creation of my own art.

The following pages feature some of the
cultural gems across the state: The Menil
Collection in Houston, Festival Hill in Round
Top, The Orange Show in Houston, the Gal-
axy Drive-In in Ennis, the Bistro Moderne
in Houston, and The Chinati Foundation in
Marfa, along with many others.

**Meyerson Symphony Center,
Dallas, 1990**
A classic architectural photograph of
Meyerson Symphony Center in Dallas.
Nearly everywhere I pointed my camera,
I found incredible views.

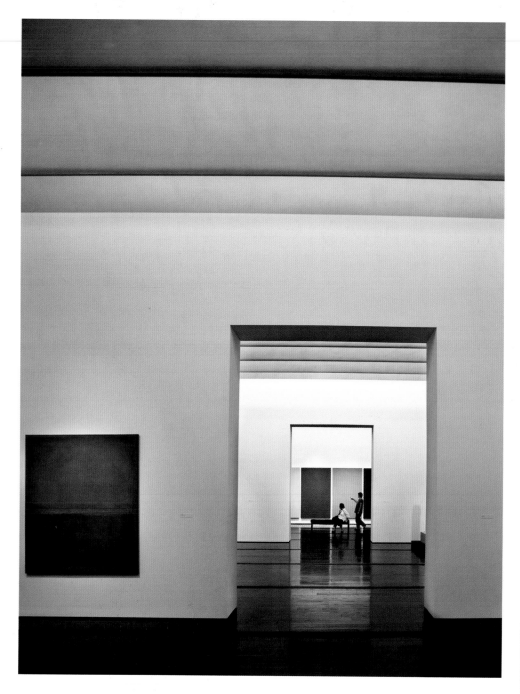

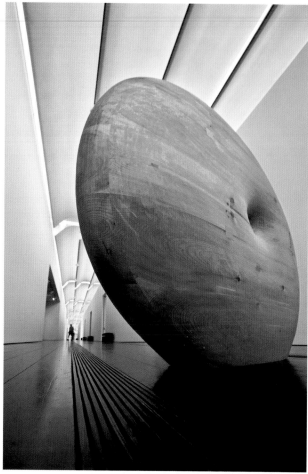

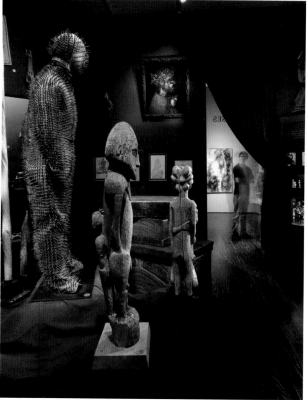

The Menil Collection, Houston, 2010
The Menil Collection in Houston is one of my favorite museums in the state. I love abstract art. The Menil has many pieces, including classic and ancient art from all over the world in its permanent gallery, and it's always free.

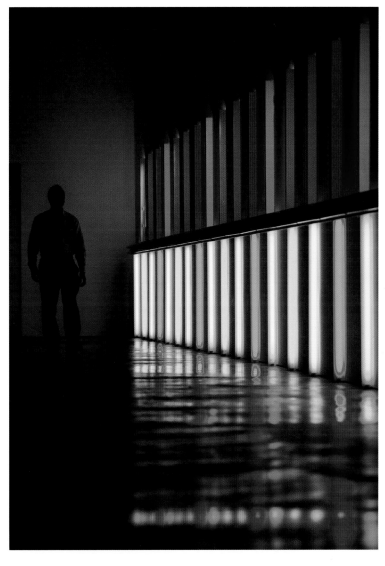

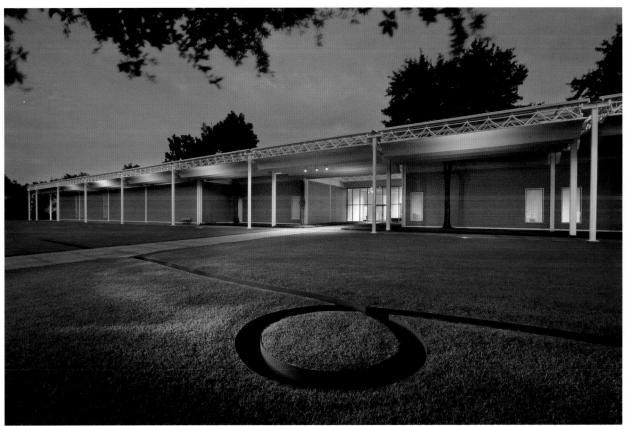

Round Top, 2010
Round Top on the 4th of July, 2010. The town hosts the oldest continuous July 4th parade in the state. I must say I am not much on parades, but this is a good one. The streets are packed with folks and all types of floats, trucks, tractors, art cars, fast cars, and beautiful people of all types and backgrounds.

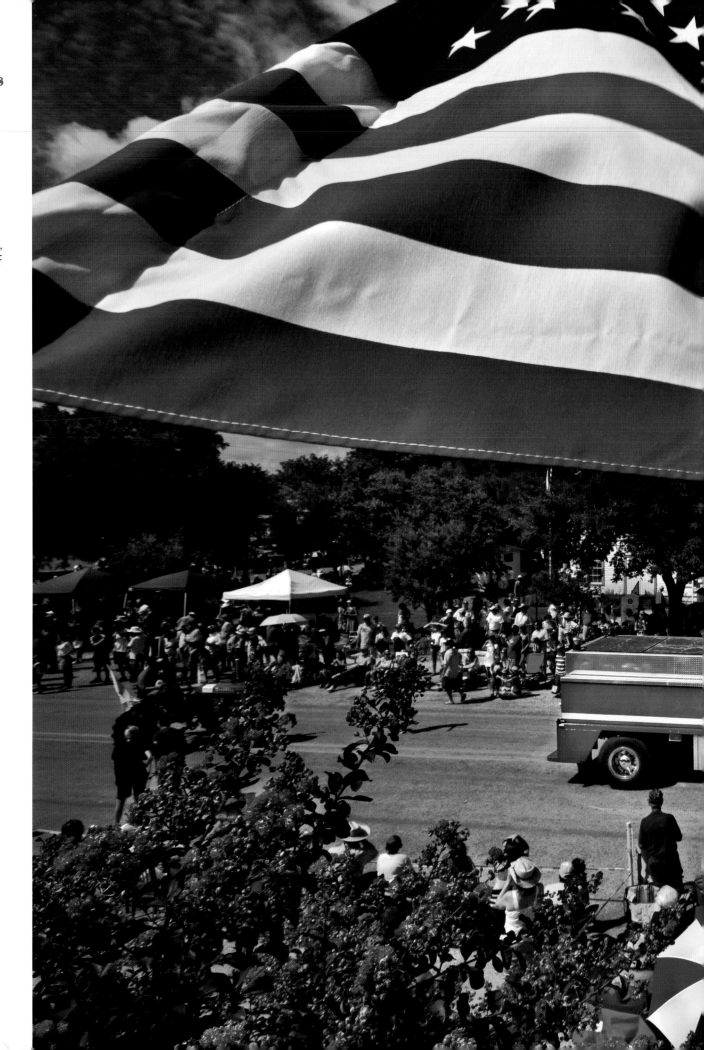

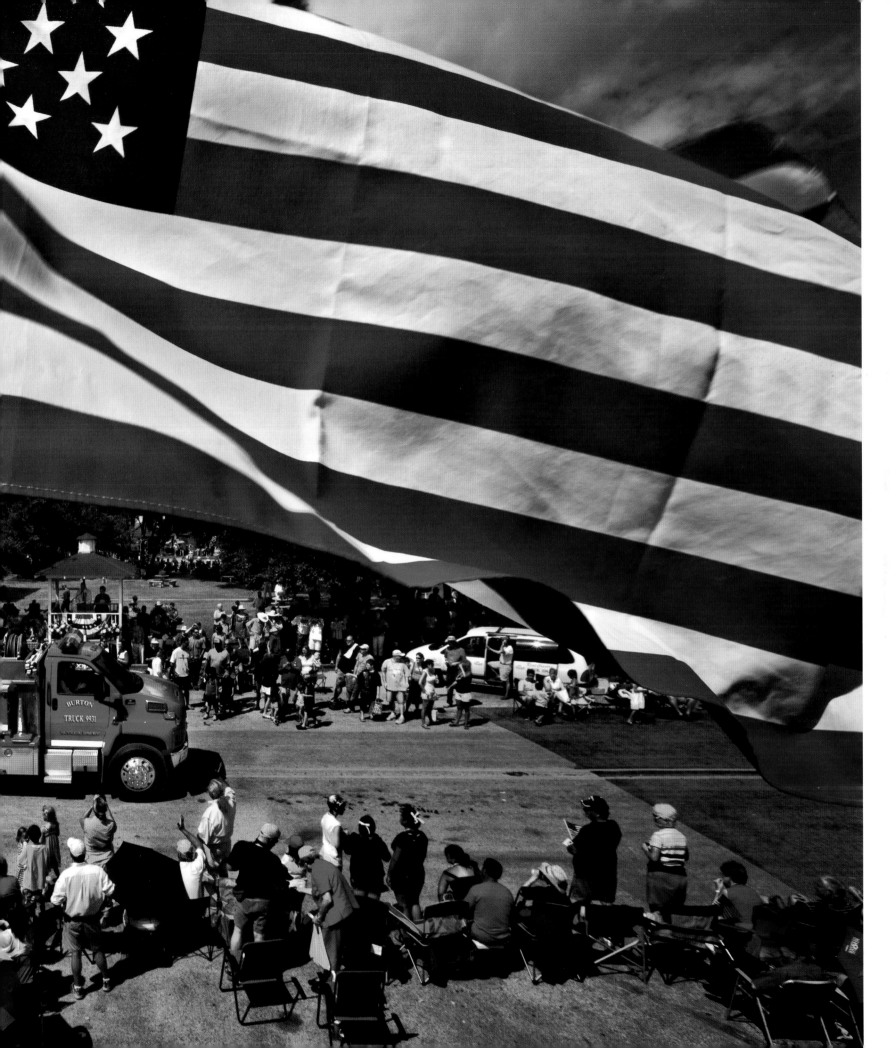

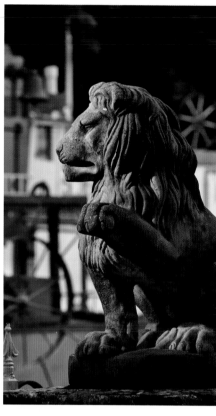

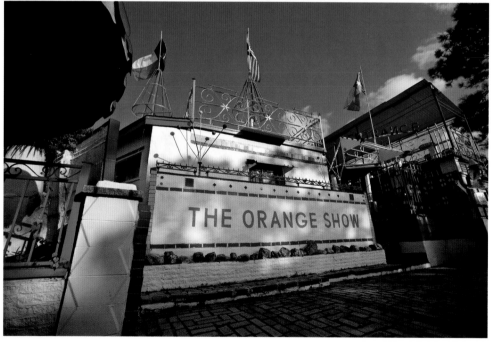

Houston, 2009

The Art Car Museum is a favorite stop for me in Houston. After years of driving by the Beer Can House, also in Houston, I finally got to light paint all of those cans. I had been wanting to do it for years. It is one of the most unusual houses I have ever shot. Actual beer cans are used as siding throughout the house. The Orange Show, also in Houston, is an incredible place to photograph. I used strobe lights to make the umbrella and clown prominent against the cloudy sky.

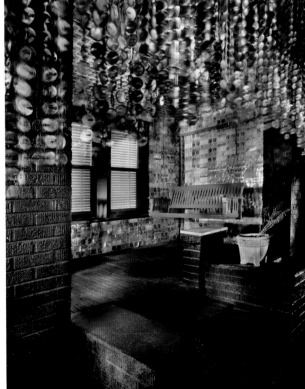

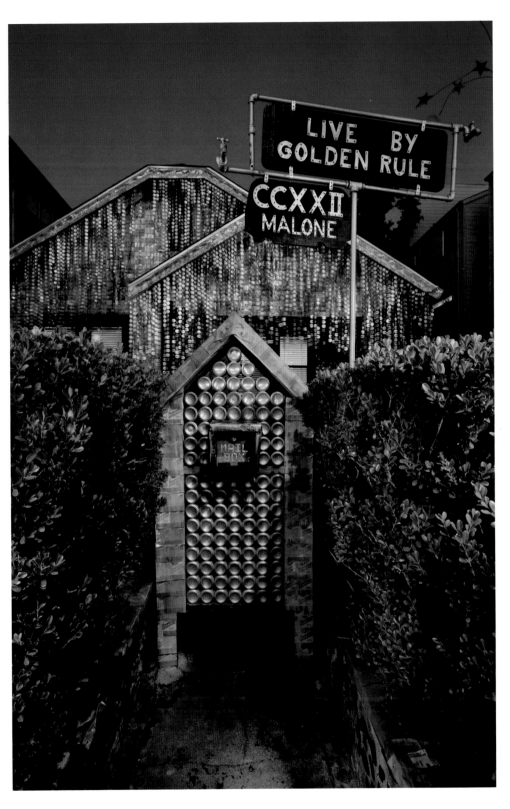

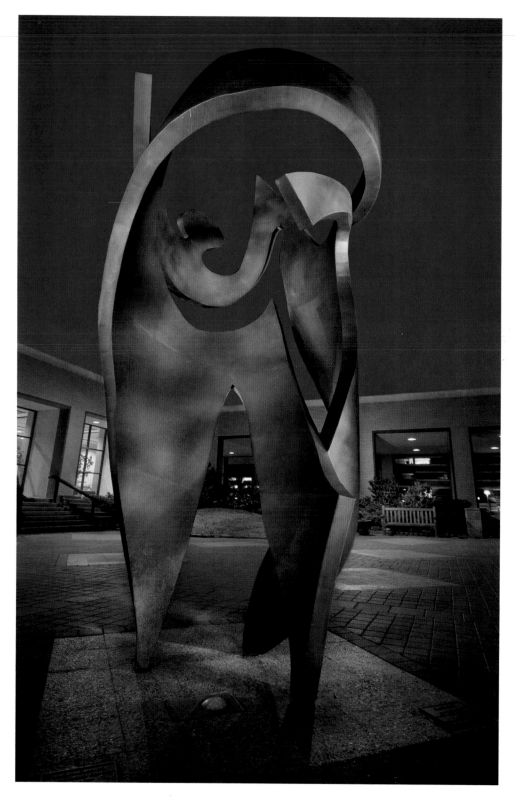

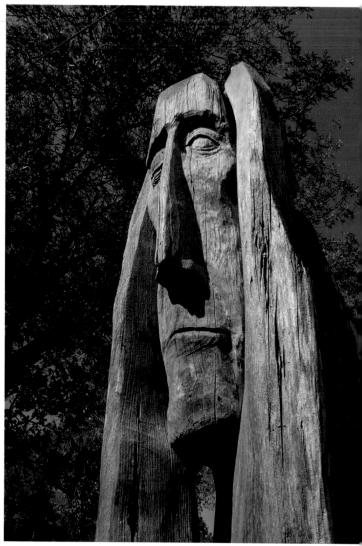

My Creative Roots, Caldwell and College Station, 1990, 2006, 2012

I was very fortunate to have grown up in a creative atmosphere. My dad pursued his creative vision through art in different mediums. My mother, who has a very green thumb, would also boldly experiment with new recipes in the kitchen. The bronze sculpture against the twilight sky is on the A&M campus and is titled *Rapport*. It was designed by my dad, Joe C. Smith, a.k.a. jlyle.

My dad, with his passion for abstract art, would have fun with me sometimes by calling me square. My only comeback was to say, "At least I am making a living at it." Growing up with that kind of support gave me a strong internal confidence to push myself to find my own creative vision.

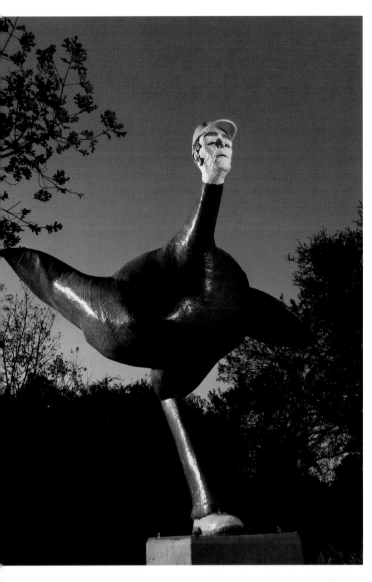

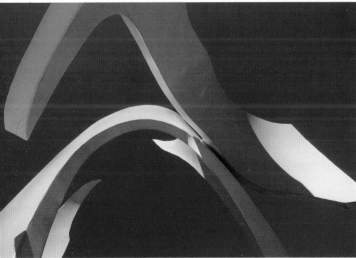

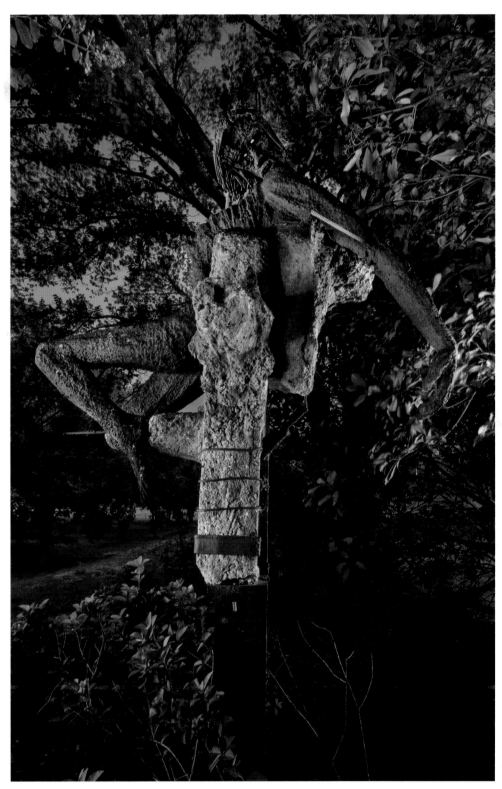

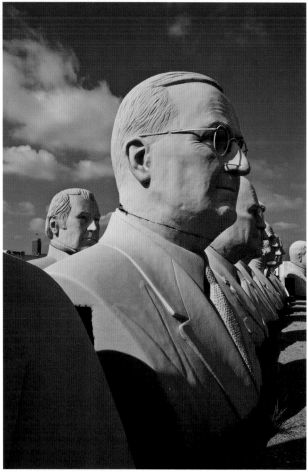

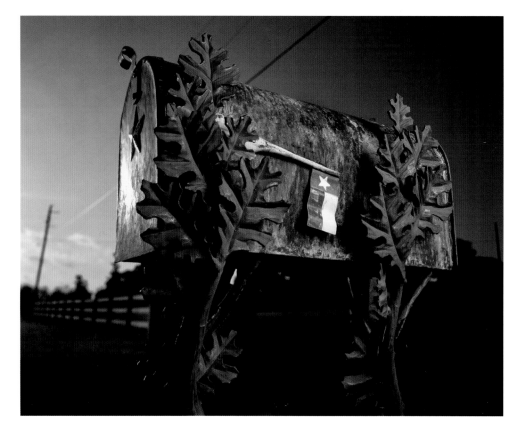

Quirky Texas, 2003, 1996, 2003, 2009
◄▲ Mirror in a window on South Congress in Austin, 2003.

◄ Mailbox in Fredericksburg, 1996.

▲ *Presidential Heads* by David Adicks in Houston, 2009.

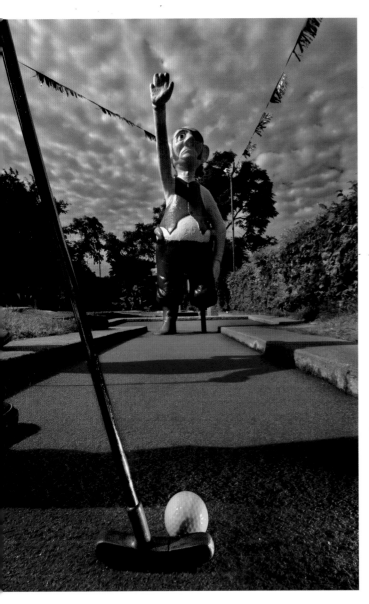

⬆ Peter Pan Mini Golf, Austin, 2003.

➡ Replica of an old-style diner at the Devil's Rope Museum in McLean. I asked the museum staff to turn off the fluorescent lights so I could light paint the scene, making it look like streetlights and car lights were coming through the window, 2009.

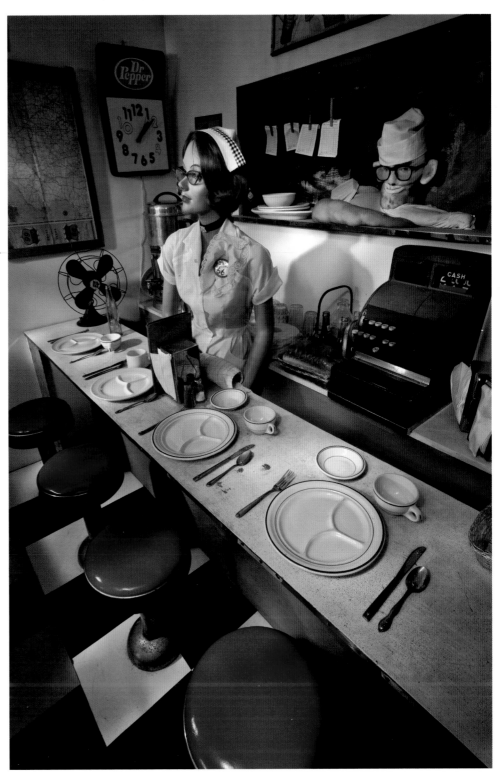

Chinati Foundation, Marfa, 2009

When I arrived at the Chinati Foundation in Marfa, the rain kept me from getting the shot I needed of the *Animo Et Fide*. Luckily, intern Luis Porras was so intrigued by my light painting technique that he opened up the gate at 5:30 a.m. and assisted me during the shoot. Many of my images would not exist without such timely assistance from others.

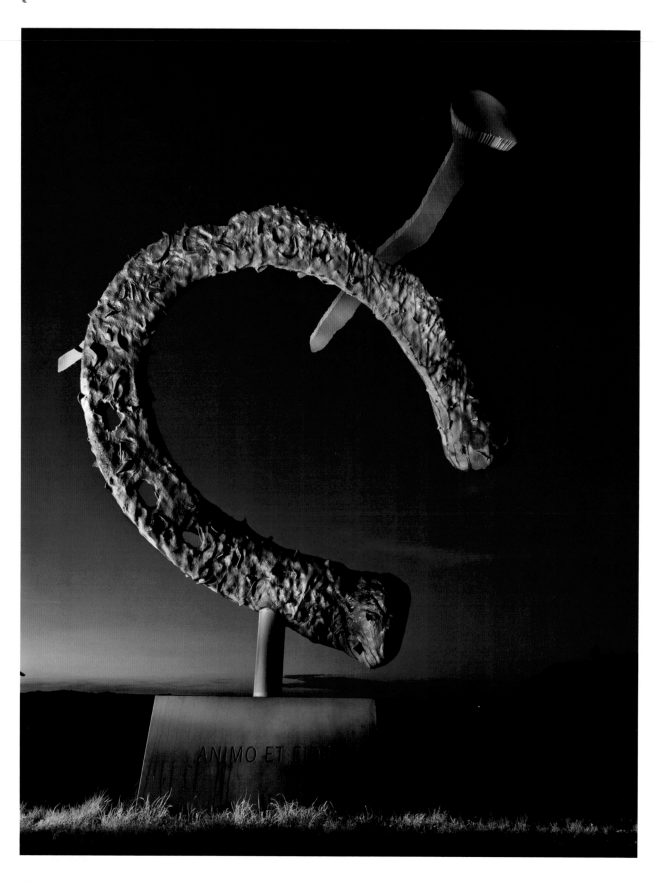

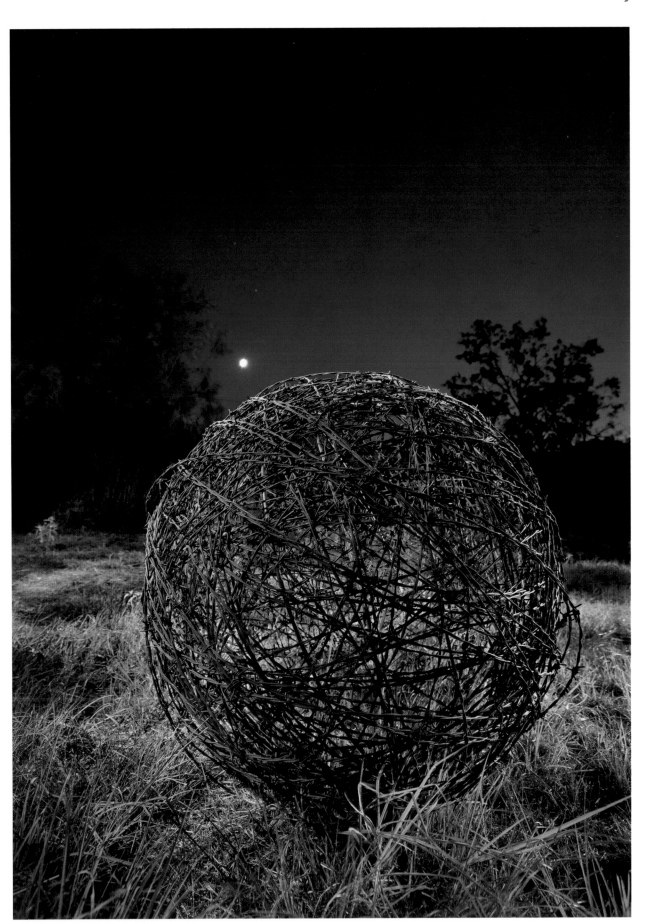

Star of Texas B&B, Brownwood, 2010
In Brownwood at the Star of Texas Bed and Breakfast, I came across this ball of barbed wire under the light of the full moon, which added a little mystery to the scene.

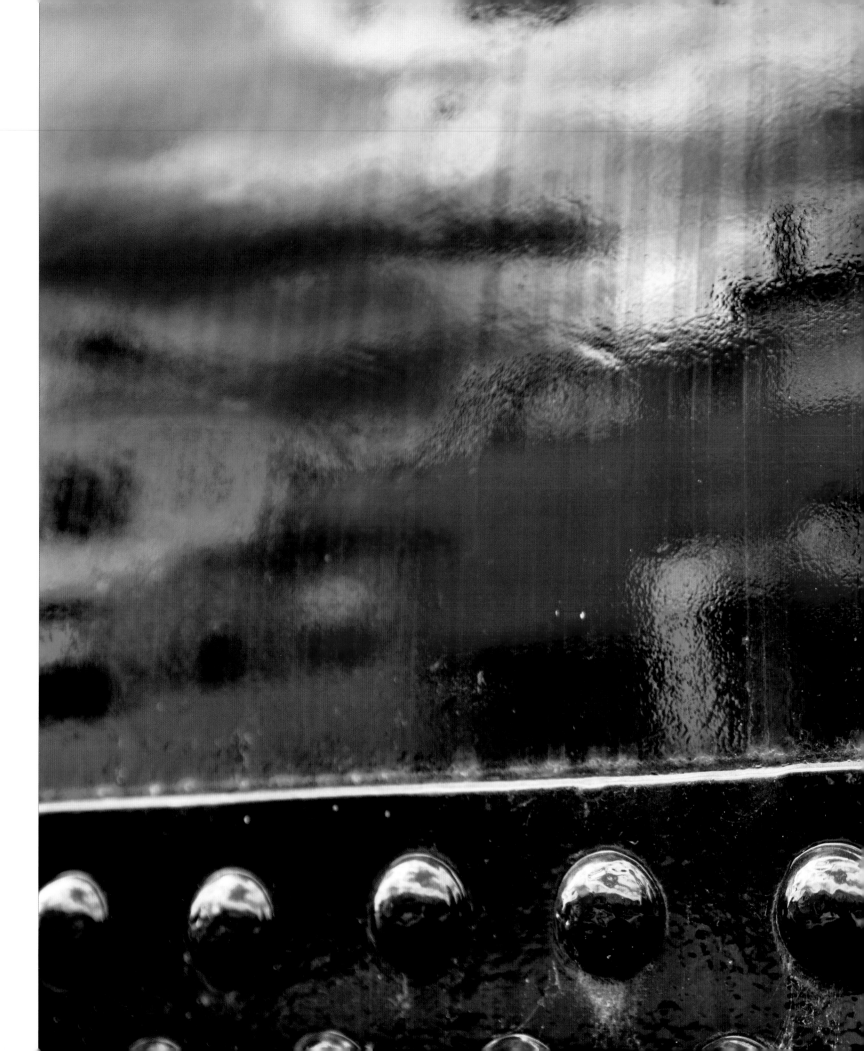

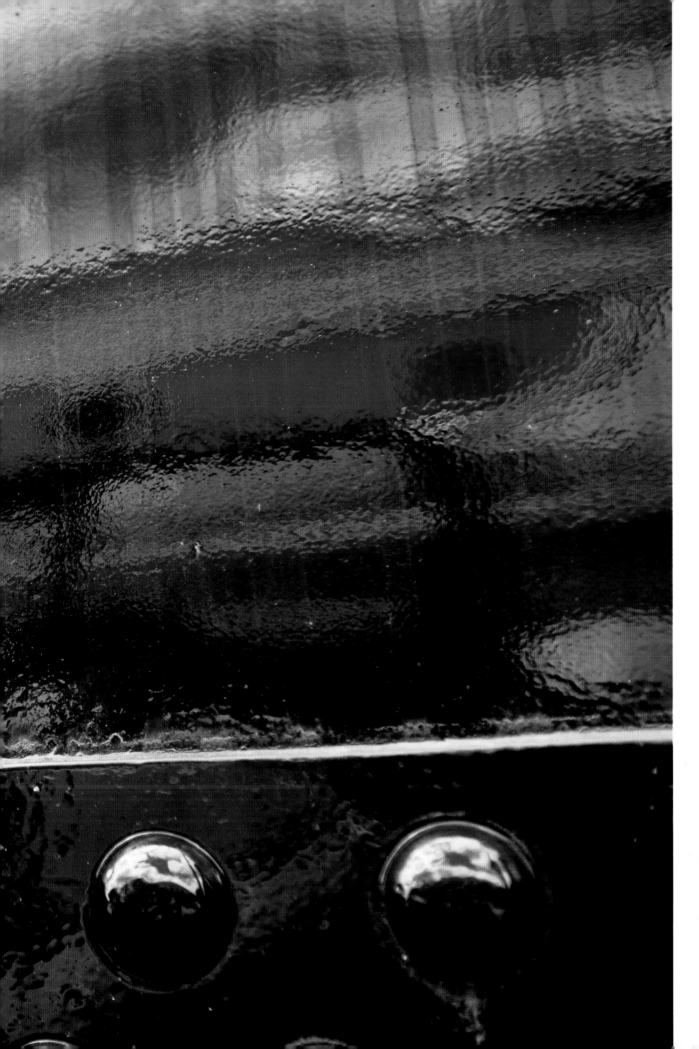

Museum of the American Railroad, Fair Park, Dallas, 2009
To keep my work fresh and fun, I always look for abstract, textural scenes like this one of a freshly painted diesel engine reflected onto a gleaming steam train. The museum has since relocated to nearby Frisco.

Round Top, 2010
Art car in the square after the
4th of July Round Top Parade.

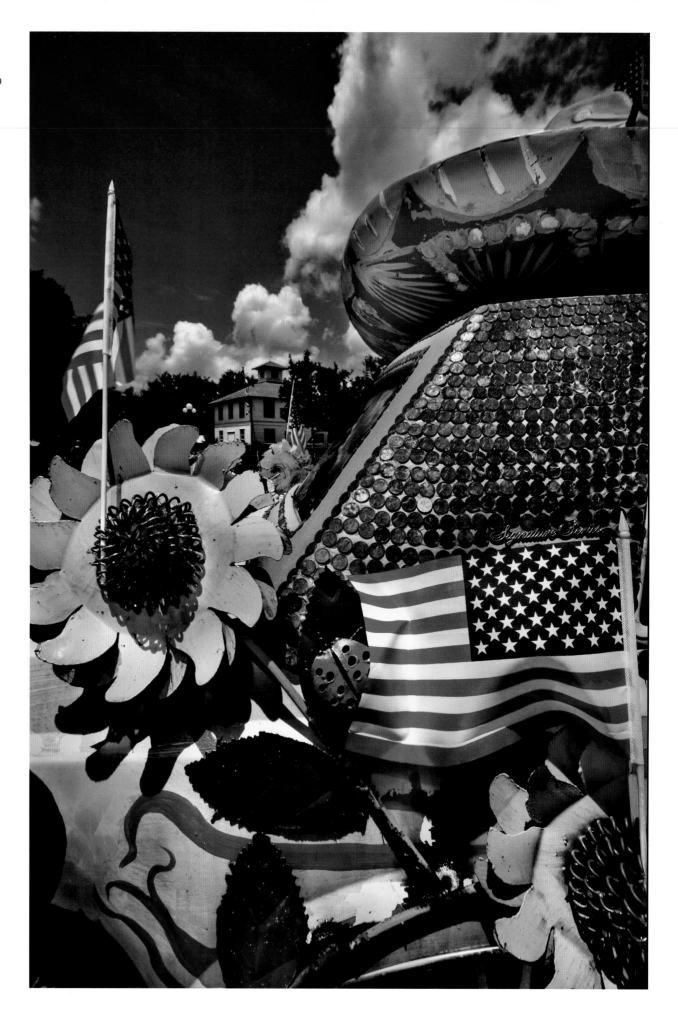

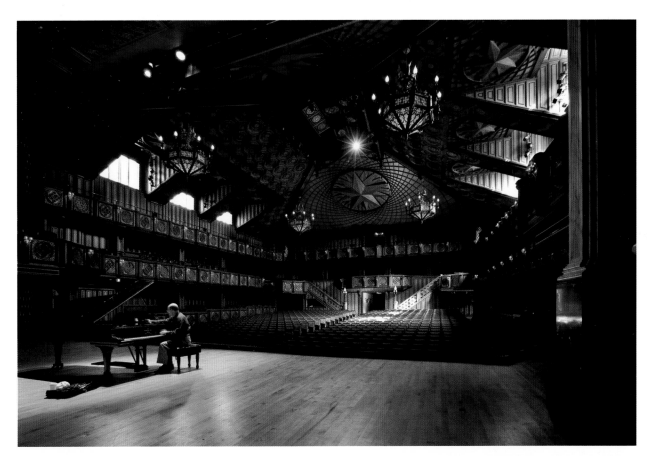

Festival Hill, 2010
I covered a free concert at Festival Hill put on by the summer music students. I asked that the windows be opened during the last song so I would have enough light to photograph folks throwing streamers from the top balcony. Timing is everything, and I just have to hope and have faith that it will all come together.

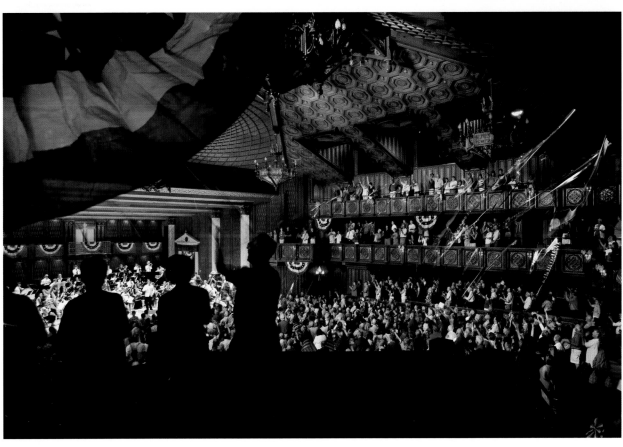

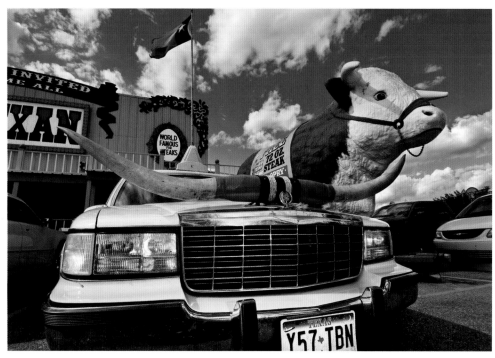

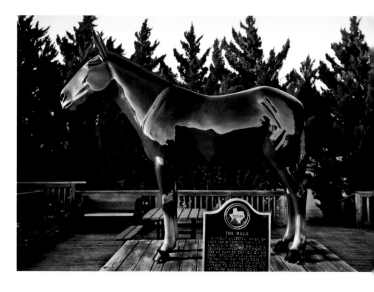

Animal Art, 2007–11

 Paisano Pete in Fort Stockton, 2010.

Dogs of the world at the San Antonio Museum of Art, 2008.

Big Texan in Amarillo, 2007.

The Mule in Muleshoe, 2009.

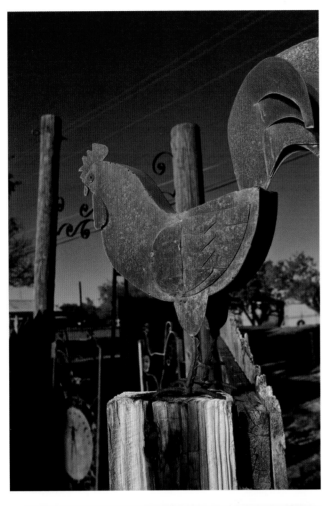

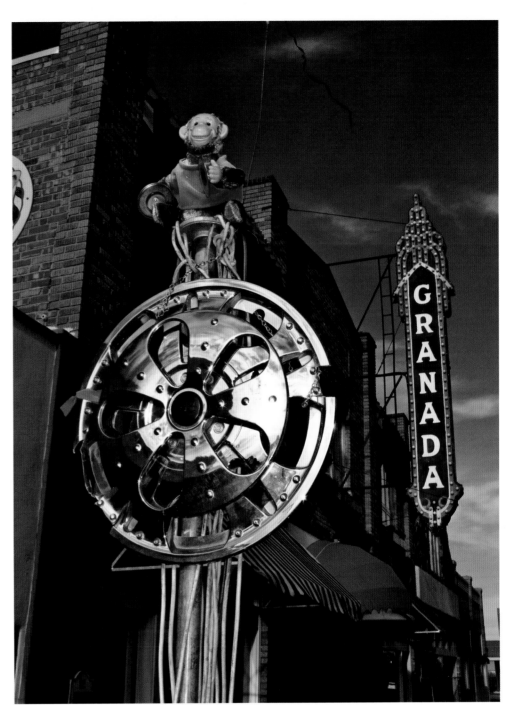

⬆ Granada Theater in Alpine, 2009.

⬆⬅ Rooster art at the Chicken Art Farm in San Angelo, 2011.

⬅ Swordfish at King's Island, Lake LBJ, 2009.

Galaxy Drive-In, Ennis, 2009
At the Ennis Galaxy Drive-In, the Shelby Car Club of Midlothian was gracious enough to let me play with several scenes for a story on drive-in movie theaters around the state. They were very patient and cooperative with me.

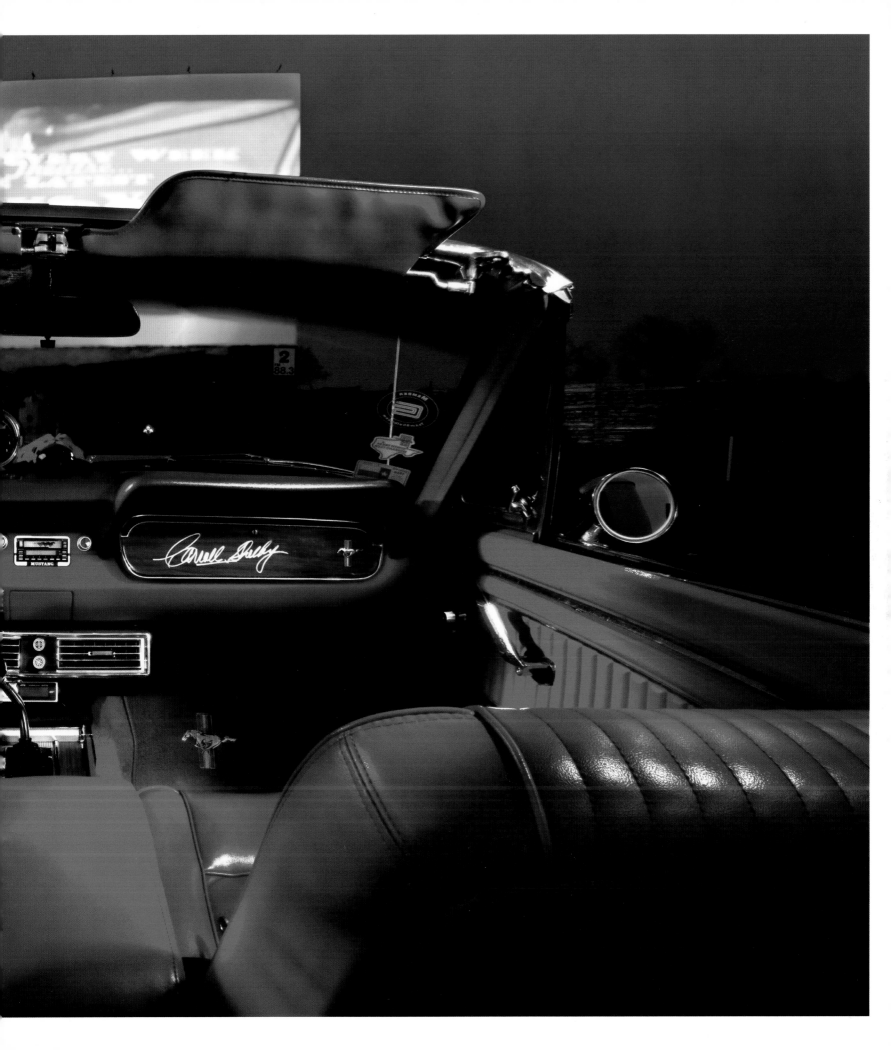

Sky-Vue Drive In Theatre, Lamesa, 2009
Old-style movie projector with modifications to accommodate a large film reel so the owner could load an entire movie at a time, turn on the projector, and get back to the concession stand to sell their famous Chihuahua Sandwich.

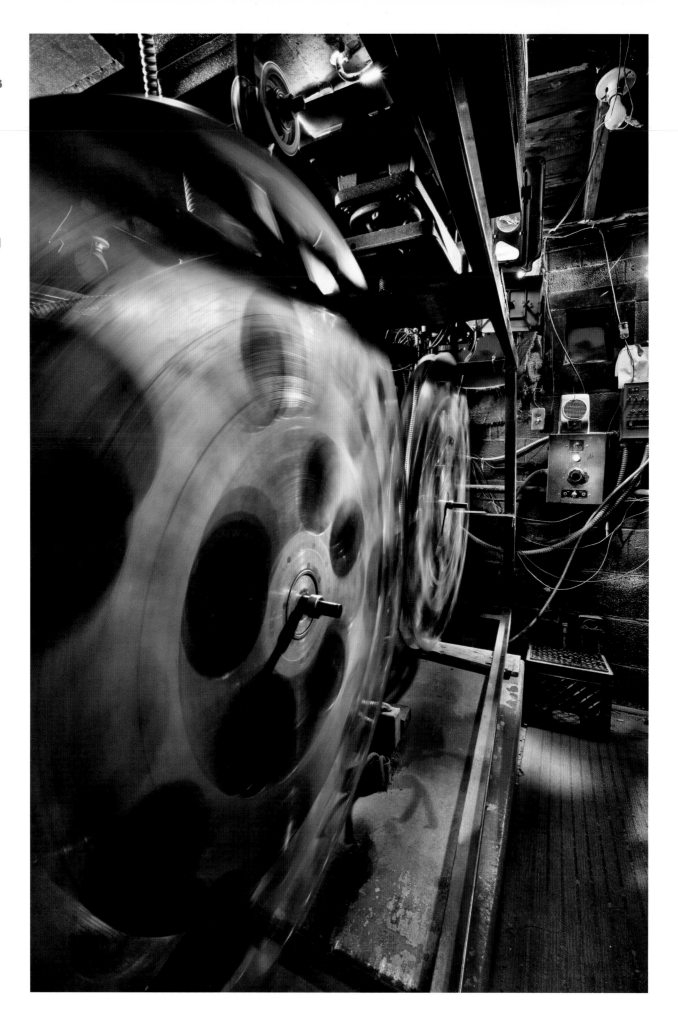

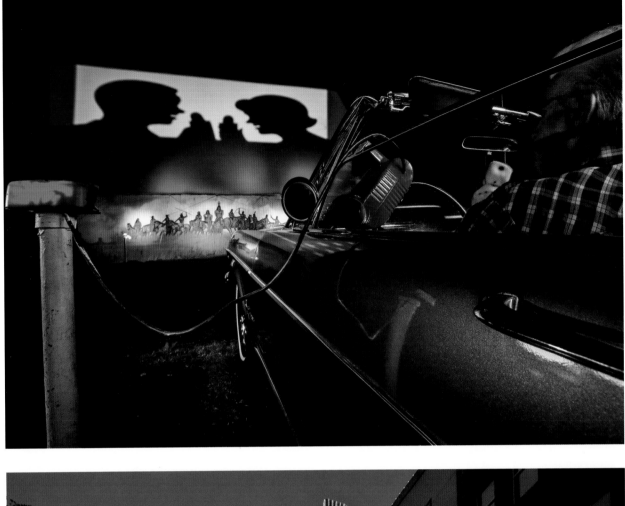

Galaxy Drive-In, Ennis, 2009
This couple from the Mustang Car Club sat still for thirty seconds while I light painted their car. Some people cannot do it. I don't even think I can.

Majestic Theatre, Eastland, 2009
Built in 1920 and originally called the Connellee Theatre, the movie palace closed during the 1930s and was reopened in the 1940s by the Interstate Theatre chain with its new name.

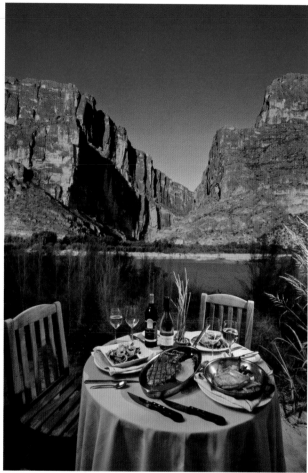

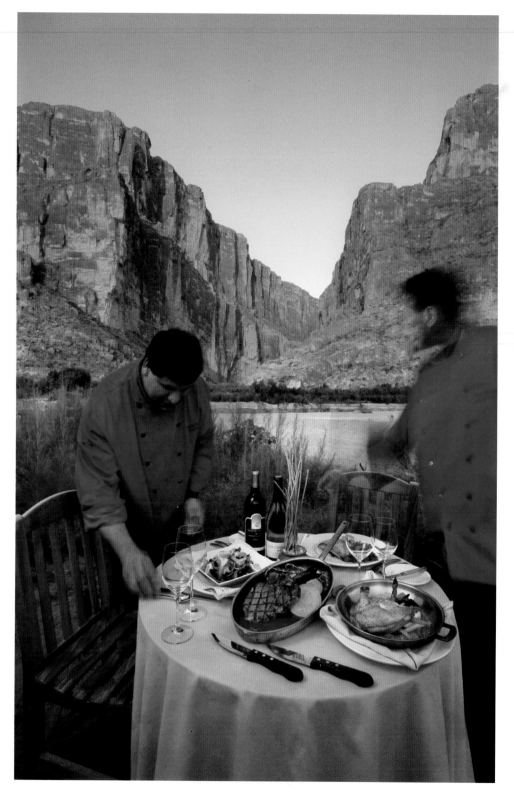

Chefs from the Ocotillo Restaurant, Lajitas, 2006
We set up a gourmet table before sunrise at Santa Elena
Canyon in Big Bend National Park. I don't think these guys
usually get up very early. They were amazed at how beauti-
ful it is at that time of day. The shot selected for the cover
was taken at a much closer angle. I did not realize that the
wine was from California; the labels had to be changed to
Texas wines. I try to think of everything, but I miss a few
details sometimes.

Hot Dr Pepper

On this assignment I decided to go all out and make this photograph really jump off the page. I arrived at the Dr Pepper Museum in Waco and asked them to explain how hot Dr Pepper is served. The counter person said, "we heat up Dr Pepper to 180 degrees then pour it over a cold lemon." Expecting this assignment to be easy—a little backlight showing the steam from the hot beverage—I should be done in less than an hour. After much frustration and several test shots later, it seemed like I was not going to get the results I was expecting. So, instead of using a Styrofoam cup, I asked if they had clear glass with the Dr Pepper logo so we could see the lemon and the beverage. Instead, they offered plastic cups from the 1990s. Straight out of a sealed bag, these cups were so scratched up they looked dirty and unappealing. However, as soon as the hot beverage hit the cold lemon instant fog appeared flowing up and out of the cup covering most of the imperfections. I have usually found that if I can stay focused on getting a great result the universe seems to deliver.

Tigua Indian Restaurant and Visitor Center, El Paso, 1985
This was my first food shot. At that time the magazine was hiring a food photographer as needed. While on assignment in El Paso, I decided to try my hand at shooting food. From this point on, I shot ninety percent of the food photography for *Texas Highways.* Over the years through much trial and error and study of food photography, I have learned some techniques to create food photos that will make viewers hungry.

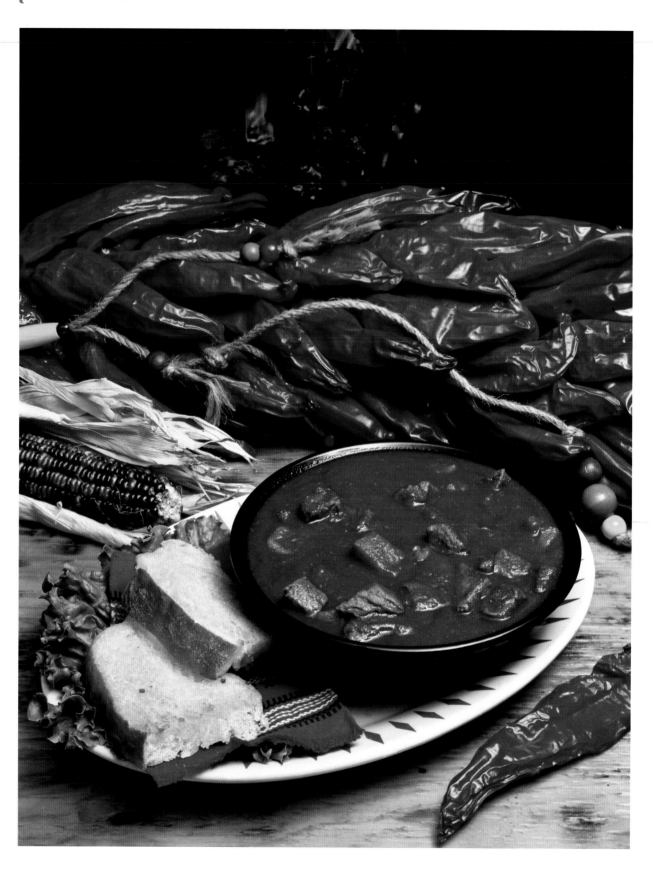

**Bistro Moderne,
Houston, 2006**
La Bouillabaisse de Marseille,
prepared by Chef Philippe
Schmit at Bistro Moderne in
Houston. I especially enjoyed
working with the wait staff and
visiting with Chef Philippe.

Red Velvet Cake, Studio, Austin, 1995

I have learned from a number of chefs and seasoned food stylists, but one stands out from the rest—Fran Gerling. For twenty years, Fran tested the recipes and styled the food for *Texas Highways*. I had never really had red velvet cake before this shoot. I left Fran's kitchen with a new favorite dessert. It was fantastic!

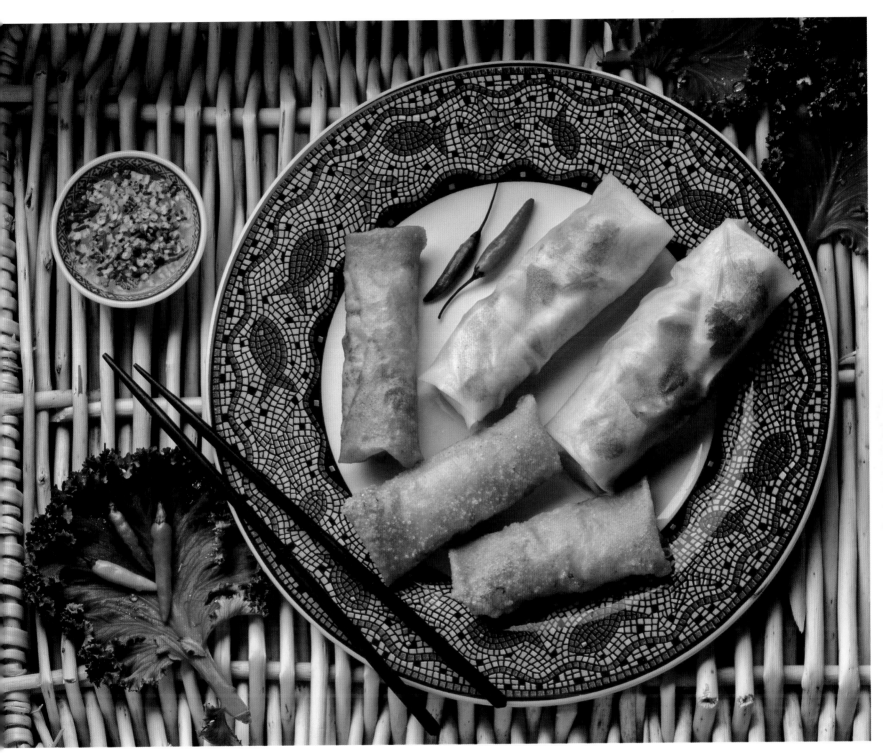

Egg Rolls and Spring Rolls, 1997
Fran Gerling and I went shopping at Pier 1 Imports. We
borrowed the dishes and used the top of a wicker box for a
small table to display these spring rolls.

Fran Gerling's Kitchen, Austin, 1985–2000

Fran would test recipes and go shopping with me to find the perfect dishes and props to tell the story. I would show up in the morning, and by the end of the day we would have captured two or three styled food shots that eventually appeared in a *Texas Highways* cookbook. Lots of good conversation was had in that kitchen. The trick was to come up with interesting and textural sets—that's what kept our creative juices flowing. The Mexican Soup is sitting on a small mirror that I found in a local Austin shop.

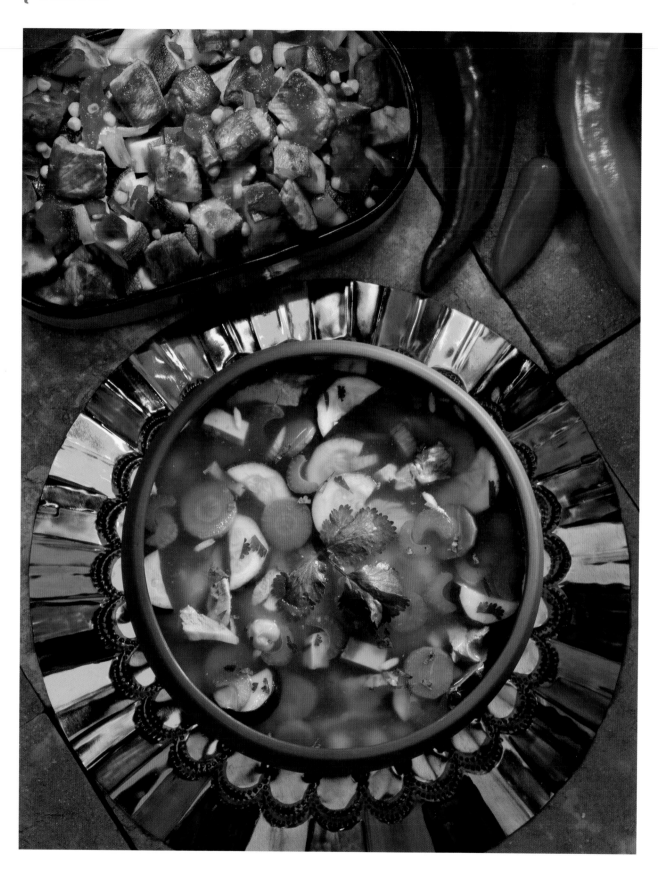

◀◀ Pork chop on an old piece of metal and grill with a colorful bowl to add some contrast to the photo. It was a challenge that we both loved.

◀ Classic crawfish étouffée.

◀◀ Soup in a beautiful glass bowl.

◀ This shot of blackened catfish became the cover of *Cooking with Texas Highways* cookbook.

Vineyard expert Bobby Cox took me on a tour of some vineyards in the Lubbock area. I used selective focus to create this pretty portrait of grapes.

Texas Wine, Austin, 1989
◀ The shot of Texas wines was one of the most controversial covers because many objected to wine being on the cover of a travel magazine. If I remember right, twenty-eight people cancelled their subscriptions.

ACKNOWLEDGMENTS

I would like to thank all of the folks that have inspired, motivated, got up early, or stayed up late to help me to make some of my favorite photographs over my 30-year career at *Texas Highways*. There are too many to name everyone, but a few stand out:

Ned Fratangelo, for suggesting we hook up a boat light to his car battery, allowing me to start practicing light painting for the next twenty-five years.

Art Walton, Charles Sappington, Al Rubio, and Geoff Appold, who all provided some "aha" moments that, have shaped my personal vision.

The staff at *Texas Highways*, for providing support and encouragement, especially Matt Wetzler, Jill Lawless, Mark Mahorsky, Lori Moffatt, and Matt Joyce for design ideas, content, and copyedits.

My sister, Lynn Person, for helping with my copyediting in the early stages of the project.

Mac Woodward and Casey Roon at the Sam Houston Memorial Museum, for putting together a collection of my favorite photographs that is now a travelling photo exhibit.

Shannon Davies, Gayla Christiansen, and the whole staff at Texas A&M University Press, for having enough faith in my work to publish this book.

Charles Lohrmann and E. Daniel Klepper, for finding a few good things to say about my commitment to the art of photography.

My parents, Mollie and Joe Smith, for their support in life and art.

Thank you everyone!

INDEX